IMAGES
of America

NAPLES

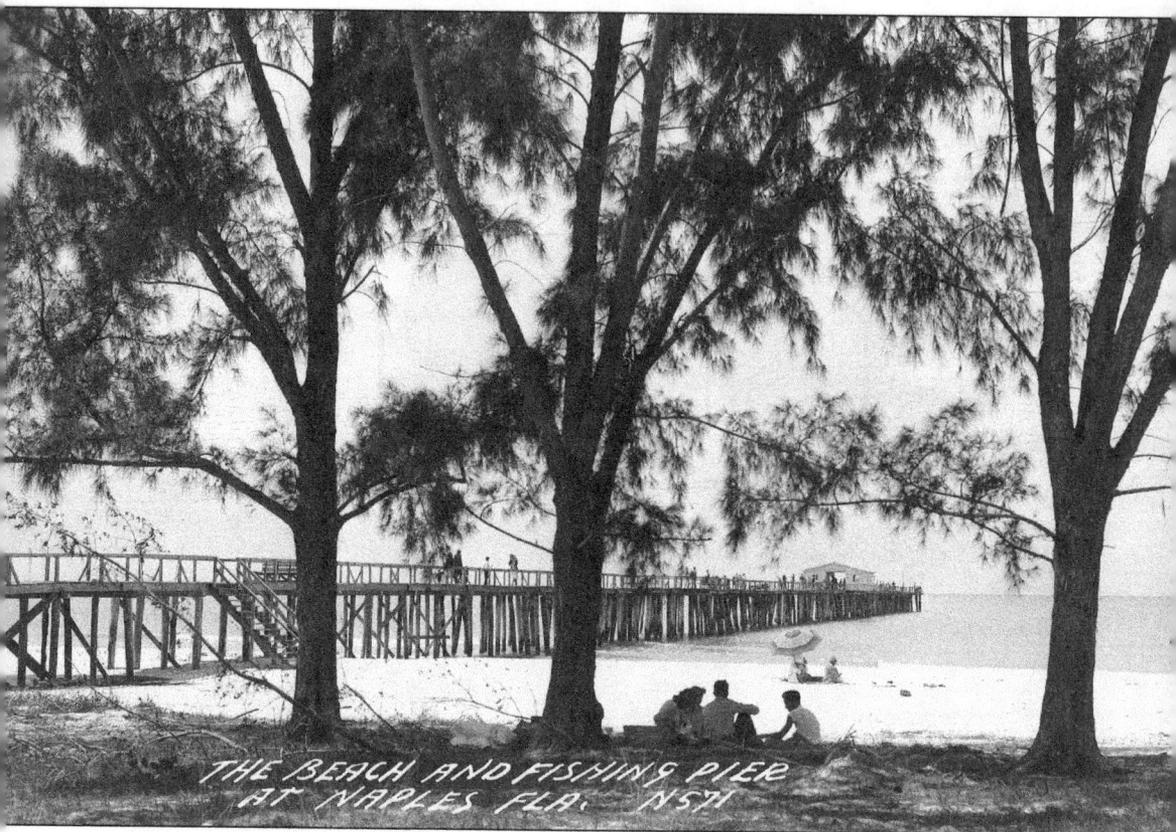

THE BEACH AND FISHING PIER AT NAPLES FLA. N5TH

The Naples Pier, pictured before Hurricane Donna came ashore on September 10, 1960, was first built in 1888, then rebuilt after the hurricanes of 1910, 1926, 1944, and 1960. The pier served as the main gateway to Naples for nearly 30 years. With the arrival of train service in 1927 and the opening of the Tamiami Trail in 1928, the pier lost its importance as a dock, but remained a popular place to fish and to watch the sunset over the gulf. In the 1920s, dances were often held on the broad planks, and a sign requested that those fishing, "Please keep the fish off the dance floor." The pier is now the well-known symbol of Naples.

IMAGES
of America

NAPLES

Lynne Howard Frazer
Naples Historical Society

ARCADIA
PUBLISHING

Published by Arcadia Publishing
Charleston, South Carolina

Library of Congress Catalog Card Number: 2004108899

For all general information contact Arcadia Publishing at:
Telephone 843-853-2070
Fax 843-853-0044
E-mail sales@arcadiapublishing.com
For customer service and orders:
Toll-Free 1-888-313-2665

Visit us on the Internet at www.arcadiapublishing.com

CONTENTS

ACKNOWLEDGMENTS

This book is dedicated to the founders of the Collier County Historical Society (now the Naples Historical Society), whose foresight in preserving the history of the young city of Naples—only 77 years old when the organization was founded in 1962—has resulted in significant contributions to the preservation of local history, including the preservation of Palm Cottage, the second-oldest house in Naples, and the compilation of an important collection of historic photographs and oral history interviews, safeguarding a now long-lost Naples for the future.

The Naples Historical Society would like to sincerely thank Mrs. Nina H. Webber for generously allowing the use of more than 60 images from her extensive vintage postcard collection for this book. A special thanks also to the *Naples Daily News* for allowing the use of their rare photographs of the demolition of the Naples Hotel, and to Gerry Johnson, *Naples Daily News* librarian, one of the best historians in Collier County. Thanks also to Dick Cunningham and his skilled staff at Naples Custom Photo for their expert digitizing of the images in this book.

A very special thank you goes to all the current and past directors, members, and volunteers who have given so generously of their time, talents, and financial support to the Naples Historical Society since 1962.

In addition, the Naples Historical Society would like to acknowledge the outstanding contribution of Frank F. Tenney Jr., director of photography for the society in the early 1970s, whose dedication to developing the organization's photographic archives, along with the diligent work of the "Tape Recorded Interview Committee," form the basis for this book.

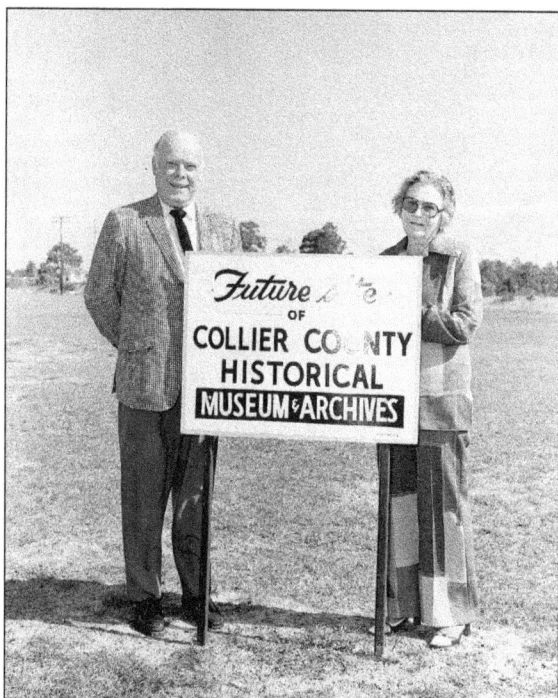

George Huntoon, left, president of the Collier County Historical Society from 1973 to 1978, and Margaret T. Scott, right, founder and first president of the historical society in 1962, pose at the future site of the Collier County Historical Museum and Archives in 1973. The Collier County Historical Society funded the building of the museum and gave it to Collier County in 1978.

INTRODUCTION

"This is it!" With these legendary words two friends from Kentucky, watching the sun set over the Gulf of Mexico, pronounced the pristine peninsula between the Gordon River and the Gulf of Mexico the site of their new winter resort town—Naples.

In 1885, Gen. John S. "Cerro Gordo" Williams, a Mexican and Civil War veteran, and his friend Walter N. Haldeman, owner of the *Louisville Courier-Journal*, envisioned their newly "discovered" paradise as a place where "invalids can escape the chilling blasts of winter and semi-tropical fruits can be grown for profit." By 1888, however, the new town on the edge of the Everglades remained remote and rustic, and a promotional brochure warned, "Visitors must not expect to find a 'city' already made; but the location and surroundings, the advantages, beauties and attractions are all there." Despite the town's lack of development, the brochure's enticing descriptions of the "novelty of climate and natural scenery" enabled the newly formed Naples Company to sell more than 1,000 town lots for the price of $10 apiece.

By 1890, the Naples Company had built a pier and the Naples Hotel, but mounting debt eventually forced the cash-strapped company into bankruptcy. Its property was auctioned off on the steps of the hotel and most of what is now downtown Naples was bought by a sole bidder—former Naples Company director Walter N. Haldeman.

Haldeman took over the development of the town and a handful of guest cottages and winter homes were constructed, many out of tabby, a primitive homemade cement. Winter visitors shared the brand-new town with a few year-round residents, hardy pioneers who often lived in makeshift palmetto-thatched huts and survived by hunting, fishing, and farming.

The 20-room Naples Hotel, affectionately called the "Haldeman Clubhouse" since most of the guests were Haldeman's friends or family, became the heart of the winter resort, offering the only public dining room and entertainment in town. The hotel was ideally situated on the narrowest part of the peninsula, between the pier and the Gordon River, and carefully centered on Pier Street, the "Main Street" of the new town. An advertisement in the February 1905 issue of *Country Life in America* emphasized the resort's easy-going ambience, "The people who have patronized the Hotel Naples in the past have been composed principally of families, and the hotel has the reputation of being a homelike place, conducted for the use of those who go to south Florida for health and for fishing and hunting. It is not at all a fashionable place, for the guests dress and do as they please."

Although Naples was a remote destination with limited accommodations and amenities, the superlative fishing and hunting lured a growing number of sportsmen to this rough paradise. Henry Watterson, editor of the *Louisville Courier-Journal*, spent many winters as a guest in one of Haldeman's cottages, and in 1906 reported, "Naples is not a resort, but to the fisher and the hunter, Naples is virgin; the forests and the jungle about scarce trodden, the waters, as it were, untouched. Fancy people condemned to live on venison and bronzed wild turkey, pompano and sure enough oysters—and such turkeys! And such oysters!"

In 1910, a group searching for good citrus grove land in southwest Florida found Naples unsuitable, with brackish water too salty for irrigation, but one explorer noted, "The high class established at Naples, the unsurpassed beach, the bay and fishing and hunting facilities make the section inviting. Naples is reached by boat almost exclusively, although there is a road, or rather a trail, overland, 36 miles from Ft. Myers, passing through Estero, passable at certain seasons of the year."

Accessible only by boat, a lack of roads proved to be the bane of Naples, and the town remained primarily a remote winter retreat for the rich until train service arrived in 1927. A year later, with the opening of the first road through the Everglades, the Tamiami Trail,

Naples was poised to become part of the Florida land boom, but the stock market crash of 1929 turned the dreamed-of boom into a bust until after World War II. Despite the difficulties of the Depression, the town hailed in a Naples Hotel brochure as the "Summerland in Wintertime," managed to keep its small but devoted winter-season clientele. The year-round population slowly grew until the town was large enough to be incorporated as a city in 1949. In that momentous year, the city's first bank—the Bank of Naples—opened, and four new motels competed against several trailer parks, fishing camps, and two hotels for the growing tourist trade.

By the late 1940s, the first dredge and fill operation in southwest Florida was underway. The new "Aqualane Shores" project carved canals and waterfront home sites out of the original mangroves and marshes once considered prime hunting and fishing grounds by the first Naples Hotel guests. The successful project spurred similar developments, including Port Royal and The Moorings. A 1956 article in *Holiday* magazine raved about the developing city, "Naples is not a typical Florida boom town. The upgrading is being done with remarkable restraint. Medicine-show tactics are outlawed, and irresponsible building is banned by a zoning code instituted ten years ago when Naples' tide of fortune was at its lowest ebb."

Naples continued to attract wealthy Northerners and by 1957 the city reputedly had more millionaires per capita than any other city in America. The city also welcomed "run-of-the-road" tourists and that year the Chamber of Commerce greeted nearly 1,000 visitors per month during the winter season. *Holiday* magazine credited the phenomenal growth to the city's prime location on the Gulf, its balmy weather—"pleasant even in July," fabulous fishing, and its quiet, small-town friendliness. "Because it caters to people of means and good taste, it has none of the flashy, super-resort aspects of many other Florida cities."

The once-remote resort was now the fastest growing city in Collier County and, in 1959, voters approved a referendum to move the county seat from Everglades City to a new location on the Tamiami Trail in east Naples. Before groundbreaking could begin, however, Hurricane Donna came ashore on September 10, 1960, with winds clocked at over 150 miles per hour. At noon, the eye of this strong hurricane passed directly over Naples. Amazingly, not a single life was lost in the city, but the storm wreaked havoc on the "Gold Coast" of Naples. Rebuilding began immediately, proving once again, in Naples, the "advantages, beauties and attractions are all there."

One

NOT YET A CITY

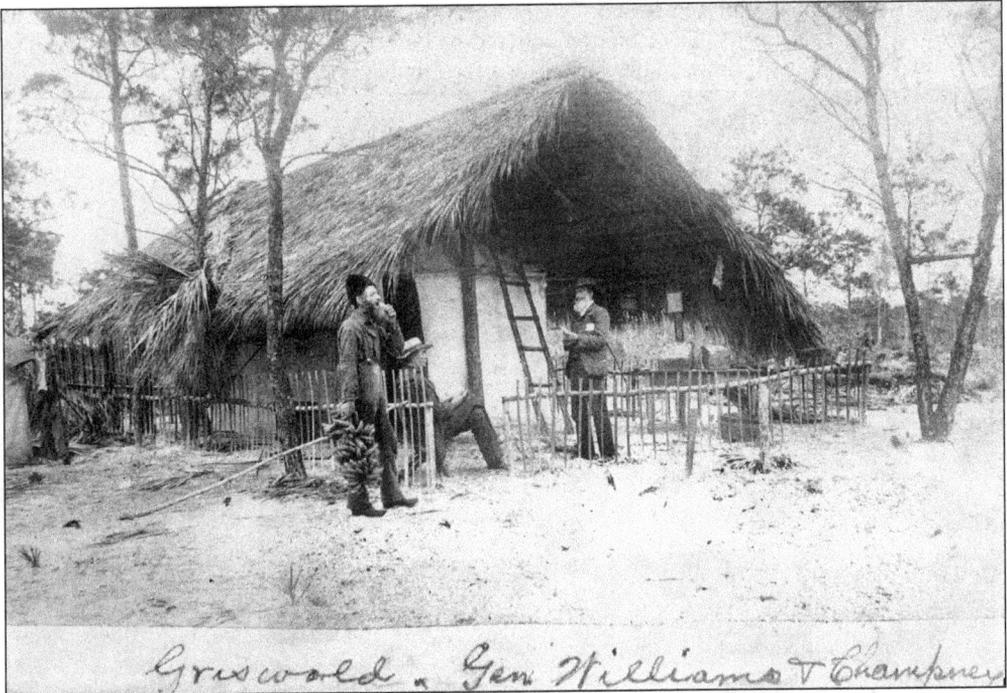

Griswold, Gen. Williams & Champney

The early Naples Company buildings were simple palmetto-thatched shacks on the beach. This photograph, taken in 1887, was later featured as a line drawing labeled "The first residence in Naples" in the company's 1888 promotional brochure. The men are identified according to the cryptic scrawl on the bottom of the photograph as, from left to right, ? Griswold; Gen. John S. "Cerro Gordo" Williams, president of the Naples Company; and Major Champney, a French engineer.

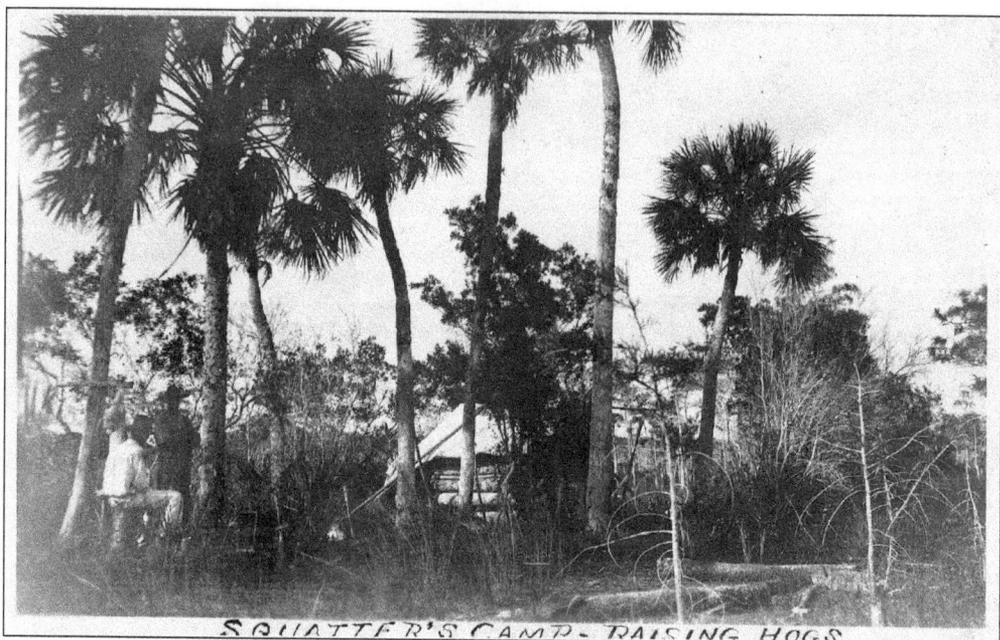

SQUATTER'S CAMP - RAISING HOGS

Before the Naples Company arrived, a series of "squatters" occupied the sandy spit between the Gordon River and the Gulf of Mexico. Two brothers, Madison and John Weeks, had settled at Gordon's Pass when the Naples Company offered to buy their squatters' rights. According to Madison Week's son, Andrew, "They gave him a terribly big price for it—$400."

ONE OF THE ISLANDS NEAR NAPLES, FLORIDA

Transportation was primarily by water on the edge of the Everglades. Small, sailing vessels transported the squatters' vegetables, salt fish, and charcoal to the main market in Key West, returning with supplies and mail to the trading posts scattered along the southwest Florida coast. The sailing vessels eventually transported visitors to Naples. (Courtesy of Nina H. Webber.)

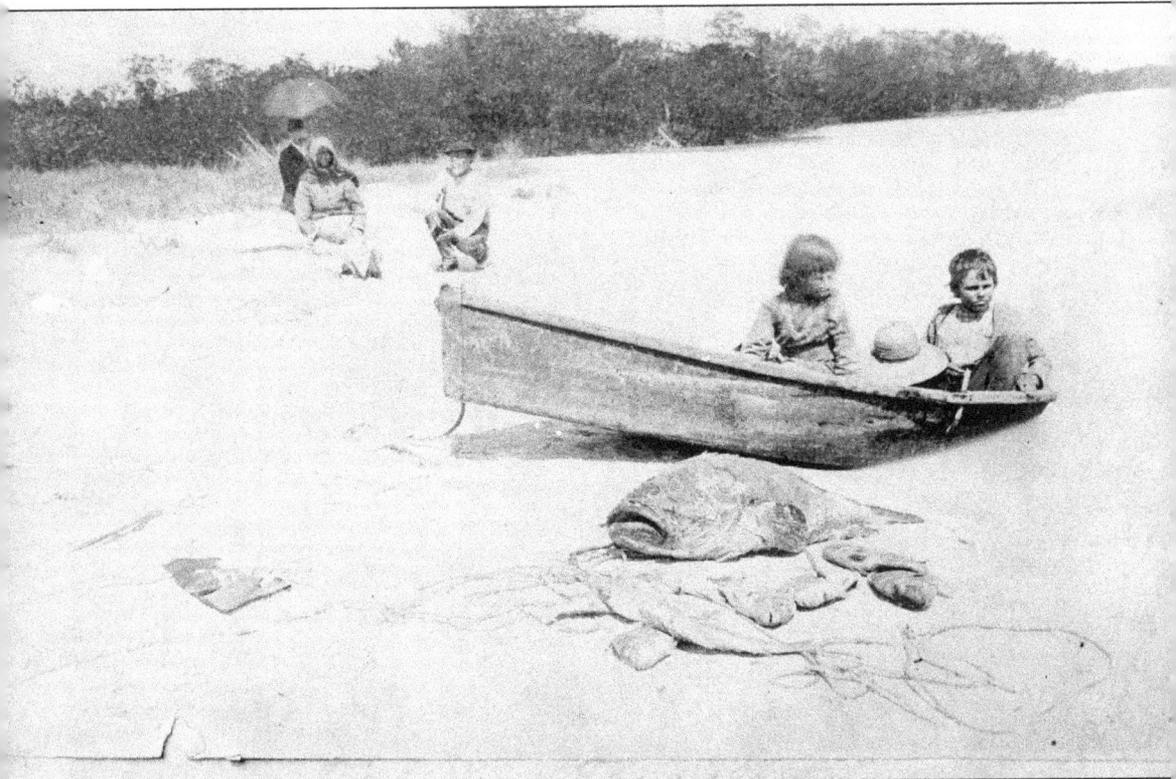

Called squatters, pioneers, or "crackers," the early settlers of southwest Florida were scattered primarily along the coast. Just a few miles north of the Weeks brothers lived Joe Wiggins, who kept bees and operated a small store; Wiggins Pass was later named after him. Squatters lived by the season, hunting alligators in the spring when the weather was dry, and in the summer moving to the Ten Thousand Islands to catch mullet for the Cuban trade. In the winter, many squatters burned "buttonwood," a type of mangrove, to produce charcoal for the Key West market. According to early pioneer Ernie Carroll, "Just about every piece of high ground from Fort Myers to Cape Sable has been occupied at one time or another by squatters. They were much like hermit crabs—when one family moved out, another would move in."

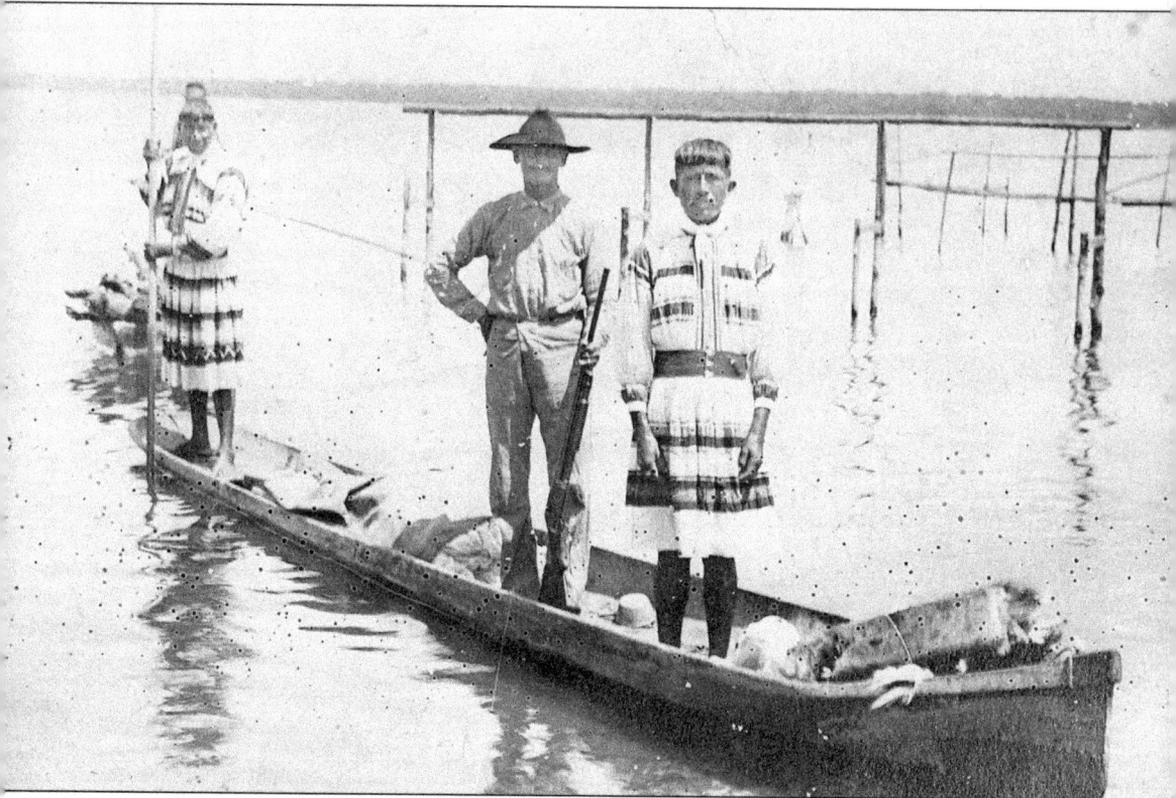

Native Americans occasionally visited the new town of Naples. In 1888, Mrs. Lillie May Maynard gave birth to Pearl Ethel Maynard, the first white child to be born in Naples. In a letter written in 1930, she told her daughter, "The Indians used to come and see you and they brought you pretty shells to play with. We tried to get them to come into the shack. They would not, but after we were all in, one of them came and looked in the door while the other one kept guard." The Maynard's "shack" was on the beach and was actually a tent with boards "halfway up and a board floor." George Osceola, John Malthers, and Gufney Tiger are pictured in this photograph, probably taken near Ted Smallwood's trading post in Chokoloskee.

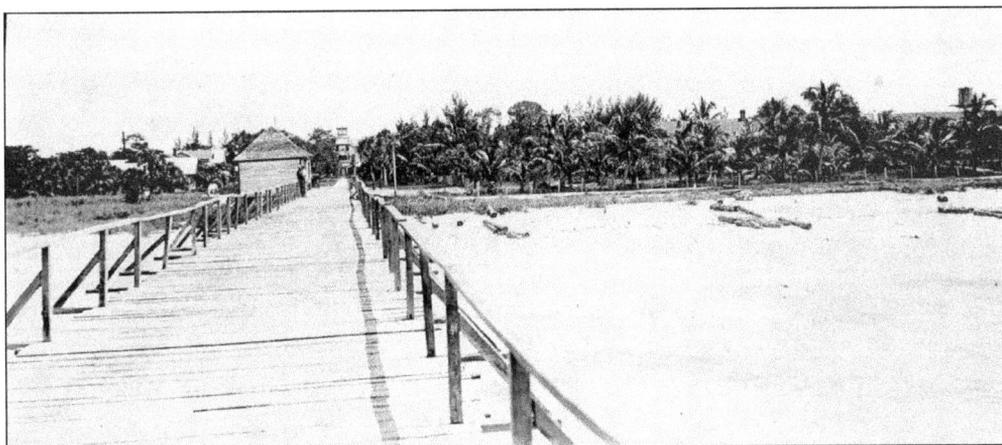

After the new town was surveyed and platted, the Naples Company began construction of a pier and hotel. Since Naples was only accessible by boat, the new 20-room hotel was carefully centered at the end of Pier Street, conveniently close to both the beach and the bay. The three-story building was constructed of Florida pine, dubbed "Lee County Mahogany" because of the red tinge of the rosin-filled wood.

The Naples Hotel officially opened on January 22, 1889. The more established town of Fort Myers, 35 miles to the north, offered only boarding houses for visitors, and a *Fort Myers Press* editorial noted pessimistically, "Fort Myers will trust to luck as usual." Rose Elizabeth Cleveland, the sister of President Grover Cleveland, was the first guest to sign the new hotel's register.

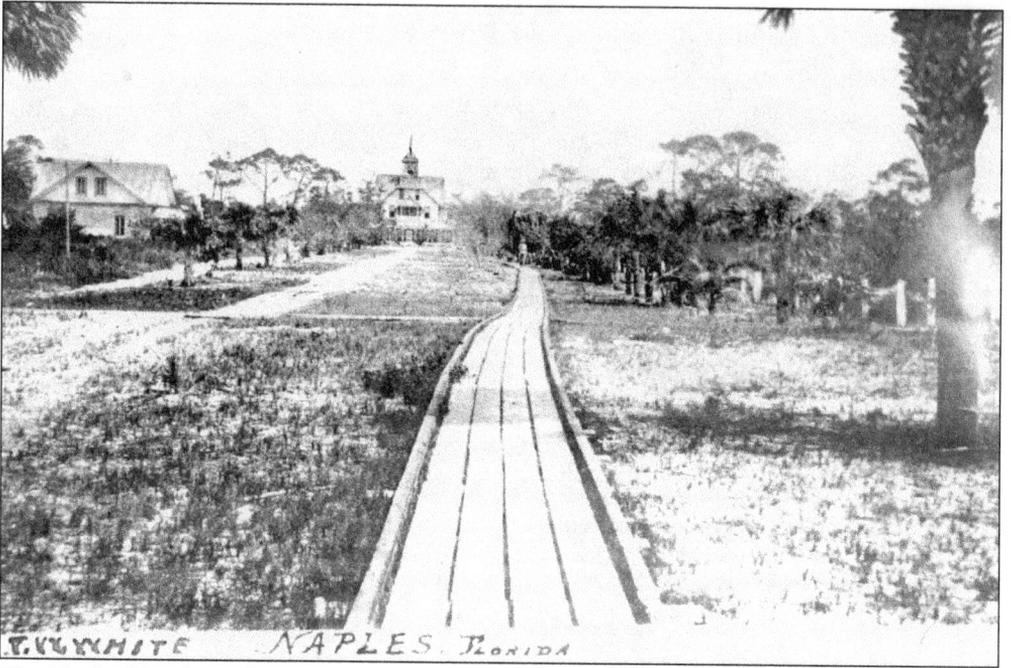

The Naples Hotel usually opened in late January and closed in late April. Each year, between 50 and 80 guests stayed at the remote hotel, many returning every year to escape the "chilling blasts of winter." The Naples Company steamer, *Fearless*, under the command of Capt. K.M. Large, made three trips a week from Naples to Punta Gorda, transporting guests to the hotel.

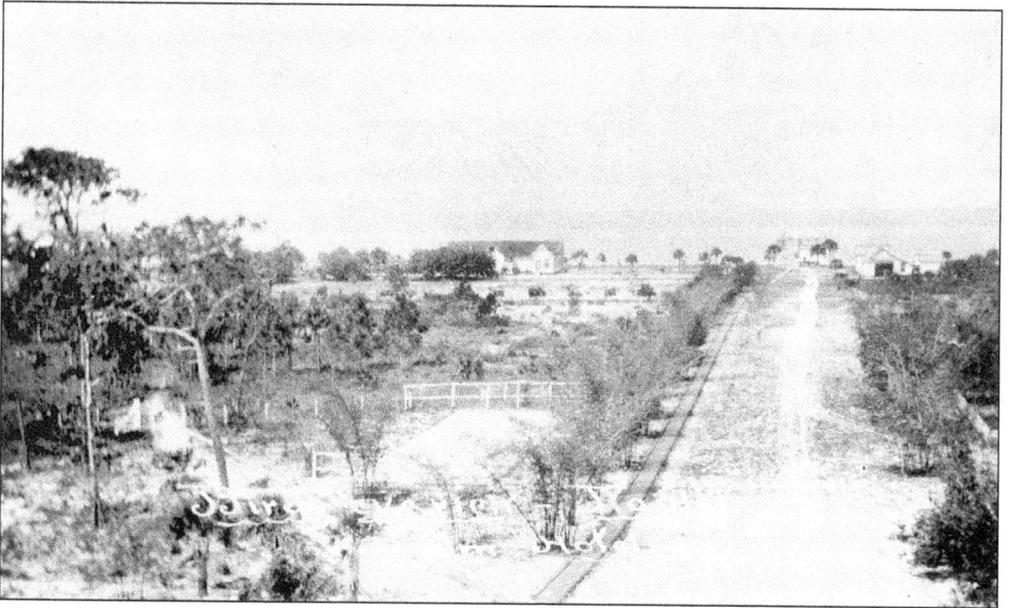

A combination boardwalk and tramway fitted with rails extended from the foot of the pier to the Naples Hotel. A cart rolled on the rails to easily transport luggage and supplies. This photo, taken from the top of the hotel, shows Pier Street (Twelfth Avenue South), the sandy "Main Street" of Naples and virtually the only road in the town, *c.* 1906.

After her first visit in 1889, Rose Cleveland returned to Naples every winter and eventually built a cottage on two beachfront lots she had purchased for $20. Her new winter home, five blocks south of the pier, fronted onto Gulf Street, a platted sand "road" directly on the beach.

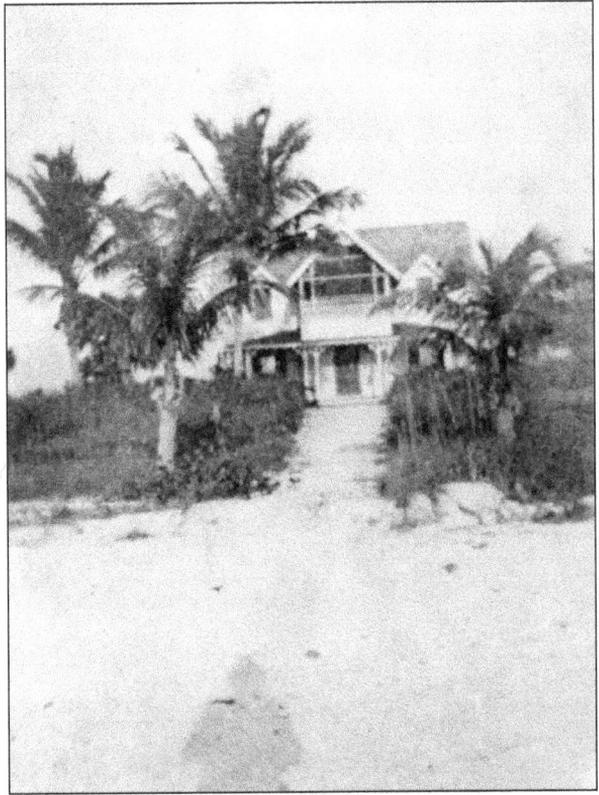

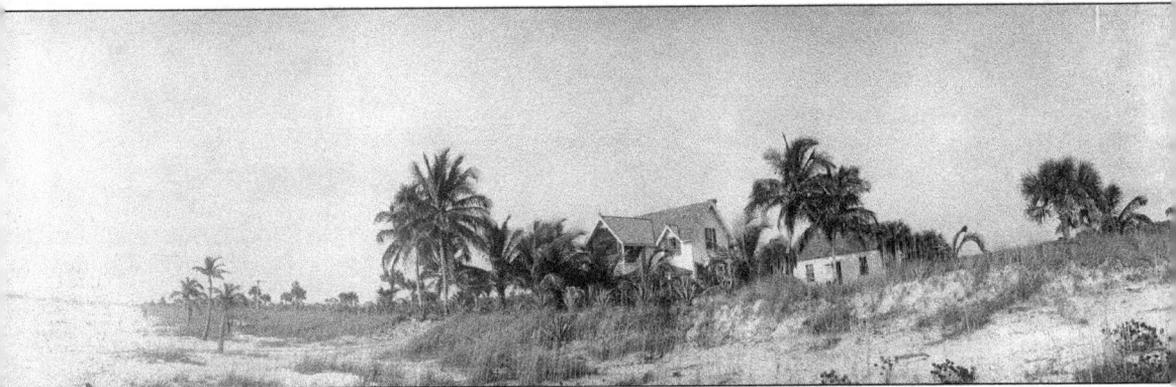

This is a northeast view of Rose Cleveland's cottage. She also purchased a tract of land several miles south of the town to start a coconut plantation. Perhaps inspired by the first Naples Company brochure, which raved, "Naples is especially adapted to the growth of the cocoanut tree," in 1889, she had several hundred coconuts delivered to the pier onboard the steamer *Pearl*, which ran from Punta Gorda to Naples.

Henry "Marse" Watterson, a friend of Walter N. Haldeman and editor of the *Louisville Courier-Journal*, was a regular winter visitor and wrote enthusiastically in 1906 about Naples and its "sea washed stretch of sandy beach, white as snow and gently firm. Eastward a trellis work of orange groves, palm gardens and orchards of coconuts, pineapples and mango. Midway, a long wooden pier, with a group of cottages nestled about, and embowered in the setting, a larger and more pretentious edifice, technically described as the hotel, but looking the house of a gentleman." Haldeman built a tabby cottage for his friend on Pier Street now known as Palm Cottage. In his autobiography, Watterson described his working relationship with his friend, "During the 35 years Mr. Haldeman and I labored side by side, there was not the least difference around us." In 1918, Watterson won the Pulitzer Prize for his editorials concerning World War I.

16

The hard-packed sand on the beach provided a natural road, and according to the 1888 Naples Company brochure, "visitors will find much to interest them in the beach covered with a profusion of beautiful shells, and in the boating and bathing. The beach affords a fine driveway and promenade."

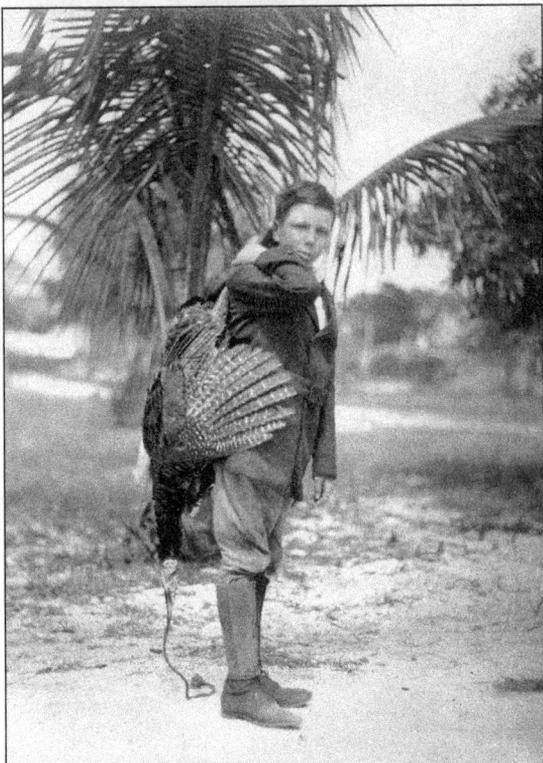

A reputation for superlative hunting and fishing lured a growing number of sportsmen to the rough and remote resort of Naples, and a promotional ad declared, "Sportsmen, whether with rod or gun, will find an abundance of game, including quails, water fowl, plumage birds, snipe, deer and turkeys." Although local hunters and fishermen were employed to supply the hotel with fresh game and seafood, guests also supplemented the kitchen.

This rare photo shows the lower dock of the Naples pier, where guests could disembark at low tide. To the right is a small passenger boat used to ferry hotel guests from Fort Myers. In 1904, the Atlantic Coast Line Railroad extended its service to Fort Myers, allowing the Naples Company to replace the large steamer with smaller boats that could make daily trips from Naples to Fort Myers. Daily trips meant ice could be brought in from Fort Myers more frequently; the smaller boats usually returned with several 200-pound blocks of ice packed in sawdust. A grandson of Capt. Charles Stewart, one of the first Naples boat captains, remembered, "Fort Myers had an ice plant, and Naples had none. One time they were leaving Matanzas Pass at Fort Myers beach when they had to put in for safety. By the time they arrived at Naples, all they had was a heap of sawdust." By 1923, the Naples Hotel had added a new powerhouse, with ice-making machinery, and ice was furnished to the cottages and visiting yachts.

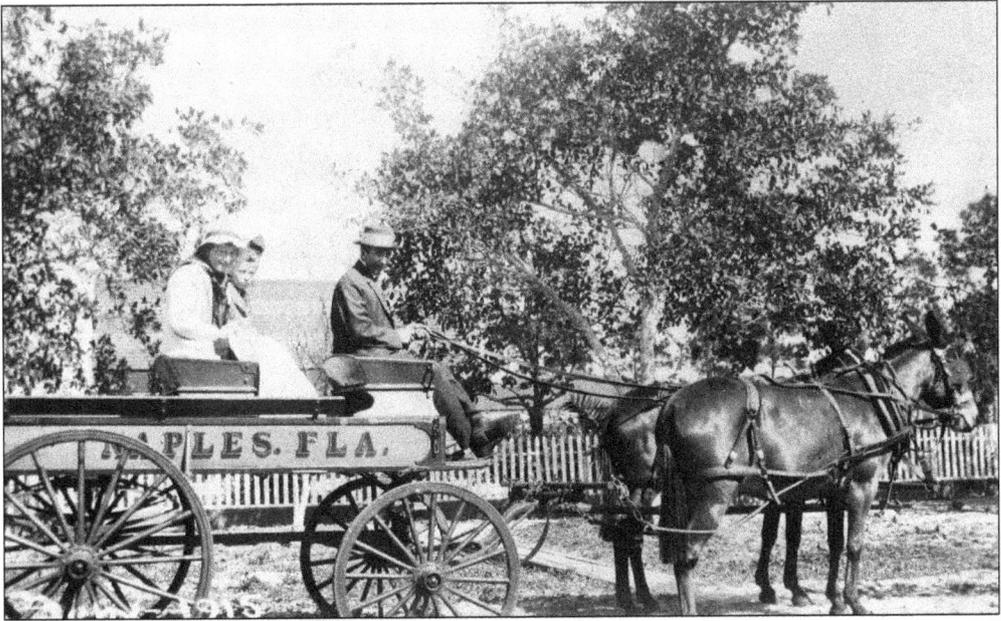

If the Gulf of Mexico was too rough for the hotel boat to make the trip between Naples and Fort Myers, a wagon would be sent to pick up the passengers and supplies, a trip that could take a full day on a rough trail, often impassable in bad weather.

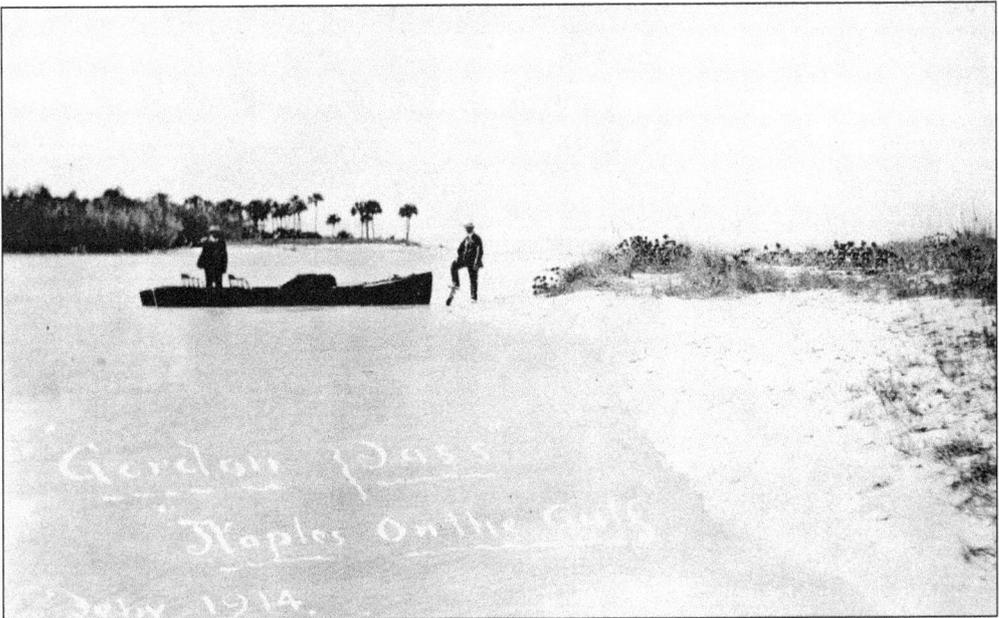

Gordon's Pass was named after an early squatter, Roger Gordon, who established a fish camp there around 1874. The pass was constantly changing and often too shallow for boats to pass through, even at high tide, increasing the importance of the pier for landing freight and passengers. An early fishing guide, Rob Storter, remembered at one point the pass was knee deep at low tide and there were "lots of pompano at that bar."

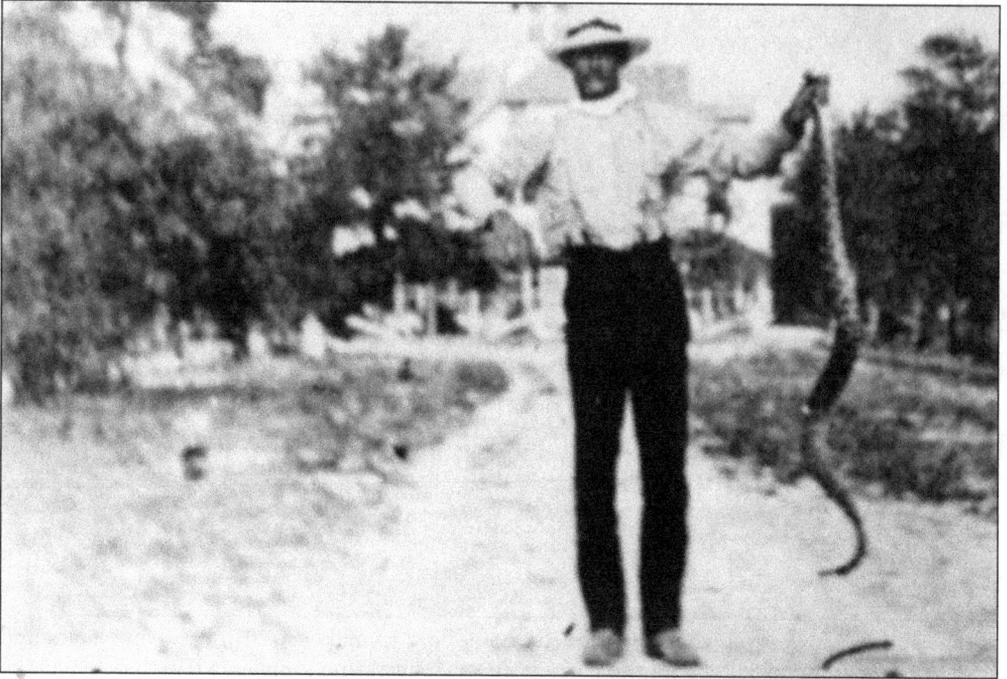

Captioned "Billy Weeks and live rattler," this *c.* 1906 photograph shows the Naples Hotel in the background. Billy Weeks, son of Madison Weeks, often worked with his brothers, Andy and Tom, hunting and fishing for the Naples Hotel. Andy remembered being paid "10¢ a pound for hams, 8¢ for the shoulder, 75¢ for a nice hen turkey and $1 for a gobbler."

The Naples post office officially opened on April 8, 1888; the first post office building, on the left, was located at the foot of the pier. In 1908, Capt. Charles Stewart moved into the small cottage next door and succeeded Will Pixton as postmaster. In addition to his work as captain of the hotel boat, Stewart served as postmaster until 1949.

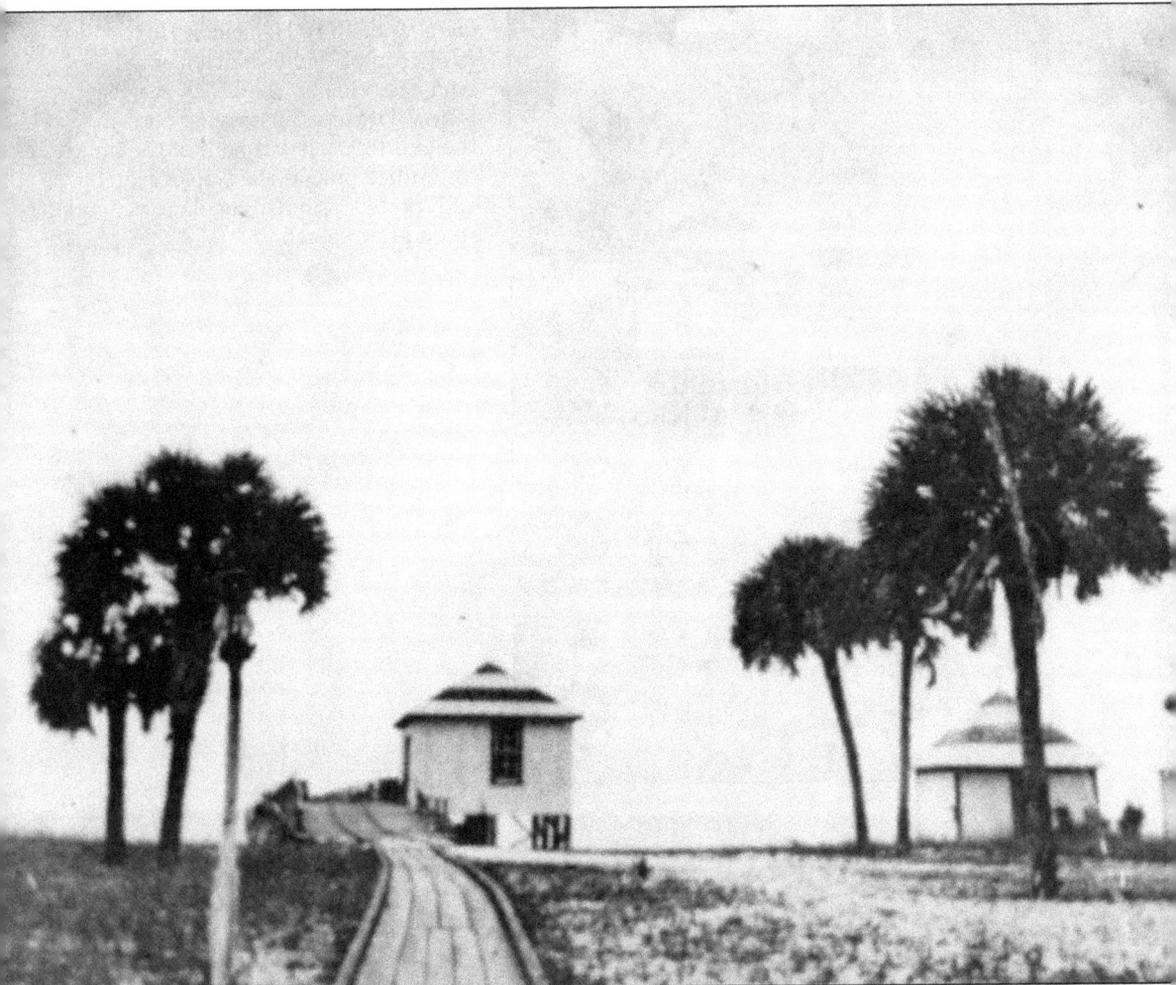

A bathhouse and changing rooms were built at the base of the pier for the convenience of hotel guests. An advertisement in the March 4, 1909 edition of the *Fort Myers Press* stated, "The pier, which extends 900 feet out into the Gulf of Mexico, affords immeasurable pleasure and delightful sport to those desiring still fishing and lovers of sunshine and moonlight." Naples was hailed as "The most delightful and picturesque winter resort on the west coast of balmy Florida." The advertisement continued, "Those looking for comfort and health, together with the best fishing and hunting procurable, should certainly visit Naples. The resort is reached by the Atlantic Coast Line Railroad to Fort Myers, and thence by boat 35 miles down the Caloosahatchee River and the Gulf of Mexico. The Season for 1909 opened on January 15th and closes the last of April." Note the painted roofs, used as "addresses" in early Naples.

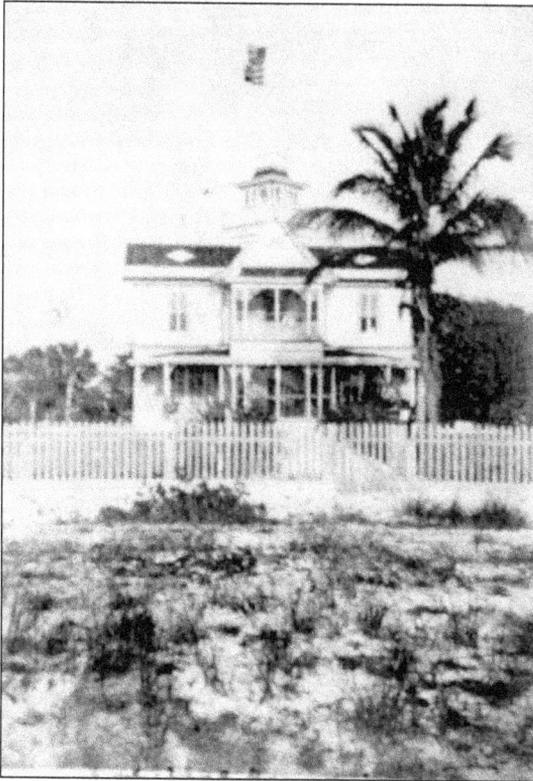

Gen. William B. Haldeman (1848–1924), son of Walter N. Haldeman, built Sea Villa on the beach at what is now Thirteenth Avenue South in the late 1800s. It was built of the same rosin-filled pine as the Naples Hotel and sported a similar cupola tower and second-floor porch.

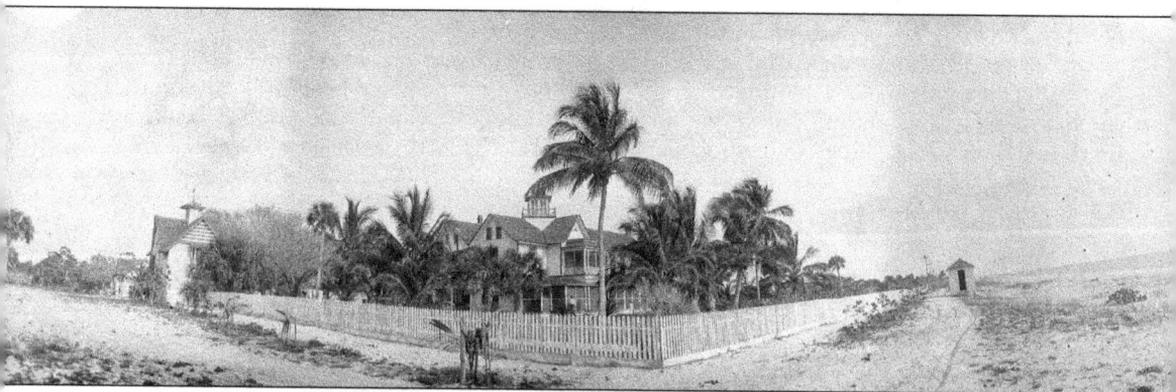

Over time, new rooms and porches were added to Sea Villa and eventually a carriage house with a matching cupola tower was built on the property (left). Note the small bathhouse on the beach in front of the house and the lush yard of coconut palms.

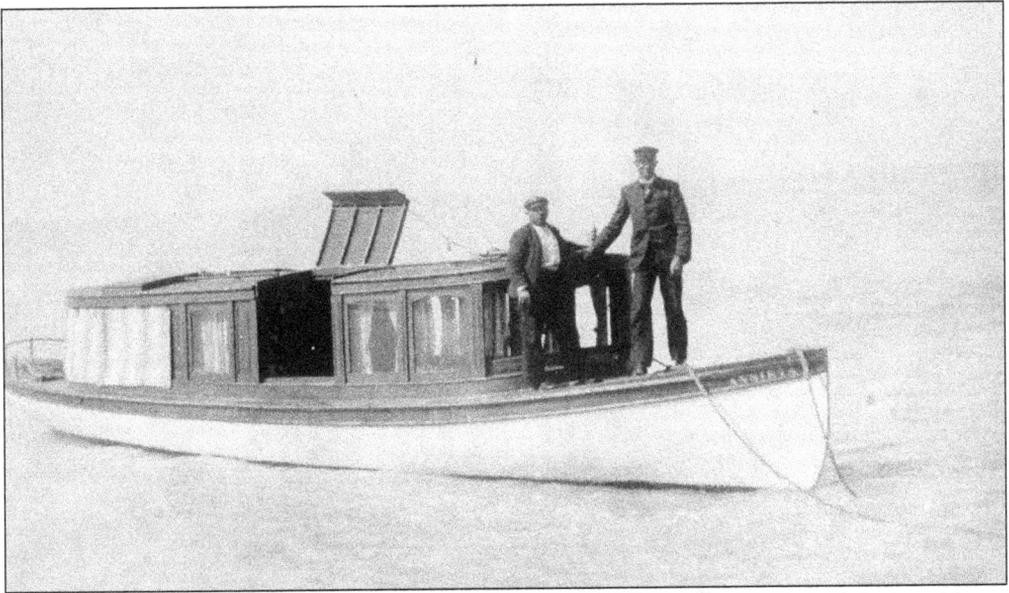

Capt. Charles W. Stewart moved to Naples in 1900 and became the captain of the hotel boat, working first on *Bessie*, then *Annieta* (pictured above), and finally the *Bon Temps*. His son, Arthur, remembered that *Annieta* had a "good-sized cabin." As long as the weather was good, Stewart could make the run to Fort Myers daily, returning the boat to its shed on the Back Bay (Naples Bay) each day.

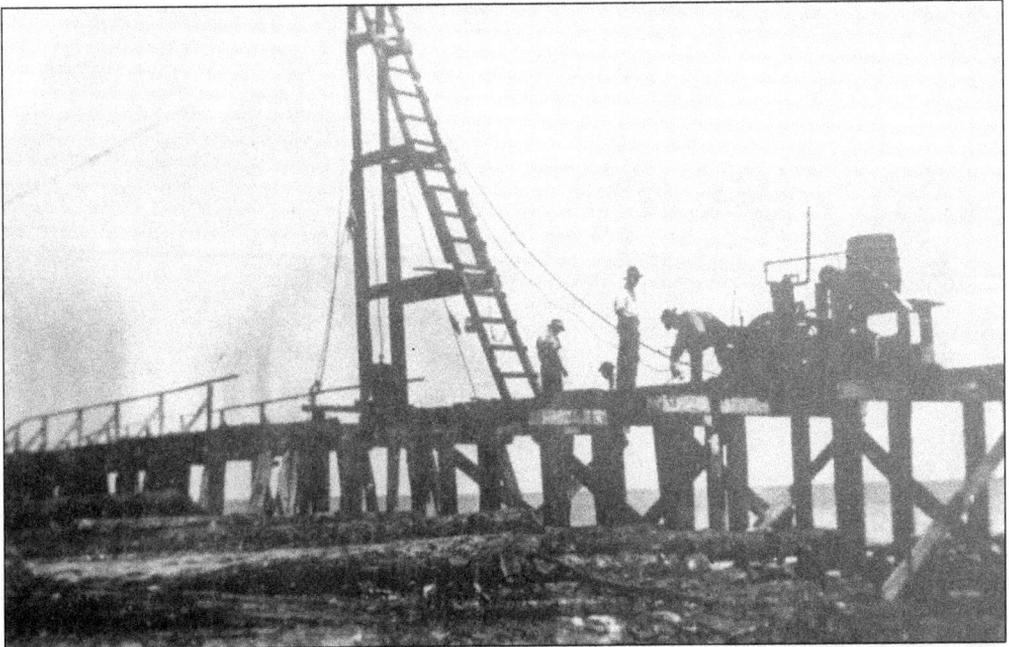

The hurricane of 1910 almost destroyed the pier and the Naples Hotel was forced to remain closed during the entire 1911 season while the vital dock was rebuilt. Les Bronson assisted with the rebuilding and reminisced, "Andrew and Billie Weeks cut the pilings from pine trees that grew out at Rock Creek. They floated and rafted them down the creek, out to Gordon's Pass and brought them to the pier. We drove everyone down with a 1,000-pound drop hammer."

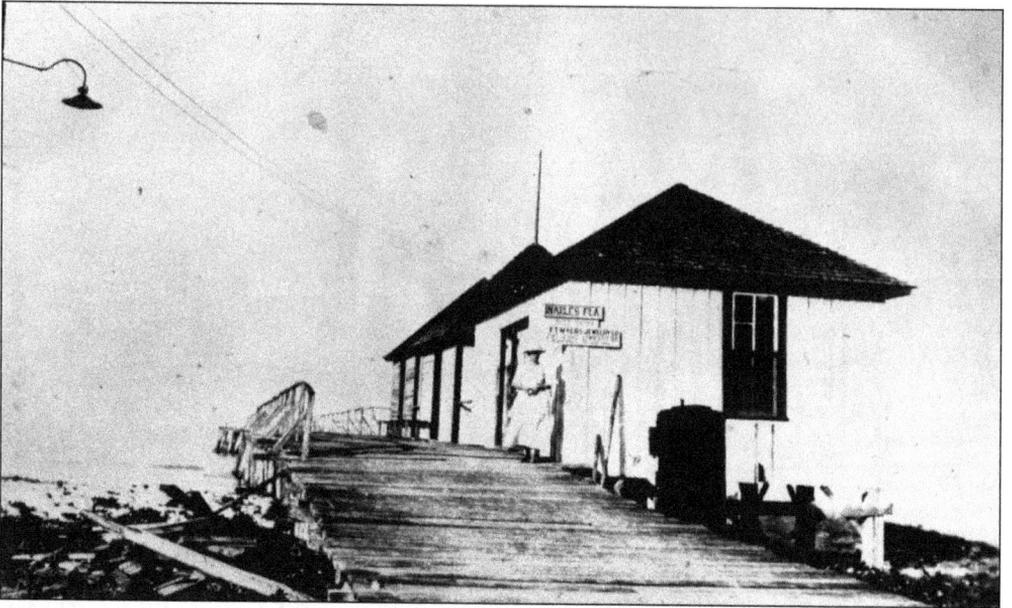

The post office was eventually moved onto the pier, where it remained until 1922, when an accidental cigarette fire destroyed the building and almost 20 feet of the pier. It was later moved to a small room next to the commissary building (later called the Seminole Market) on Third Street South, behind the hotel.

This photograph, c. 1912, is perhaps the earliest image of the road connecting the Naples Hotel to Back Bay (now Twelfth Avenue South). The hotel and its distinctive cupola are visible in the background. A 1909 advertisement for the Naples Hotel raved about the fishing opportunities, "in beautiful Naples Bay, which is only a ten minute walk from the back of the hotel."

24

The first Naples Company brochure confidently stated, "The fishing is probably unexcelled in southern waters, and the exciting part of it to the angler is, that when he casts his line, he does not know whether it will be taken by a minnow, a whale, or something intermediate." In this photograph, an angler proudly stands by a large sawfish hanging from one of the pier's freight platforms.

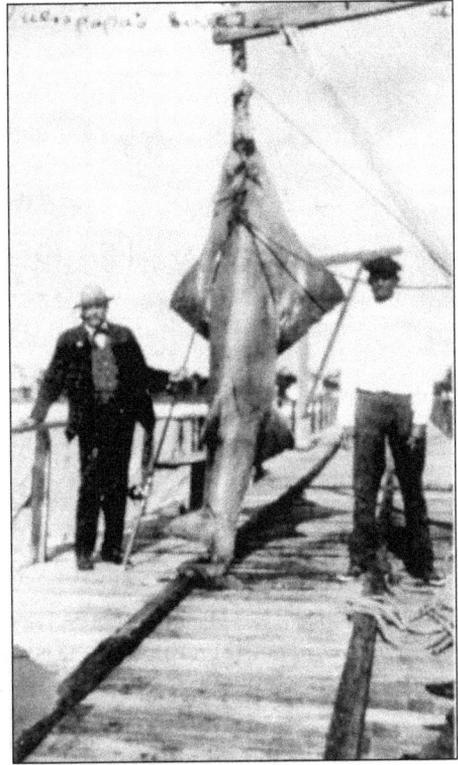

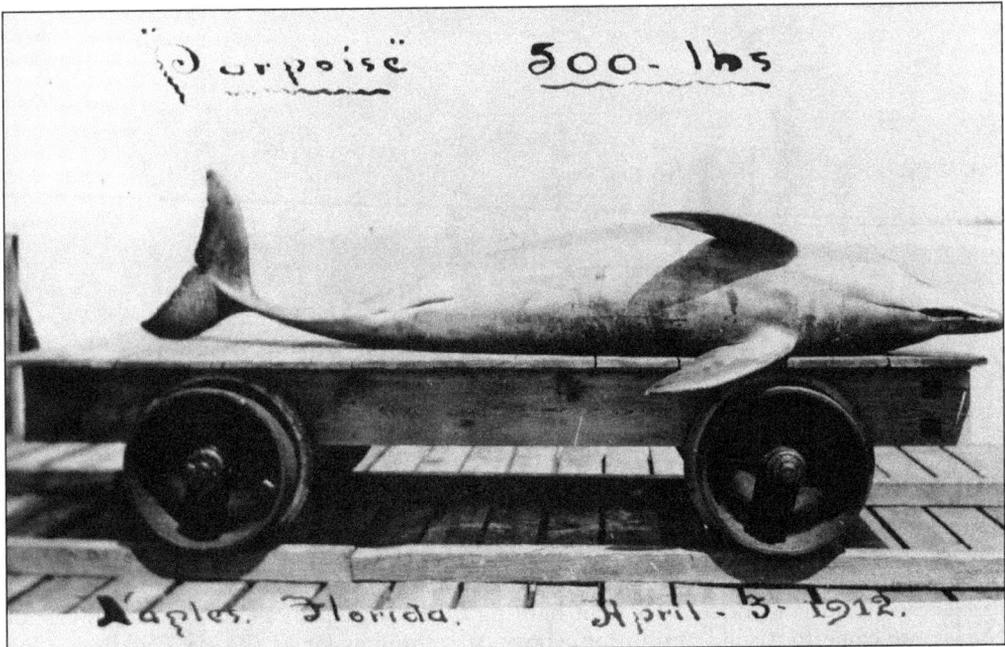

"Porpoise" 500-lbs

Naples, Florida. April 3 1912.

A "500-pound porpoise," photographed on April 3, 1912, rests on the pier's freight cart. The cart, mounted onto rails, was used to haul freight and luggage to the Naples Hotel. The rails extended down Pier Street, directly to the hotel.

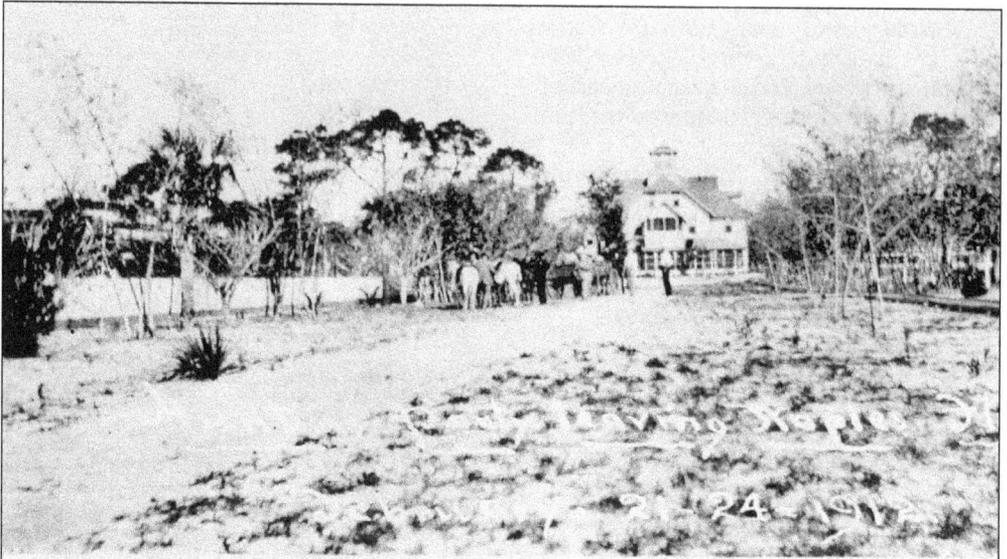

Hunting Party Leaving Naples, Fla, Feb. 21-24-1912

In 1912, John "Hack" Hachmeister and five other friends, including George M. Hendrie, Walter O. Palmer, William J. Pulling, C.B. Alexander, and T.J. Kenna, came to Naples for a hunting and fishing expedition. On February 21, the hunting party departed from their rental cottage on Pier Street (Watterson's Cottage, later called Palm Cottage) for a three-day expedition into the Big Cypress Swamp. The Naples Hotel is in the background.

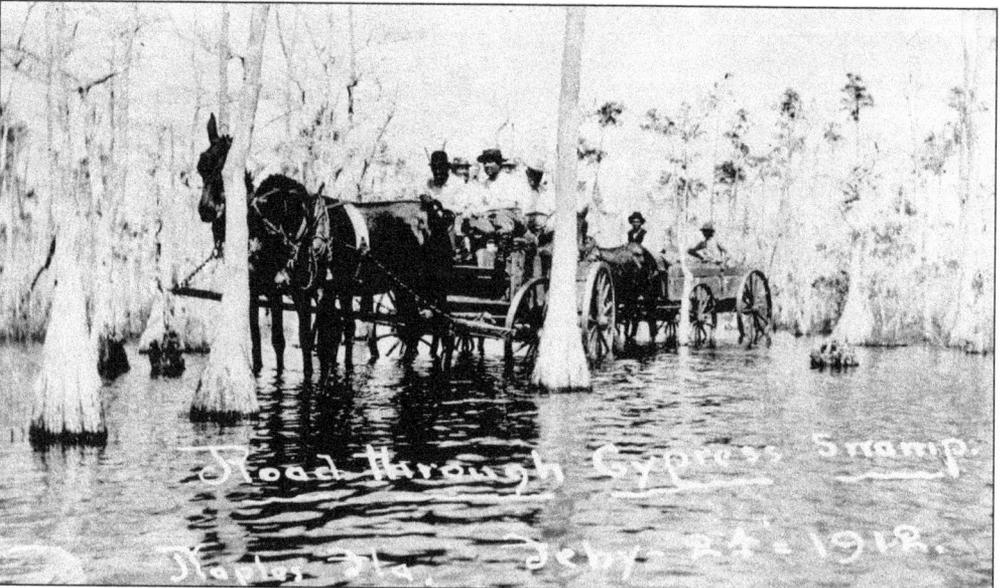

Road through Cypress Swamp.
Naples, Fla, Feby. 24th 1912.

The hunting party most likely entered the swamp through the "Hole-in-the-Wall." According to Florence Haldeman Price, who went hunting in the swamp in 1908, "Two miles east of Naples, we came to a solid curtain of cypress, stretching as far as the eye could see. One place had been cut through the barrier, only broad enough for our wagon. With frontier humor, it was called the Hole-in-the-wall. There was no other way anyone from Naples could go directly east."

The group hired local guides, including Andrew "Andy" Weeks, who eventually worked as George Hendrie's hunting and fishing guide for the next 30 years. As a young boy, Weeks learned all the skills needed to survive in the rough wilderness of southwest Florida. By age 12, he was earning 25¢ a day skinning birds for a New York taxidermist.

With these four photographs, John Hachmeister began enthusiastically documenting his life in Naples, and today his photograph collection provides some of the earliest views of the remote resort. During this visit, Hachmeister and his friends stayed in Naples from February 1 through March 24, 1912, splitting a grand total of $3,192.70 for the rental cottage, food, equipment, and guides.

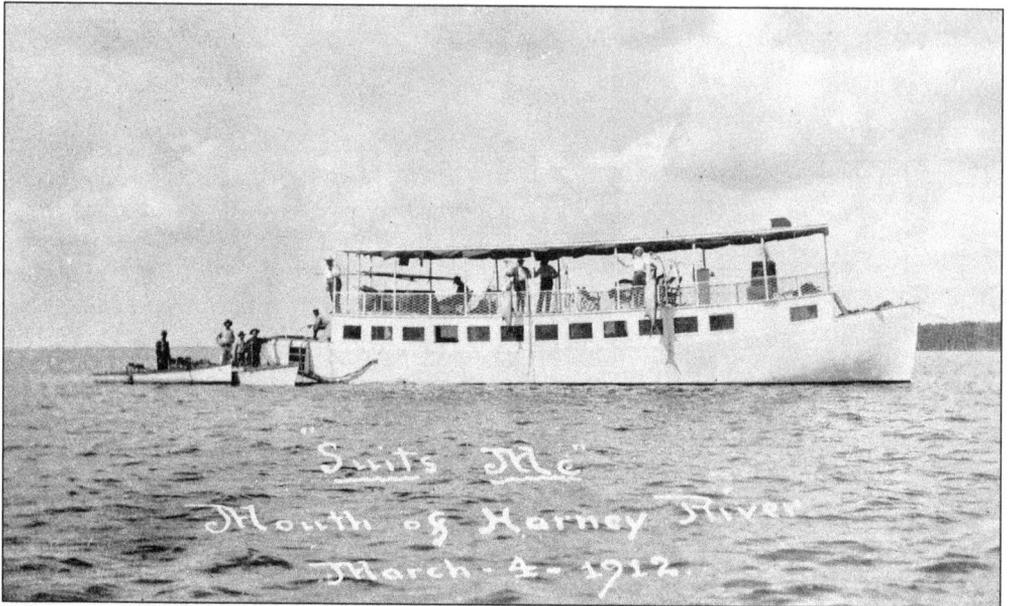

"Suits Me"
Mouth of Harney River
March-4-1912

The Ten Thousand Islands, just south of Naples, proved to be a successful fishing ground for John Hachmeister and his group of friends during their 1912 visit. Promotional brochures of the era assured sportsmen seeking tarpon, "In Naples, tarpon, the king of all fishes, is here in great abundance."

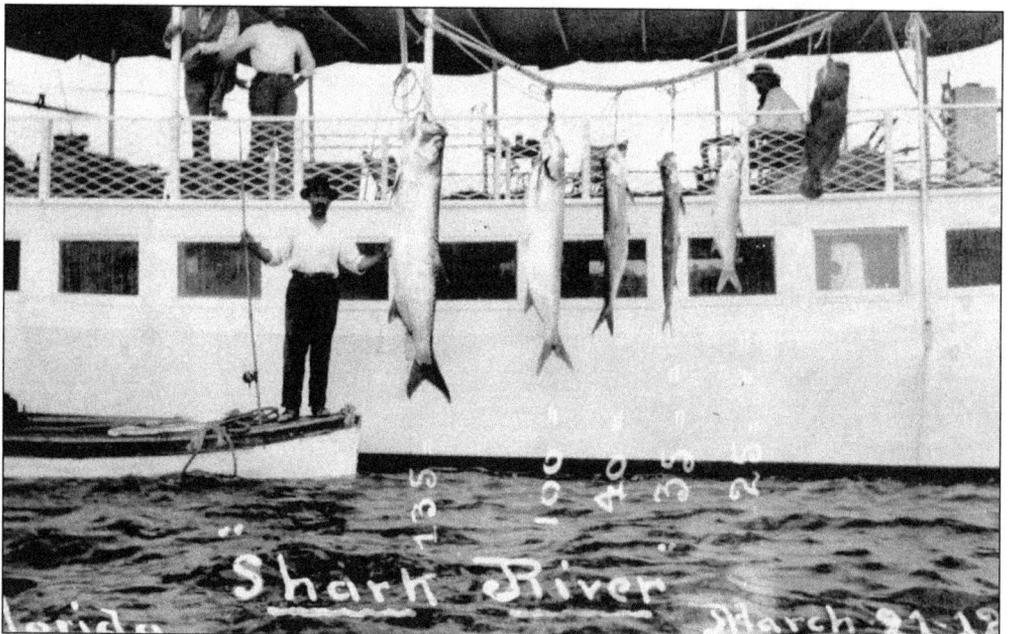

Shark River
Florida March 21-12

Andrew Weeks, standing on the small launch, also served as a fishing guide to John Hachmeister's group. The day's catch was displayed and arranged by size, with a large 135-pound tarpon on the left and a small 25-pound tarpon on the right.

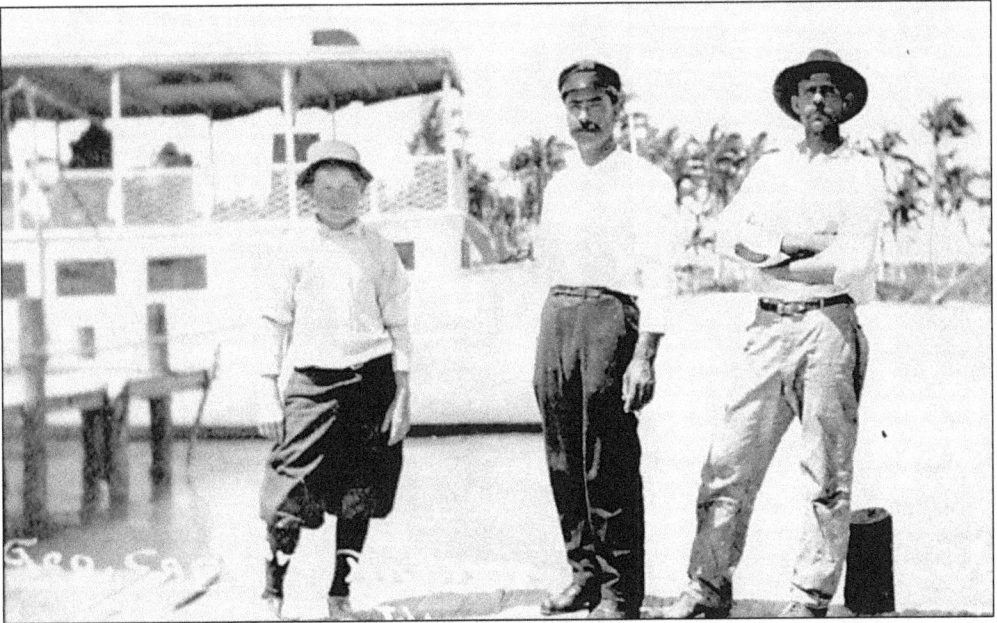

Pictured from left to right on the dock are George ?, Captain ?, and Andrew Weeks. Weeks usually received $2 a day as a fishing guide, rowing his boat all day for his clients. He later became the first guide to offer a boat with a gas engine, but he had to guarantee a larger catch of fish for his $4 daily fee.

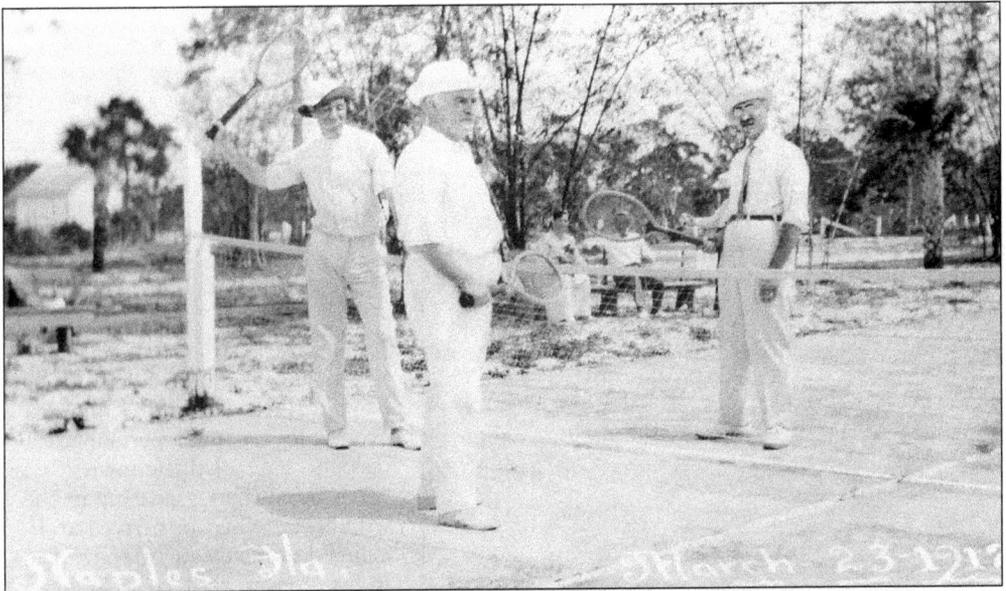

On March 23, 1912, the day before John Hachmeister's group left Naples, some of the friends enjoyed a game of tennis, probably on the Naples Hotel court. After this visit, Hachmeister and most of his friends returned each year, eventually becoming permanent winter residents and central figures in the small winter community of Naples.

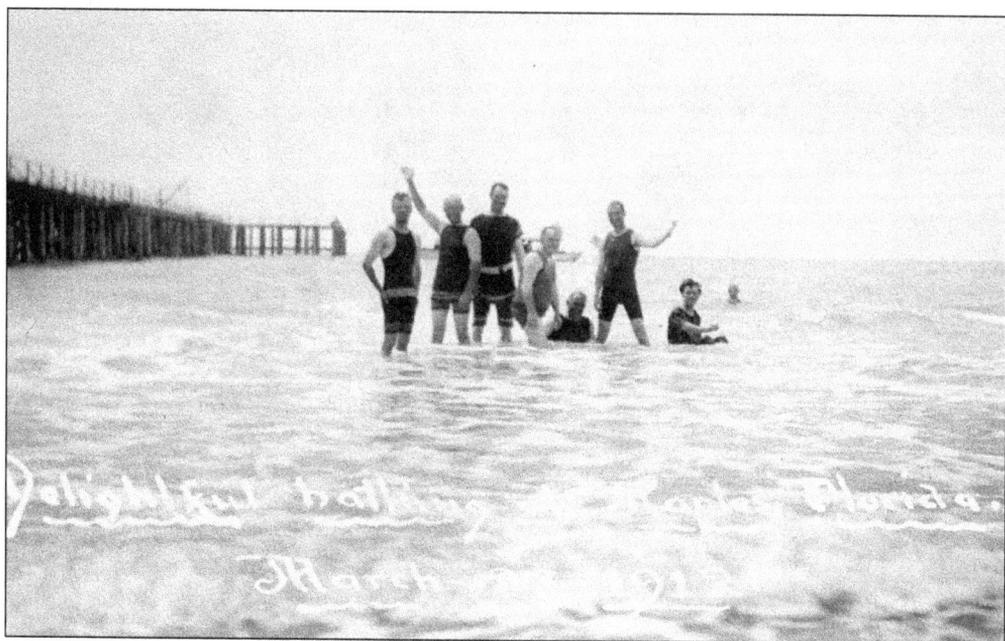

During their 1912 visit to Naples, John Hachmeister's group enjoyed all the amenities of the resort town, and Hachmeister enthusiastically wrote on this photograph, "Delightful Bathing in Naples, Fla." The pier and its freight lift, often used for hoisting large fish, are visible in the background, and a small steamer has just left the dock.

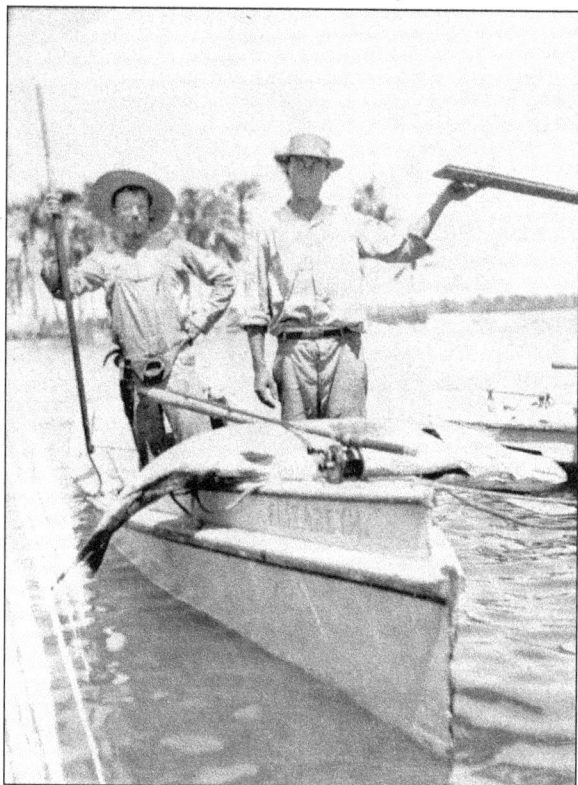

Speed Menefee, on the left, visited Naples in the early 1900s and eventually became a permanent resident. He called the town "little more than a clearing in the wilderness" when he arrived and claimed to have caught 36 wildcats in his chicken yard. In 1925, he became the first mayor of Naples, a position he held until the end of the first town council meeting, when he resigned.

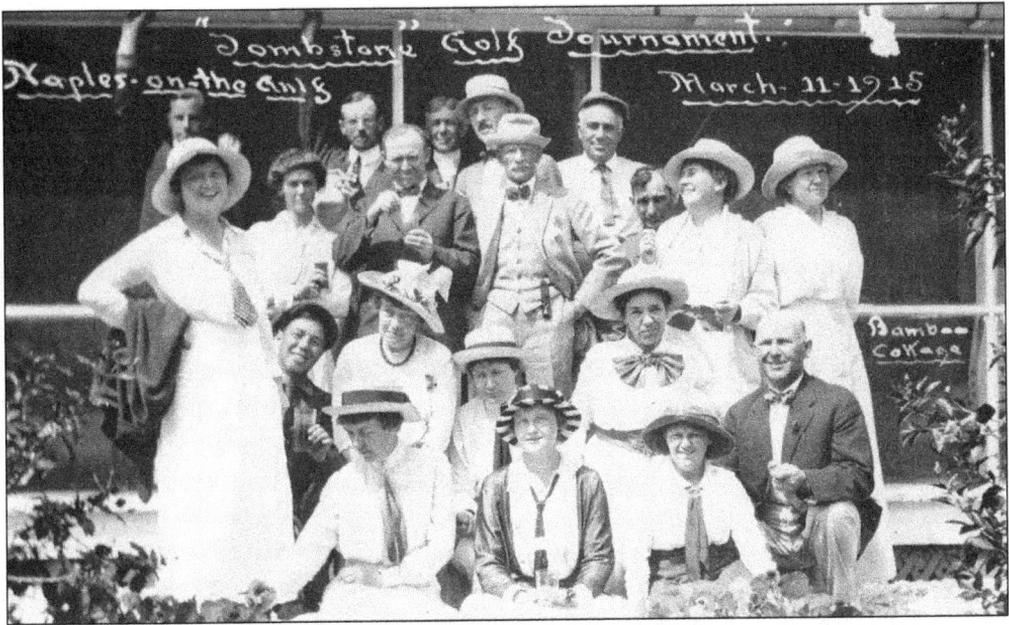

Each winter, John Hachmeister, the wealthy manager of nine racing associations, and his group of friends returned to Naples, with many group events held at "Bamboo Cottage," on Pier Street (Twelth Avenue South). By 1915, the Naples Hotel, still the social center of the small resort town, had added a rough nine-hole golf course, located to the north of the hotel, between what are now Third Street South, Fifth Avenue South, and Eighth Street South.

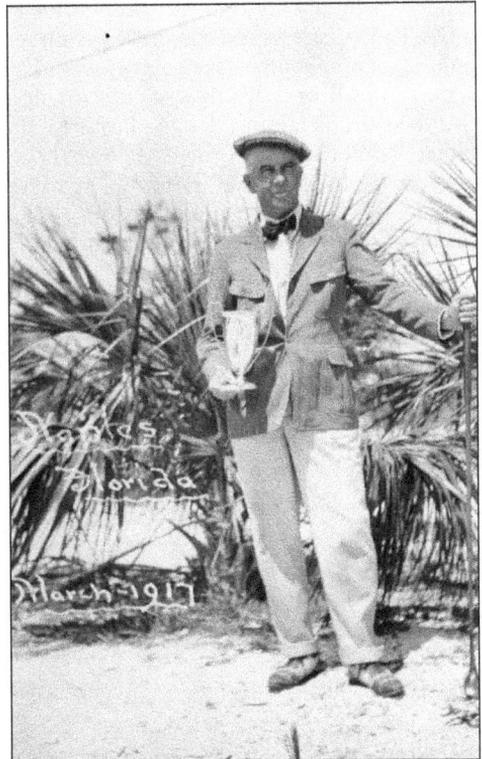

John Hachmeister's collection included a photograph of this unidentified winner of a 1917 tournament. In 1928, Hachmeister's friend, Walter O. Parmer, won a similar cup called the "Cottager's Handicap Cup" and was presented with the prize silver trophy by another friend, William J. Pulling. (The trophy is now on display in Parmer's former home, Palm Cottage.)

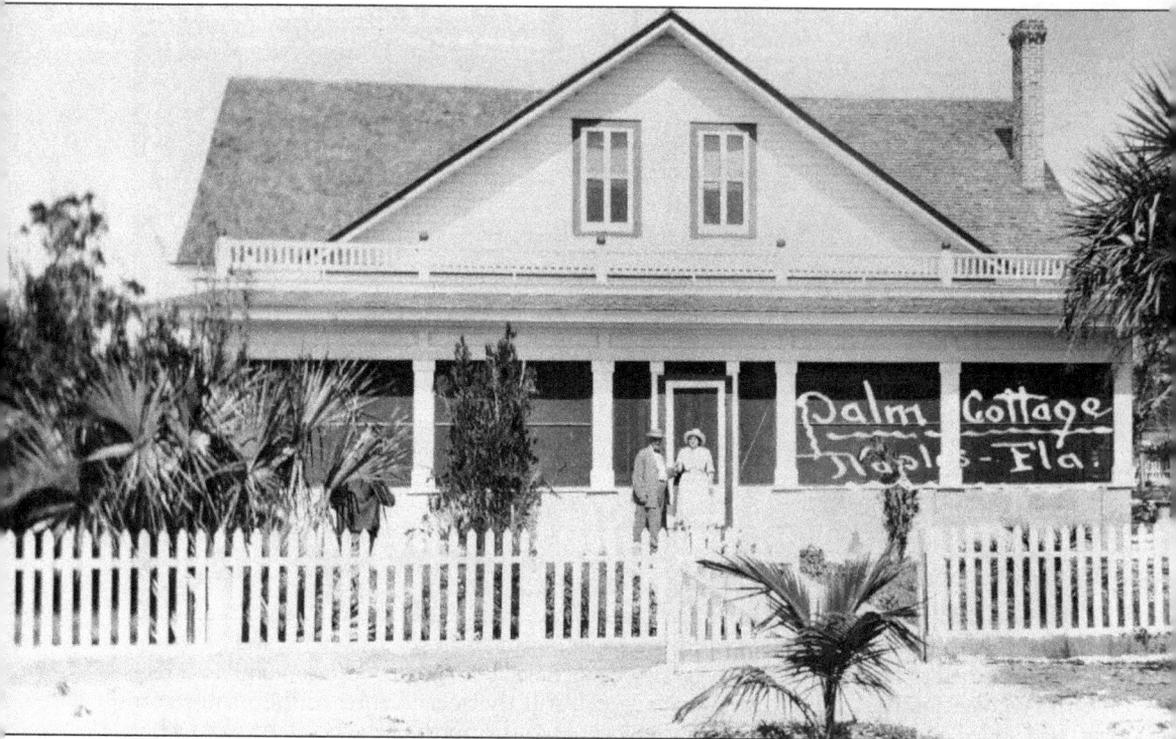

In 1916, Walter O. Parmer bought the former Watterson Cottage, where Henry Watterson had stayed during his working vacations as a guest of Walter Haldeman. The Parmers renamed the house Palm Cottage and spent every winter there until Walter's death in 1938. The cottage was built of tabby, a type of homemade cement crafted from crushed, burned shells mixed with sand, water, and whole shells. It was built on a grand scale, with 12-foot ceilings and approximately five to seven bedrooms, designed to serve as a rental cottage and guest overflow for the Naples Hotel. Parmer stayed in the cottage in 1912 as part of John Hachmeister's hunting and fishing expedition. In 1938, his friend George Hendrie, who also owned an estate across the street called The Pines, purchased the cottage. It is now the second-oldest house in Naples and is a historic house museum and headquarters of the Naples Historical Society.

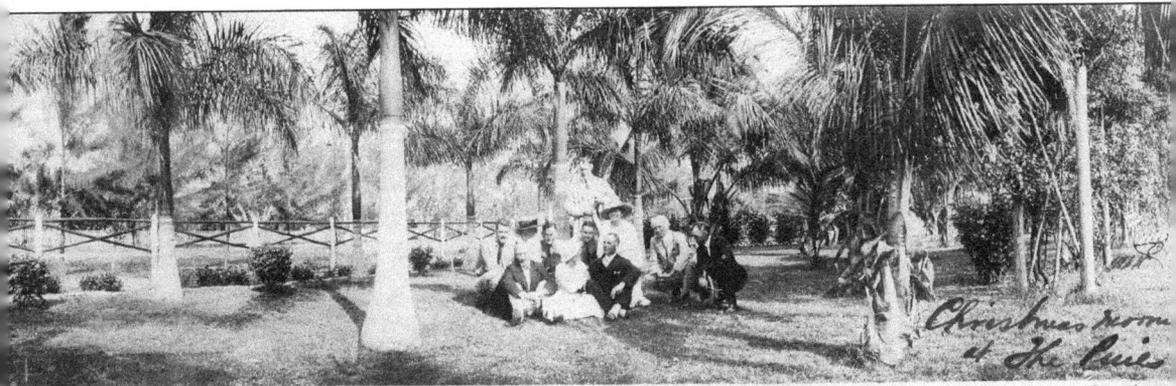

Christmas from The Pines — 1918

Across the street from Palm Cottage, in a prime location between the pier and the Naples Hotel, was The Pines, George M. Hendrie's estate. John Hachmeister's friends posed for this group photo taken on Christmas Day 1918. Andrew Weeks, who worked for Hendrie for 31 years, described Hendrie's house as "big and beautiful, with a very large fireplace. The grounds covered a city block. At one time, it was the showplace of Naples." Hendrie is standing at the back of the group.

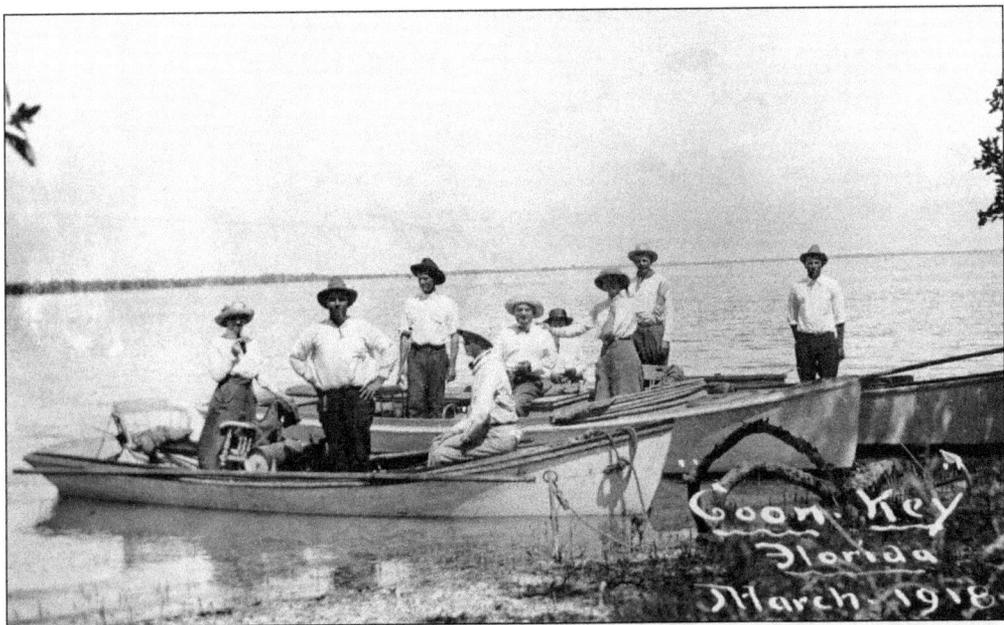

Coon Key Florida March 1918

John Hachmeister was an avid photographer and continued to document his winter visits to Naples. In March 1918, the group of friends again visited the Ten Thousand Islands, this time on small boats. A Naples Hotel brochure boasted, "For those who enjoy inside fishing on quiet water with light tackle, the bays and passes abound in redfish, snook and other varieties of Florida fish. Guides and boats for fishing are always to be had at moderate prices."

33

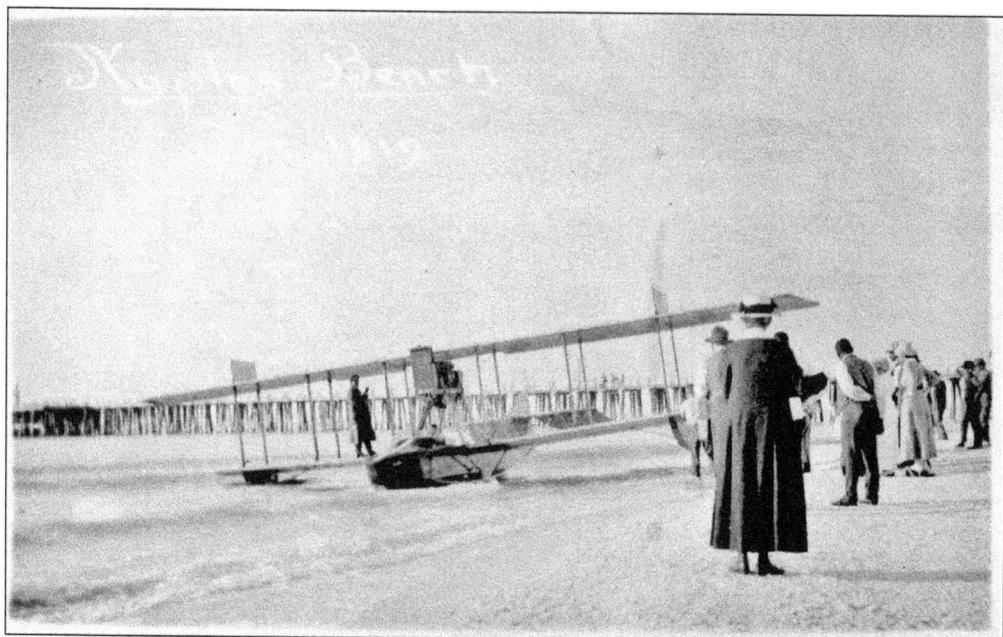

By 1915, Naples remained accessible primarily by boat—or airplane. The broad, flat beach and the rough Naples Hotel golf course often doubled as landing fields. The Naples pier is in the background.

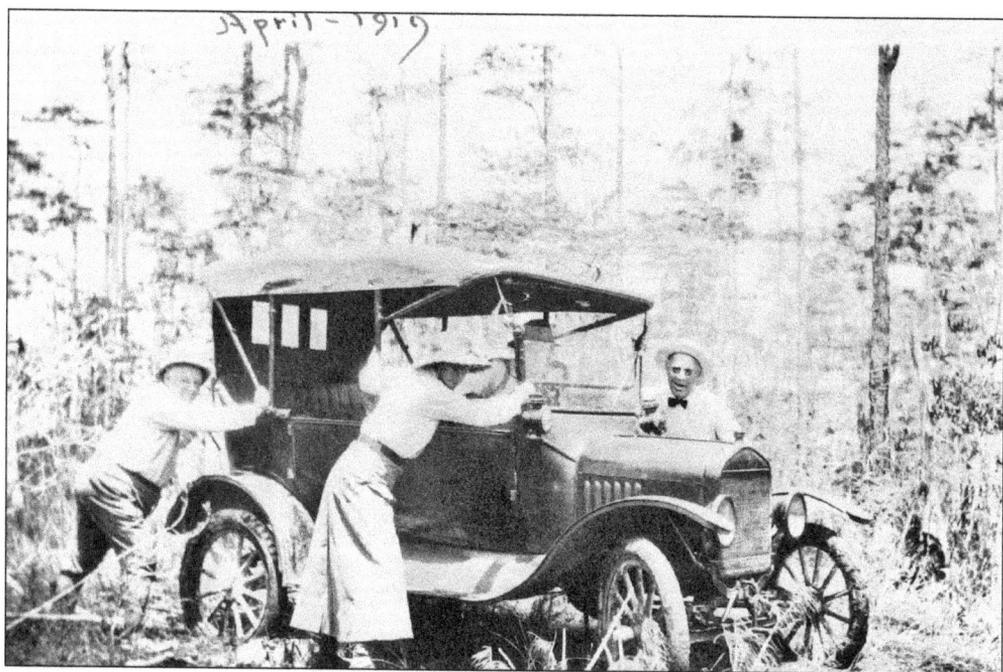

John Hachmeister captioned this April 1919 photograph, "He Ho to Panther Camp." The Weeks brothers dubbed the hunting camp deep in the Big Cypress Swamp "Panther Camp" after a close encounter with three Florida panthers during an alligator hunt. Pictured from left to right are Bob West, Mrs. Jim Hamill, Jim Hamill, and John Hachmeister.

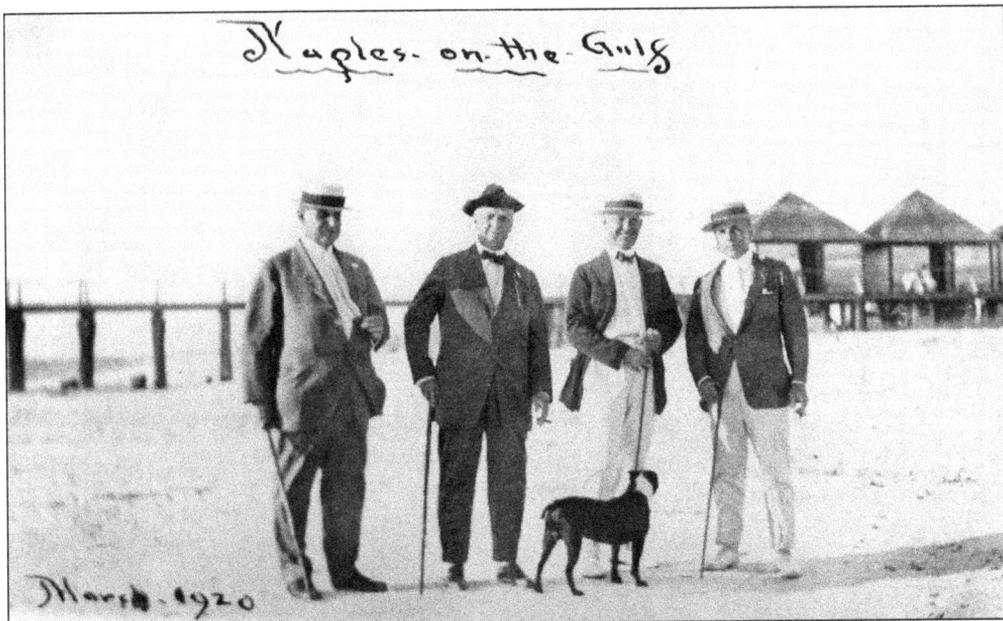

Naples-on-the-Gulf

March 1920

In 1919, John Hachmeister retired from the racing business and moved to Naples, buying a house on Broad Avenue South he dubbed "Hack's Shack." He continued his photography hobby, but rarely recorded the names of people in his photographs, leaving the four dapper men in this March 1920 photograph unidentified. Note the pier in the background, with the post office, bathhouse, and storage sheds on the right.

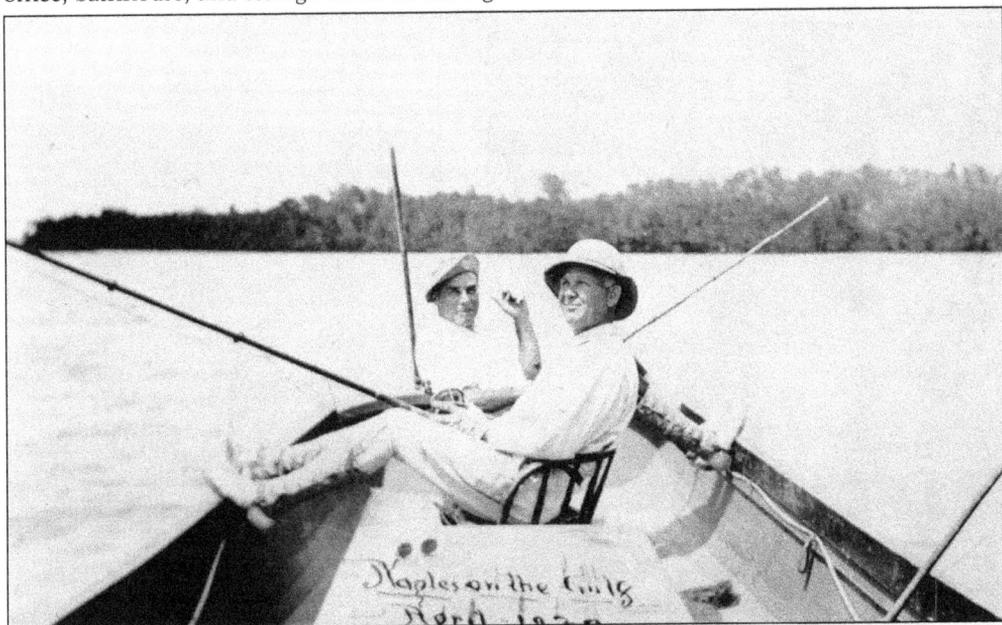

Naples on the Gulf
North Isle

Two men enjoy a day of fishing in this April 1920 John Hachmeister photograph. According to a Naples Hotel brochure of the era, "For yachts, houseboats, and launches, there is probably no other place in Florida whose waters offer more delightful opportunities. The tropical bays and rivers, their scenic beauty, their romances, the wild birds, surf bathing and fishing, all make an impression that lingers."

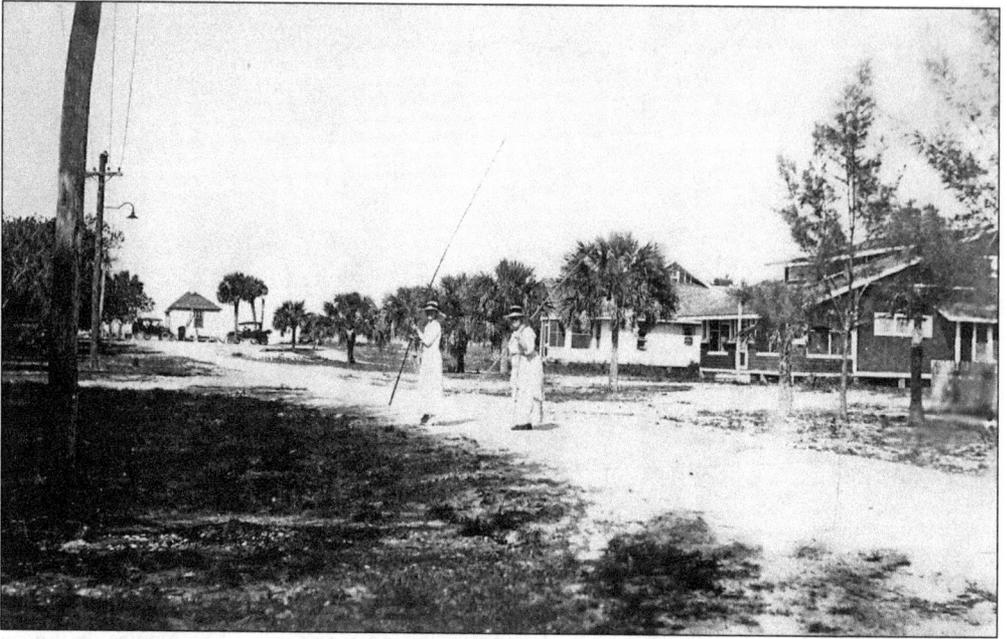

In this c. 1920 photograph, two women dressed in their high heels walk towards the pier with fishing poles in hand. By 1920, the pier extended 1,000 feet into the Gulf of Mexico, and a Naples Hotel brochure assured guests, "From the hotel pier, those who do not care to go out in boats can catch Spanish mackerel, sea trout, redfish, snook, sheepshead, mangrove snapper and many other varieties."

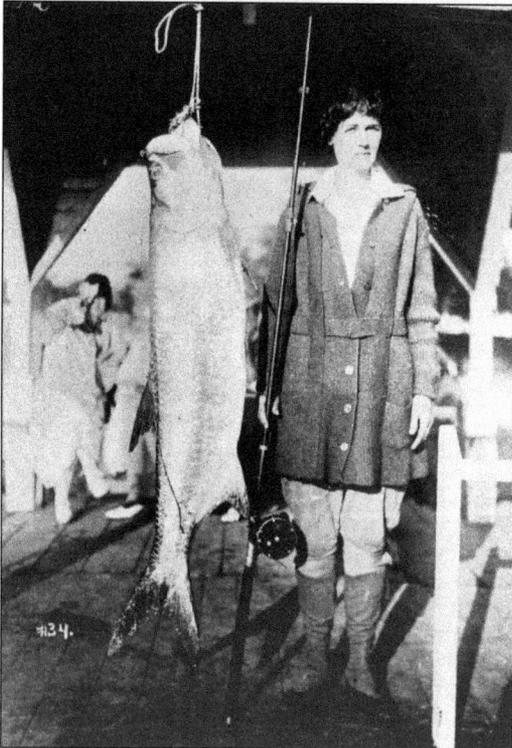

The chance to catch a tarpon, the "Silver King," attracted a growing number of anglers to Naples for the "royal sport." The c. 1923 Naples Hotel brochure claimed, "Tarpon are taken earlier from Naples than any other of the Florida resorts. This king of all game fish is found in great numbers nearby; and many fishermen come to Naples especially for the tarpon fishing." In 1924, the Naples Hotel logo and letterhead featured an embossed silver tarpon.

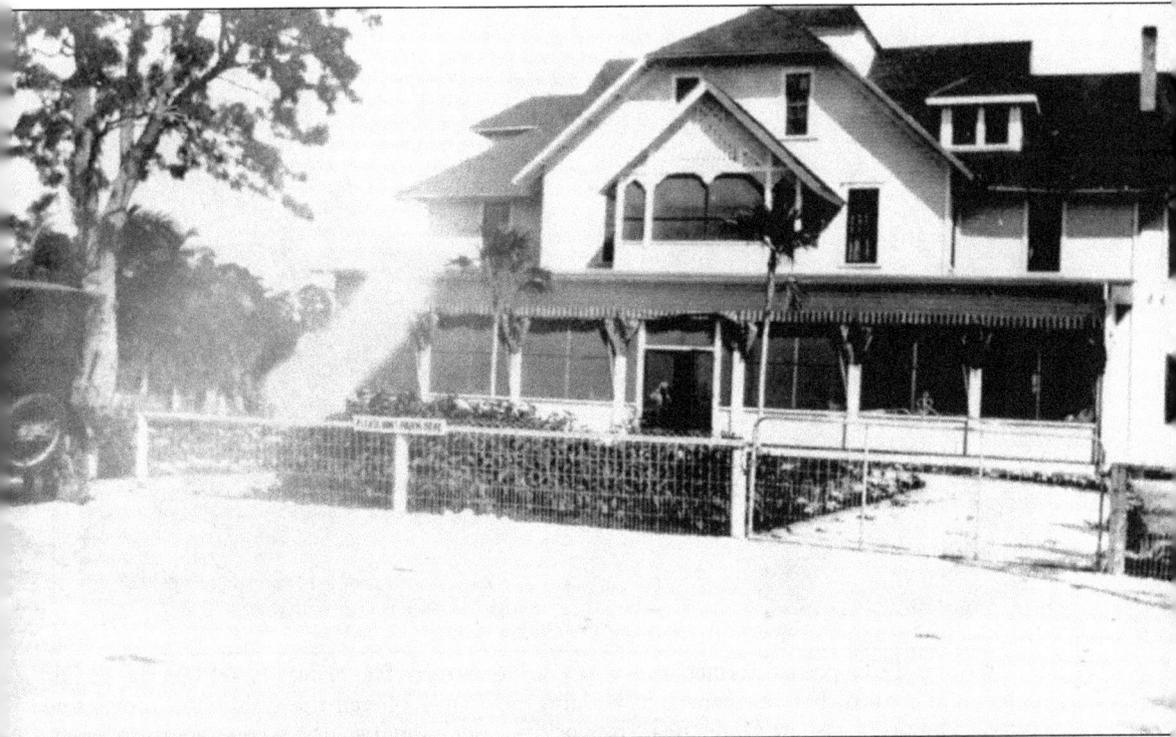

By 1916, a 40-room addition to the Naples Hotel was added to the south side of the original building (visible on the right side of this photograph). As the social center of the town, the hotel offered "Cottagers Evening" every Thursday, and winter residents gathered weekly for dinner and an evening of games. During his 1922 visit, Dr. Earl Baum recalled, "After dinner, we would play bingo, or a horse race game a lady would run for us. There were six horses painted different colors and a big chart was laid on the floor. We rolled the dice and the horses would be moved. Everyone made a bet and the money went to the Woman's Club to help in the promotion of Boy and Girl Scout activities." The hotel also offered its guests other amusements and noted in its 1923 brochure, "The spacious porches, solarium and lobby of the hotel are rendezvous for both young and old, where bridge, whist, Mah Jong and other social gatherings are enjoyed."

LOOKING TOWARD THE PIER AND GULF FROM NAPLES HOTEL, NAPLES, FLORIDA. 103215

This set of c. 1920s postcards offers two views of Pier Street. The Naples Hotel was the social center of the town, but the venerable building no longer offered the only hotel rooms for visitors. The new Bayshore Hotel, near the Back Bay dock (on Twelfth Avenue South) opened in 1921. Below, on the back of this undated and never-mailed postcard, a visitor wrote, "This is to show you we really stayed at Naples, though not at this place. The people appeared too sporty." (Courtesy of Nina H. Webber.)

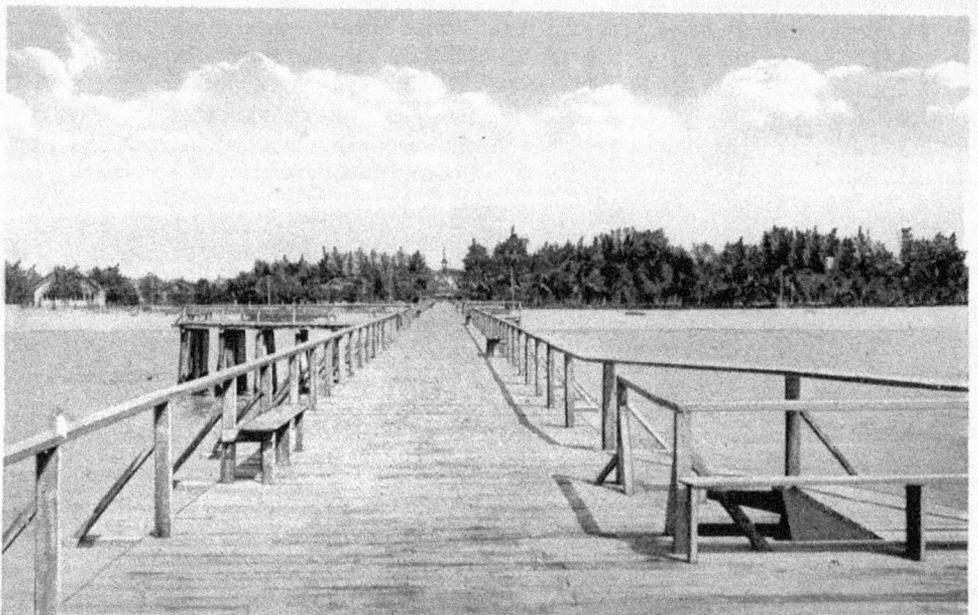

THE NAPLES HOTEL, LOOKING FROM THE PIER, NAPLES-ON-THE-GULF, FLORIDA. 104577

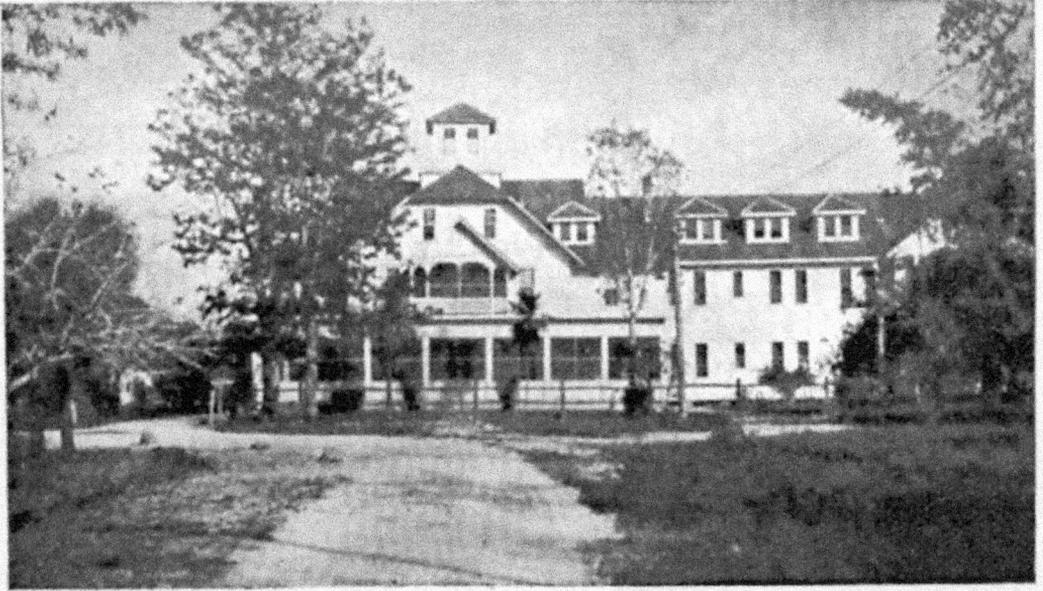

NAPLES HOTEL, NAPLES, FLORIDA

The original Naples Hotel building is clearly visible in the center of this early 1920s postcard. According to a 1923 hotel brochure, "The hotel is a three-story building with a new three-story annex, facing the Gulf. The sleeping rooms are all large, light and airy, having running hot and cold soft water and private baths throughout. A new power house with modern ice-making machinery, electric lighting plant and steam laundry have been added to the hotel, and no pains have been spared by the owners and management to modernize the culinary department. Only the best meats, our own fresh vegetables, fish just out of the water, and an abundance of fresh fruits are used. Cool nights invigorate, build up, restore health, and complete a perfect day. Truly this is a summerland in wintertime." (Courtesy of Nina H. Webber.)

In 1919, at the age of 66, Dr. Henry Nehrling moved to Naples to continue his work growing tropical and subtropical plants from around the world. He had already established a successful garden near Orlando, but after a severe freeze in 1917 killed most of his plants, he moved to Naples, selecting an unspoiled site of pinelands and cypress swamp in what is now Caribbean Gardens. Although he only lived in Naples part-time for 10 years, he was able to establish a wilderness garden filled with orchids, amaryllis, and caladiums, and, by 1929, his garden included more than 3,000 species of rare plants and trees. The renowned botanist wrote a weekly column for the *American Eagle* of Estero, which eventually formed the basis for two books, *The Plant World of Florida* and *My Garden in Florida*. He often gave tours and took Thomas and Mina Edison through the garden in 1927. Mr. Edison was especially interested in Nehrling's collection of more than 100 species of ficus; he was curious about the quality and quantity of rubber each might produce.

Two

SUMMERLAND IN WINTERTIME

In 1913, the heirs of Walter N. Haldeman sold most of their Naples Company property, including the Naples Hotel, to the Naples Development Company, headed by E.W. "Ed" Crayton and a group of Ohio business men who were determined to improve and expand the hotel and the fledgling town. For the next 25 years, Crayton carefully guided the growth and development of Naples.

Ed Crayton's house was on the north side of Pier Street, next to Palm Cottage and located between the pier and the Naples Hotel in the center of town. He was close to the other "cottagers" and the Naples Development Company offices, which moved to new offices behind the hotel on what is now Third Street South in 1921.

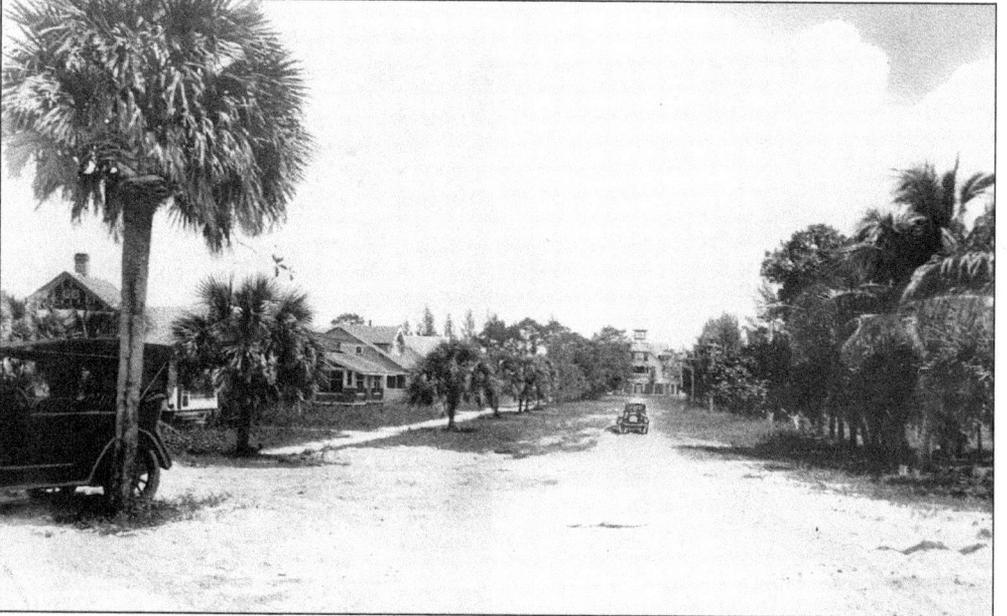

One of Crayton's first priorities was the expansion of the Naples Hotel, and he was determined to make it a financial success by attracting a much broader clientele. By 1916, a 40-room addition had been added to the south side of the original structure, and a rough nine-hole golf course added a new amenity for guests. Crayton launched an aggressive advertising campaign in Northern newspapers and magazines touting the wonders of the "Summerland in Wintertime." Note in this east view of the Naples Hotel, the combination boardwalk and tramway that once connected the pier to the hotel has been removed.

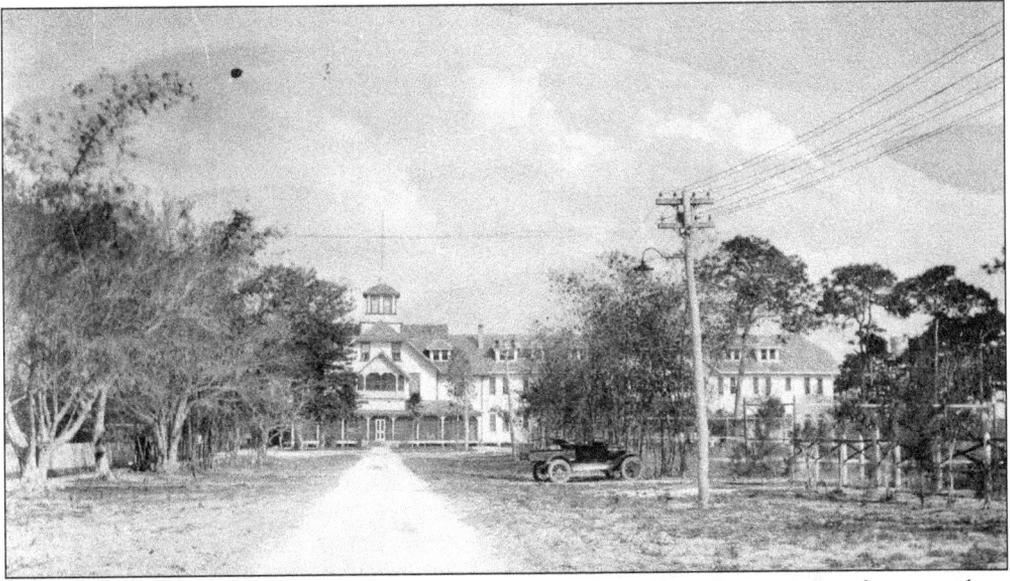

This photo shows pole-mounted electrical wires on Pier Street. A new ice and power plant opened in 1923, built primarily to serve the Naples Hotel, although houses within a mile could connect to the system. Local residents were advised, "Service will be limited, from 4 p.m. to 10 p.m." Eventually service was extended to midnight.

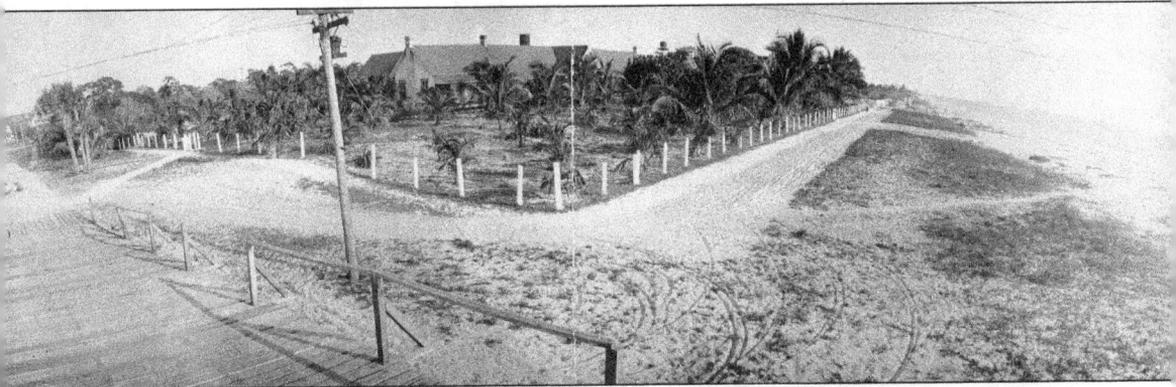

In 1887, Gen. John S. "Cerro Gordo" Williams, president of the original Naples Company, built a small house on the beach just south of the pier. Fellow Naples Company director Walter N. Haldeman bought the house from Williams and later used it primarily as a guesthouse. By the 1920s, when this photo was taken, the house was still owned by the Haldeman family. Note the broad, sandy "Gulf Street" to the right.

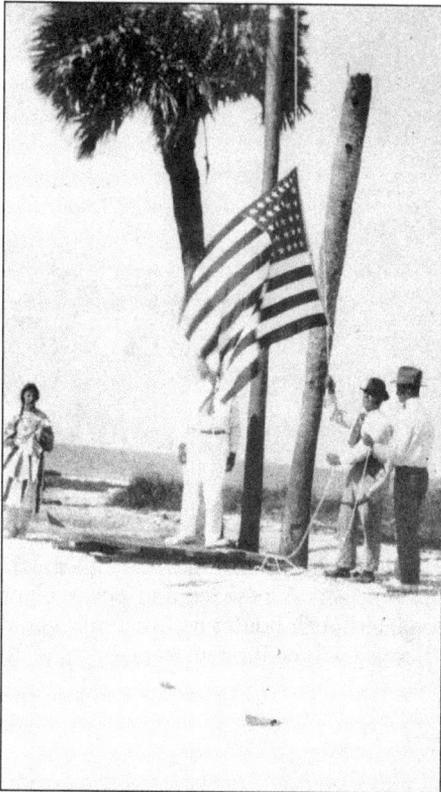

The first observance of Armistice Day was held at the foot of the pier. In 1919, President Woodrow Wilson proclaimed November 11 as Armistice Day to remind Americans of the tragedies of war and to commemorate the end of World War I, which ended in 1918 at the "eleventh hour of the eleventh day of the eleventh month." The photos show local school children participating in the program. By 1915, a one-room schoolhouse had been built by Capt. Charles Stewart and Andrew Weeks on Broad Avenue South, just one block from the pier. According to Weeks, "There were only seven permanent families living in Naples at that time."

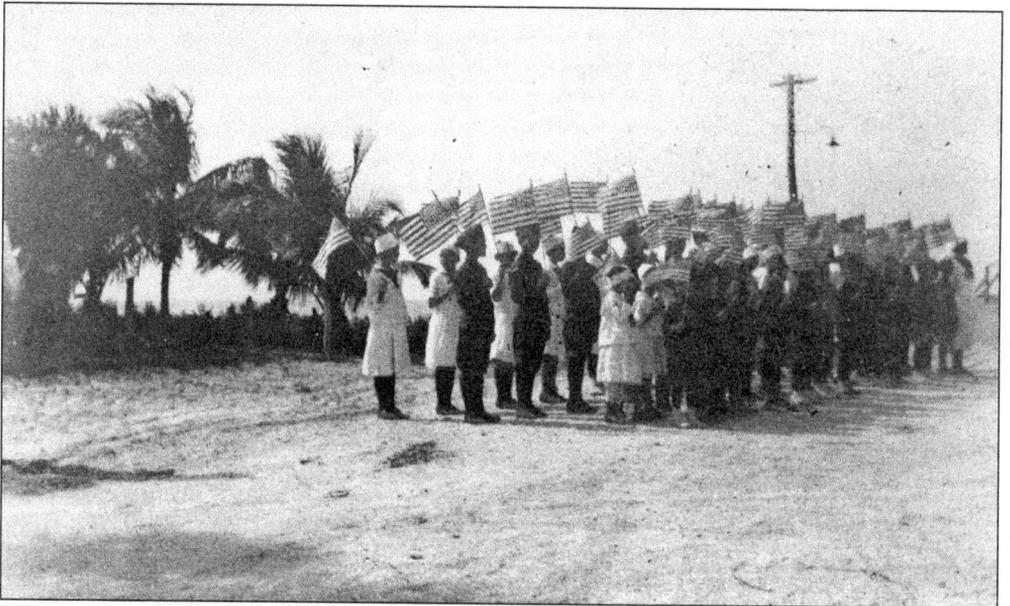

Dr. Earl Baum, an avid photographer, visited Naples in 1922 and took this shot of an artesian well behind the Naples Hotel, noting, "A good stream flowed from this well into an open ditch, which went into the Gordon River between what is now Twelfth and Thirteenth Avenue South. This was the servant's quarters and they all had their privies over this ditch. Some pollution."

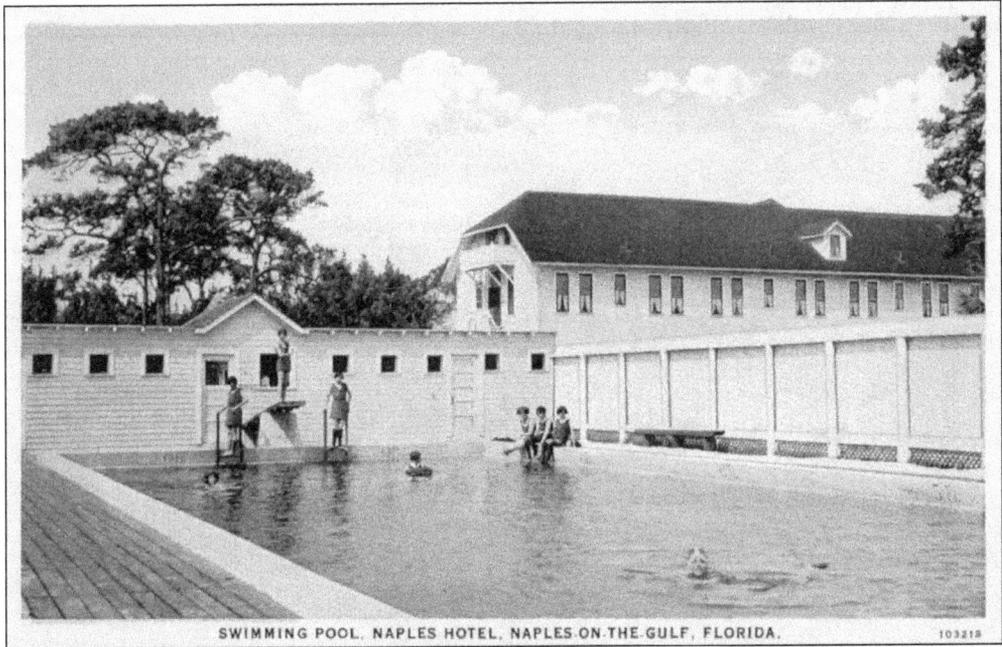

SWIMMING POOL, NAPLES HOTEL, NAPLES-ON-THE-GULF, FLORIDA.

Crayton continued to add improvements to the hotel and, by 1924, the onsite artesian well supplied a new concrete pool, 36 by 75 feet, with a continuous flow of water. A report for the Naples Improvement Company noted, "The water is quite hard, rather brackish, and in all probability, if taken internally would have a laxative effect. It is a perfectly good water for use in a swimming tank, in fact, a very desirable water." (Courtesy of Nina H. Webber.)

Naples Hotel
AT
NAPLES-ON-THE-GULF
FLORIDA

A SUMMERLAND IN WINTERTIME

This *c.* 1924 Naples Hotel brochure, a 16-page booklet that was part of Crayton's advertising campaign, highlights the resort's many new amenities: "The new Naples Hotel, which accommodates 250 guests, is one of the most attractive and delightful hotels in the south. Naples has really the finest bathing beach in Florida, absolutely free from under-tow and perfectly safe for children and bathers who are not strong swimmers. The temperature of the water is so warm that bathing may be enjoyed every day in the year." (Courtesy of Nina H. Webber.)

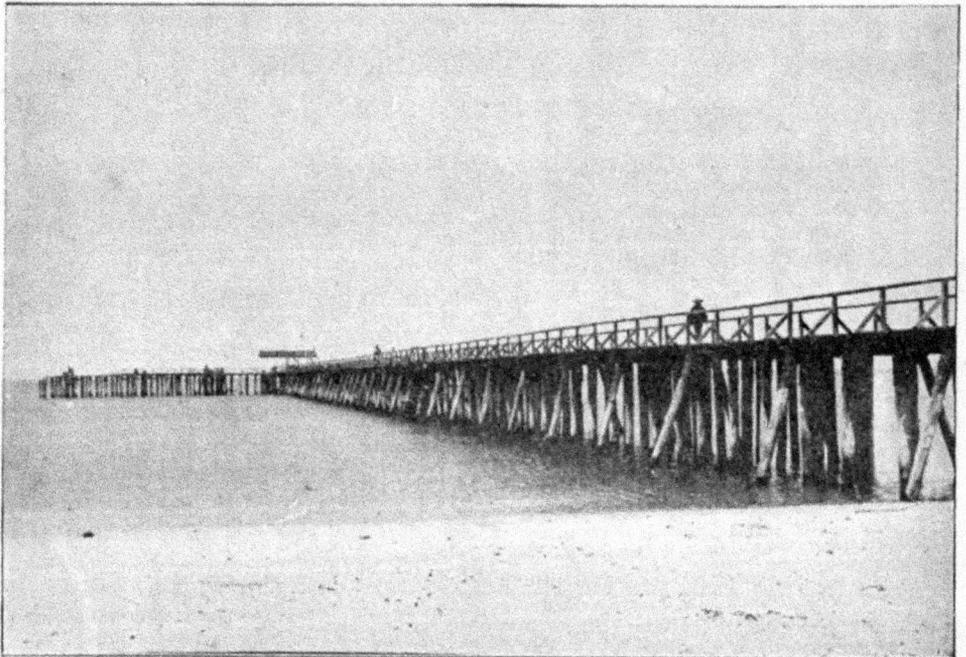

THE NAPLES PIER AND SECTION OF THE BATHING BEACH

AN ABUNDANCE OF QUAIL ARE FOUND IN THE OPEN

The new brochure described the resort's amenities in detail and featured two photographs of hunting scenes, noting, "Probably the best quail shooting in the country and surely the best deer and turkey shooting in Florida are to be enjoyed at Naples. Hunting guides are furnished at reasonable rates. Excellent care is taken of sportsmen's dogs." For those interested in trapshooting, "The trapshooting club is open daily and ladies especially enjoy shooting over the Naples traps. The management of the hotel gladly furnishes trap guns to those who wish to shoot and have not brought their guns with them." (Courtesy of Nina H. Webber.)

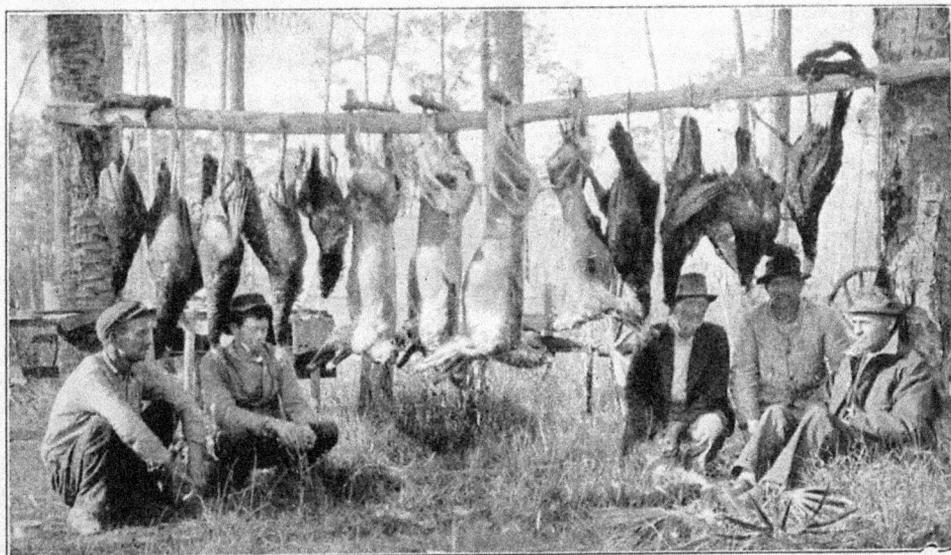

TROPHIES OF A TWO DAYS' HUNT NEAR NAPLES

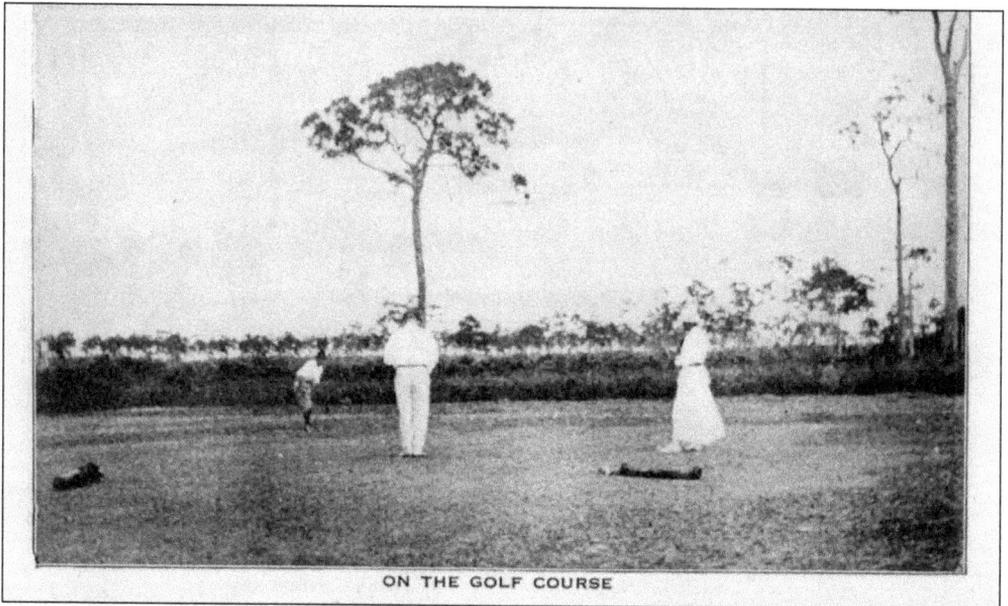

ON THE GOLF COURSE

Dr. Earl Baum described the new Naples Hotel golf course in 1922 as a "dogleg affair, made of Italian rye," and noted, "When teeing off, you sure had to watch your ball when it landed. Invariably, the ball was out of sight, under the sand, by the time you got there." Golfers had to make their own tees from small boxes of sand and water placed at each tee. (Courtesy of Nina H. Webber.)

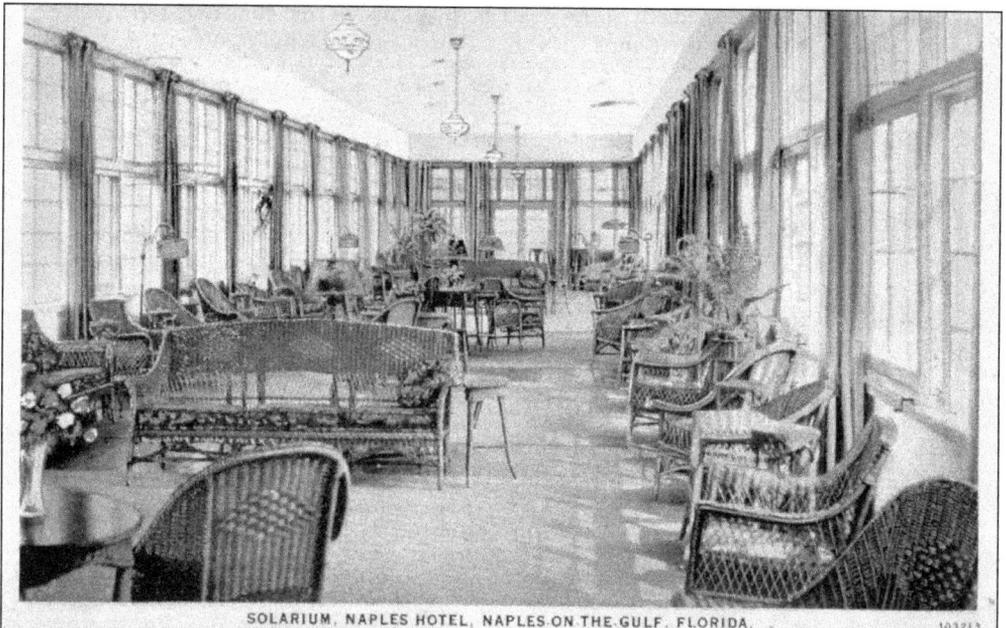

SOLARIUM, NAPLES HOTEL, NAPLES-ON-THE-GULF, FLORIDA.

The new Naples Hotel brochure proudly announced, "The new Sun Parlor, an added feature, is 112 feet in length, entirely enclosed with glass. It is tastily [sic] furnished and one of the nicest lounges in Florida." Guests were assured, "The fine broad porches, spacious lobby, trophy room, and ladies' parlor, with their fireplaces, comfortable chairs and lounges afford ample room for the groups of guests who wish to enjoy them." (Courtesy of Nina H. Webber.)

48

By 1924, the ever-growing Naples Hotel required professional management and Peter P. Schutt, who had previously managed the Bradford Hotel in Fort Myers, was hired. In a letter written to a prospective guest on December 7, 1924, he stated, "I thank you for your letter. Our hotel is conducted on the American Plan. Rates for rooms without a private bath, $42 per week, for a single room with private bath $56 to $70 per week. For a double room with private bath, $88 to $140 per week. I note that you have spent several winters at Fort Myers. I, myself, have been there for ten years and find that Naples, being right on the Gulf, is much more delightful as a resort and furthermore, we have a very lovely hotel here. So much nicer than anything at Fort Myers, that I think there is no comparison between the two places, for one to spend the winter. I am sure that these inducements should bring you to Naples, instead of returning to Fort Myers."

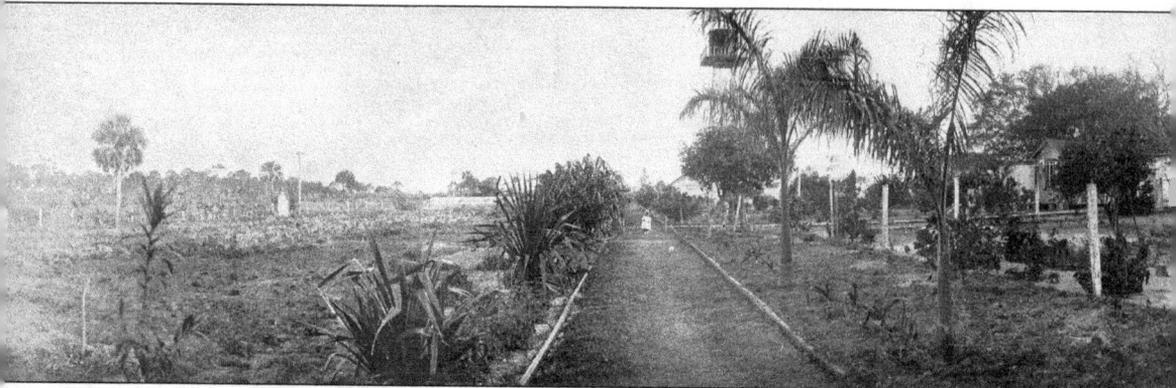

A cryptic note was scribbled on the back of this 1920s photograph, "Back of Annex to Pines." According to J. Arthur Stewart, son of Capt. Charles Stewart, there was a flower garden in the back of the Naples Hotel and the water tower was almost directly behind the hotel cupola.

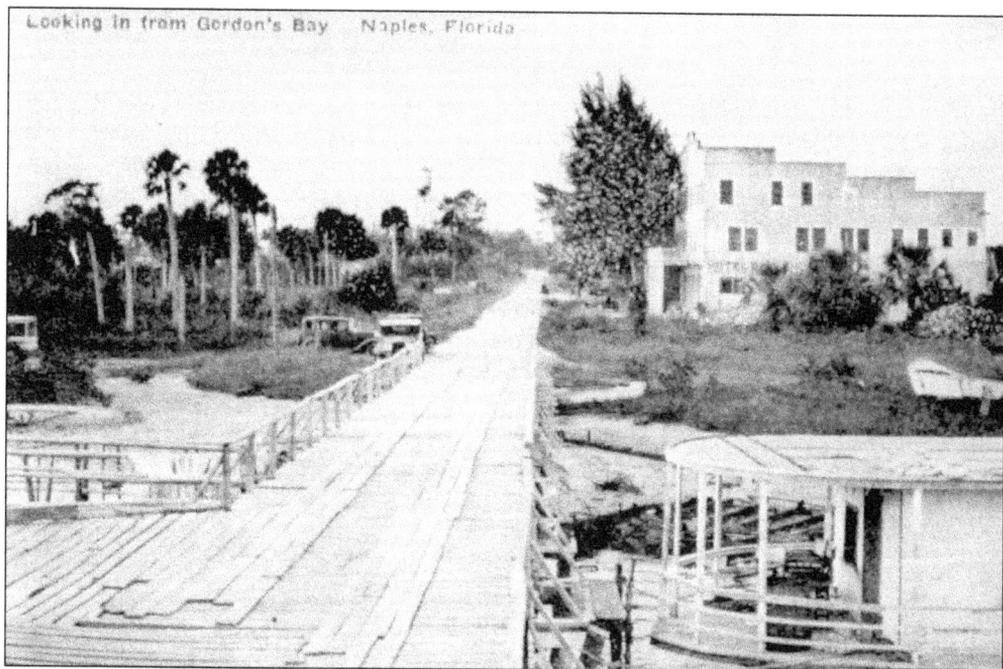

The Bayshore Hotel, located at the foot of the Back Bay dock on Twelfth Avenue South, opened in 1921. As a young girl in 1928, Mary Prince Evans Lipstate lived in the stucco building with her family and remembered, "The lobby was a long hall through the center of the building, furnished with leather couches." The building burned down in 1934. Note the cupola of the Naples Hotel is visible in the distance.

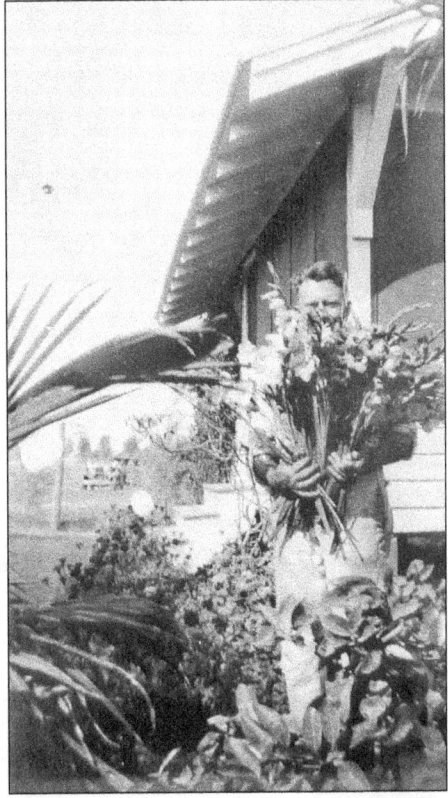

In 1925, Ed Crayton hired Robert Fohl Sr. as head greens keeper for the golf course; Fohl was also responsible for the hotel's vegetable and flower gardens and grounds maintenance. He is pictured at right, standing next to his house with flowers destined for the Naples Hotel. In the background is a car parked at the Golf Pro Shop, located at what is now West Lake Drive and Eighth Avenue South. Below, is the Fohl house with the hotel gardens in the foreground. The Naples Hotel brochure noted, "No expense has been spared by the owners and management to provide what we proudly boast of—our vegetable garden. This being near the golf course, may at all times be inspected by the guests. We do not serve canned vegetables. Last season, we were probably the only hotel in Florida which served entirely fresh vegetables."

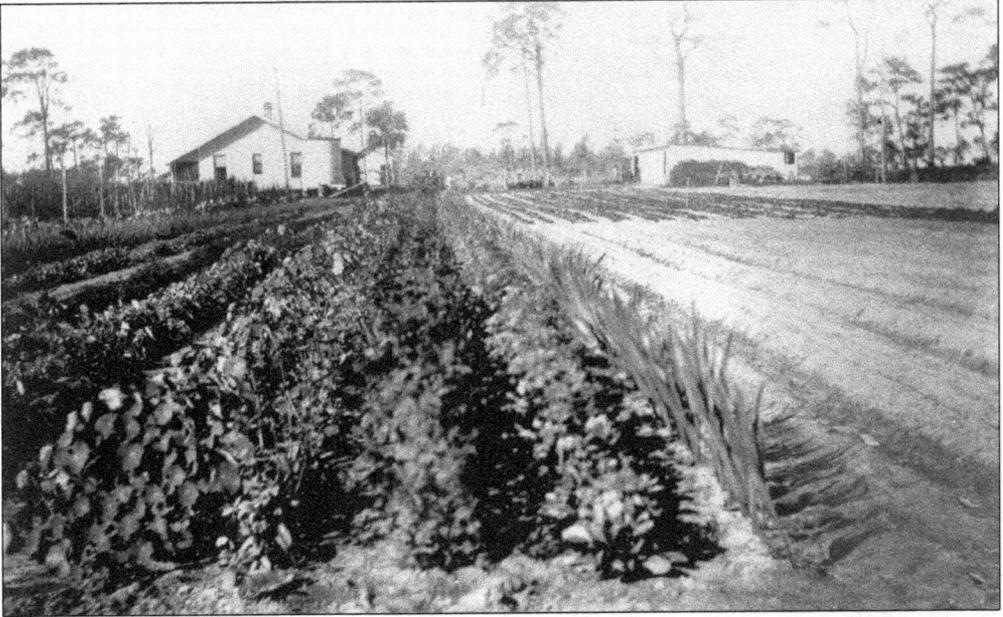

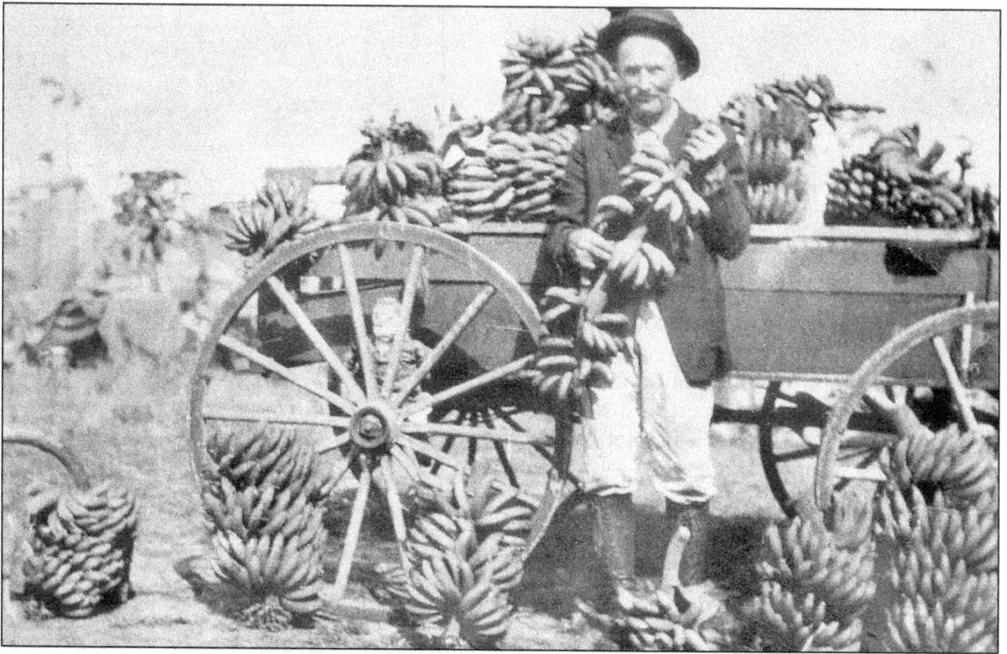

In this c. 1925 photograph, Robert Fohl Sr.'s father, Bernard A. Fohl, poses on the golf course with bananas from the "banana patch" located in center of the course. Fohl's son, Robert Jr., noted, "It was a pretty rough course, full of sand and sandspurs."

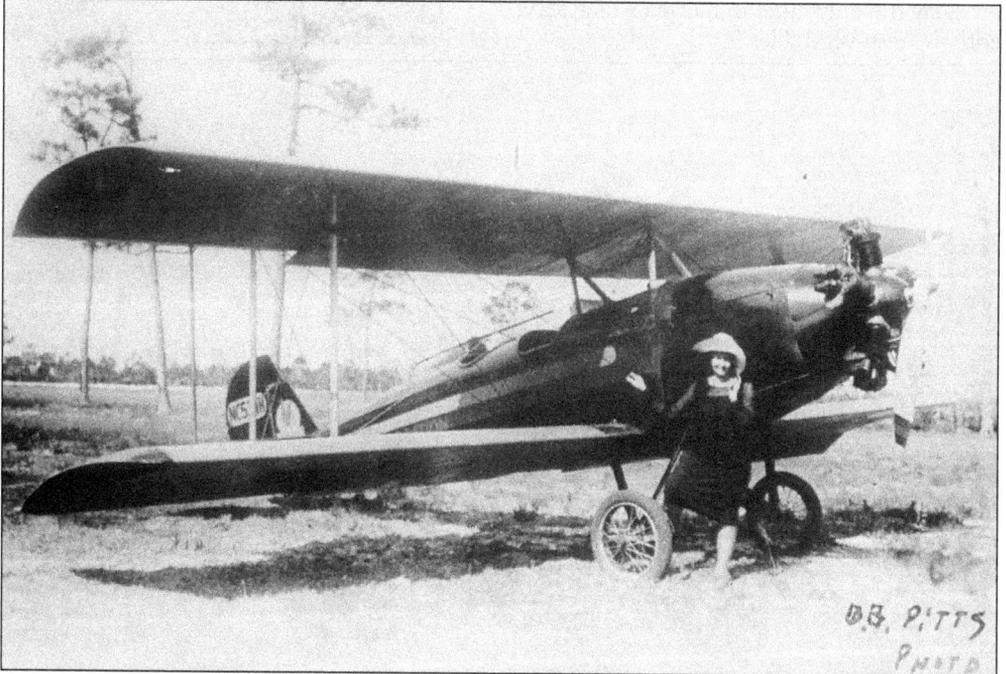

Robert Fohl Jr., captioned this February 1930 photograph "Mother Fohl on the nine-hole golf course." He added, "The plane, from Miami, blew an engine and could not make it to the beach. Most planes landed on the beach, and any such arrival always brought excitement to the community."

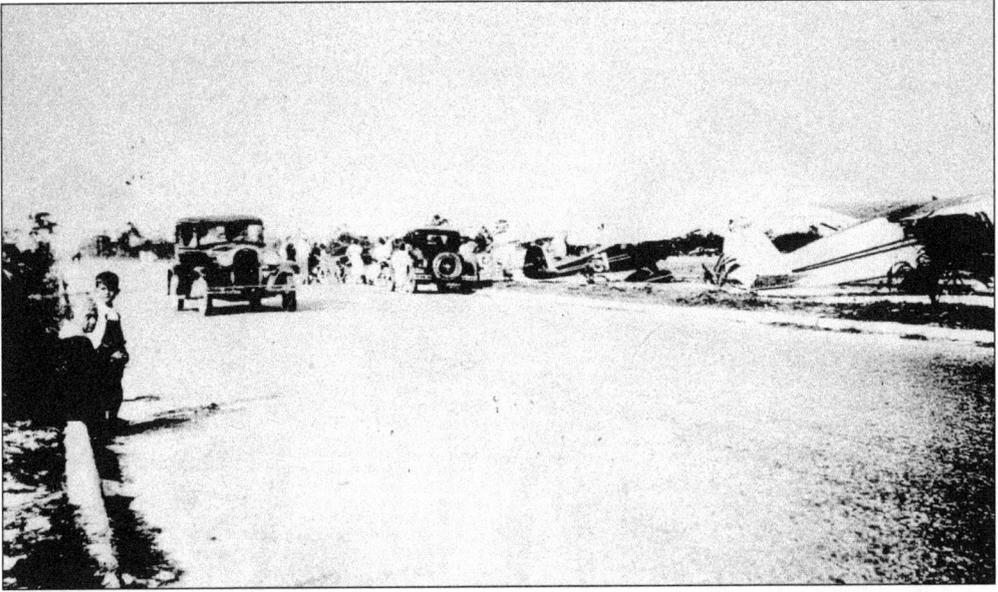

After the new Beach Club golf course opened in 1931, private planes used the old hotel course as an "airport." In this photograph, "Grandma" Carroll and her grandson J.E. Carroll sit on the curb to watch all the action. According to Merle Surrency Harris, "One afternoon, while school was in session, a group of small planes landed there. This was such an unusual happening that most of the students jumped class to go see what was going on."

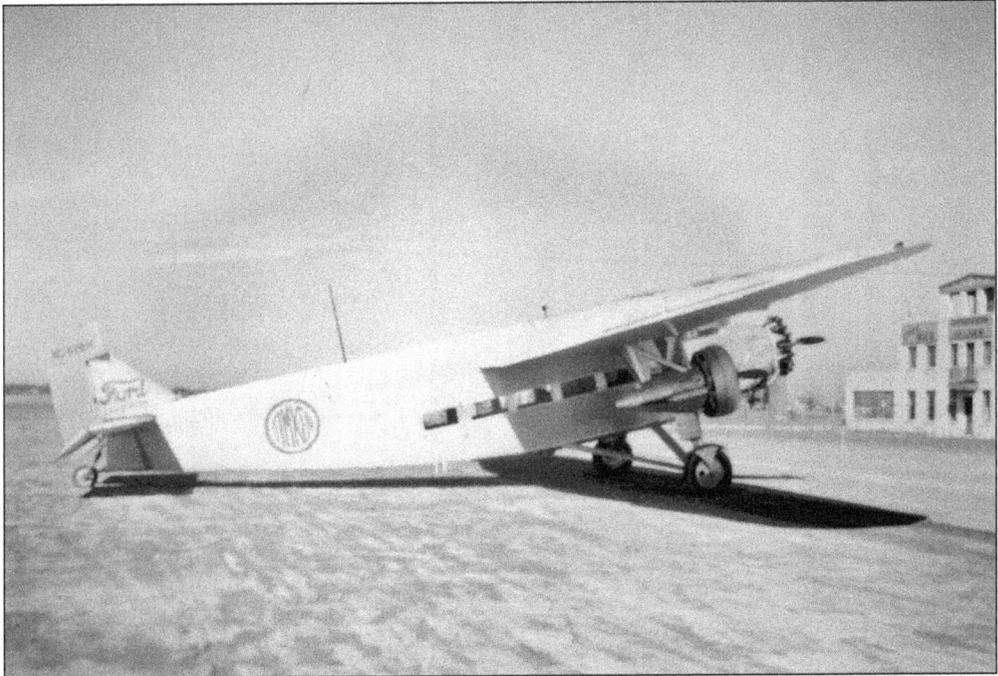

In February 1932, Henry Timkin's private Ford Tri-motor airplane landed on the old golf course to take the wealthy roller-bearing executive to Tucson, Arizona. Timkin had built one of the first large beachfront estates in Naples in 1925 and was one of the few private owners of a Tri-motor, one of the largest passenger planes in production at that time.

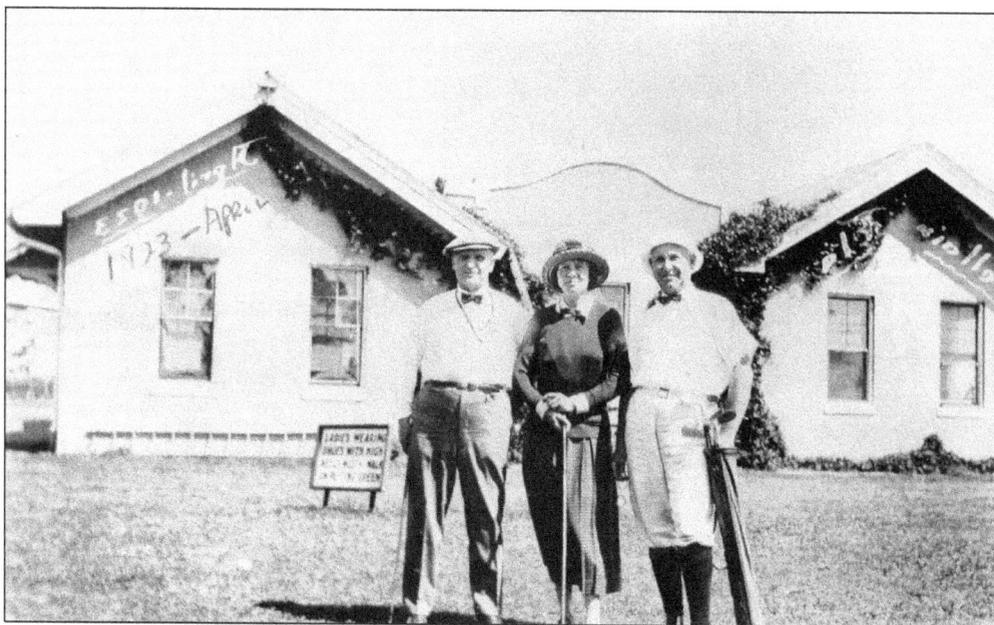

In this April 1923 photograph, three golfers stand in front of the Naples Hotel Golf Pro Shop, located at what is now West Lake Drive and Eighth Avenue South. A sign on the grass advised, "Ladies wearing shoes with high heels must not walk on the green."

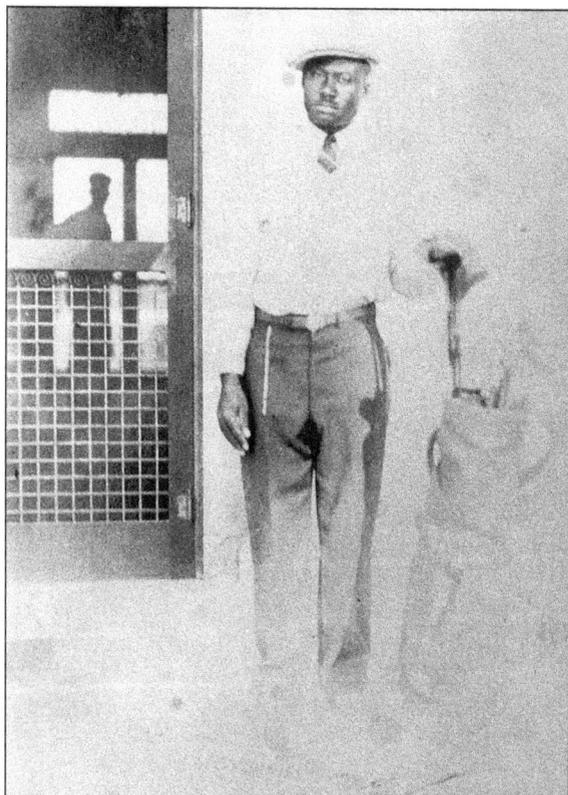

This 1925 photograph features Eddie Long, an assistant in the Naples Hotel Golf Pro Shop, by the shop door. According to Robert Fohl Jr., "Golf was a 'gentleman's game' in those days and Golf Pros wore white shirts, knickers and neckties, although players usually rolled their sleeves to the elbow."

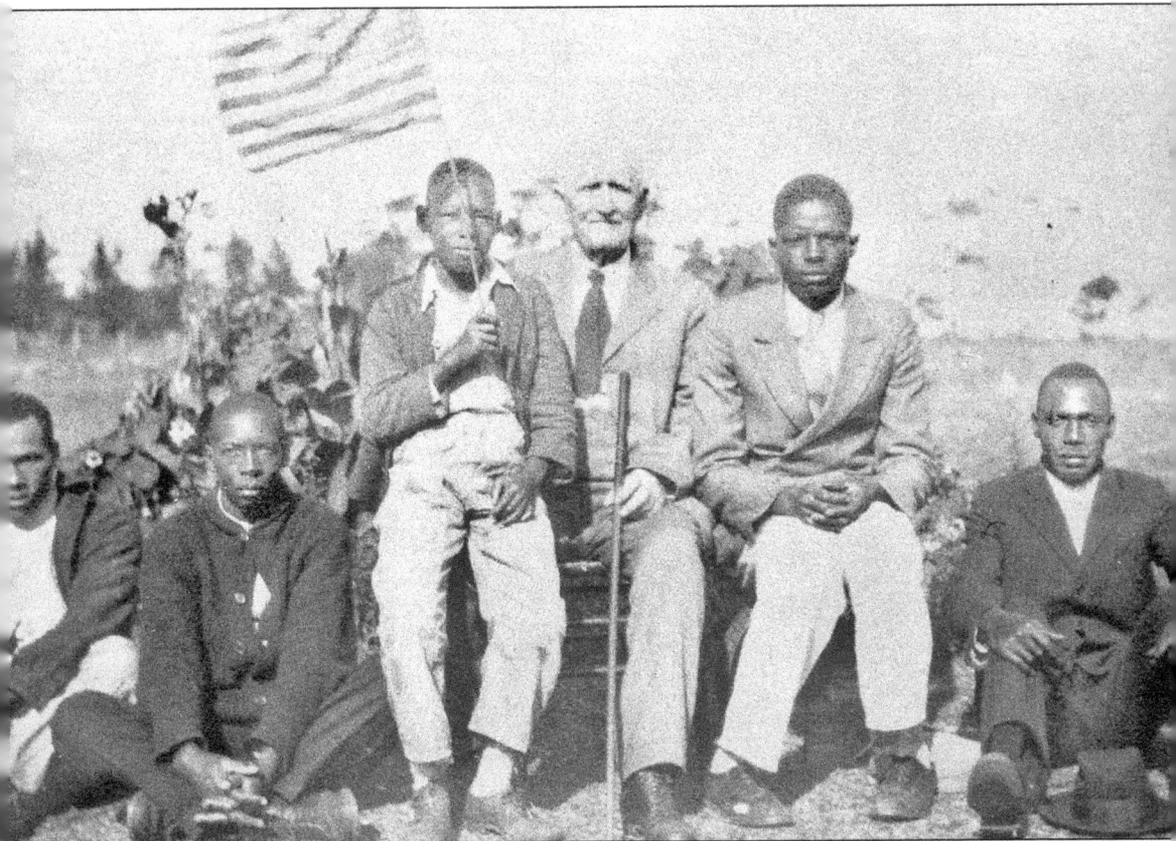

Robert Fohl Jr.'s uncle, Nick Harrman, stayed with the Fohl family during the 1930–1931 winter season. Fohl remembered, "Uncle Nick wanted to try his hand at hitting a golf ball. He needed a left-handed club, so after all the players and personnel left one evening, I went into the Pro Shop and 'borrowed' a club. Uncle Nick got to the third tee, between our house and the Pro Shop, and at his first swing broke the club and sent the wooden head sailing down the fairway. My father immediately walked over to the Naples Hotel and told the Golf Pro, Bill Fruchtemeyer, what had happened. Later, Uncle Nick cut a wooden golf head from a pine knot, and I fitted a hickory shaft with a leather grip for him. In this snapshot, Uncle Nick is seated, surrounded by caddies, and in his hand he is holding his prized golf club." Caddying was a lucrative job for black teens, since all the white teens were in high school. At this time, there was no black high school.

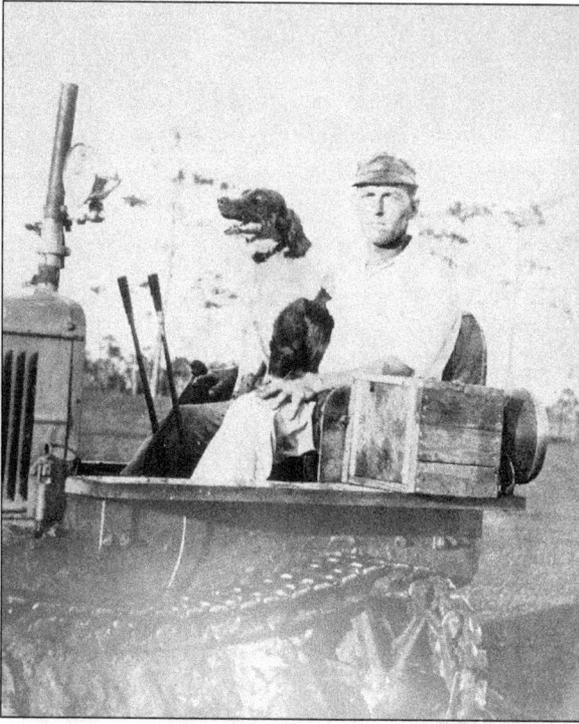

By 1930, Ed Crayton had convinced Allen Joslin of Cincinnati to build and operate a new 18-hole golf course to the north. In addition, Joslin began construction of the Beach Club, a clubhouse for the new course. Robert Fohl Sr., pictured with Andy, assisted with the construction of the new golf course.

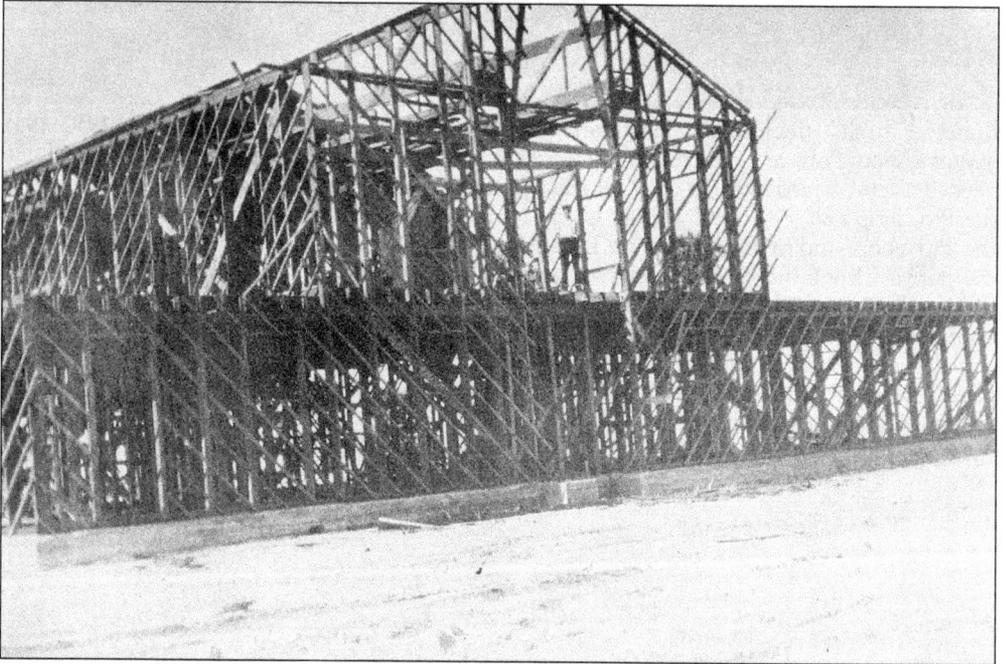

The new Beach Club, also called the Joslin Club House, was under construction by 1930, and included men's and women's locker rooms and a cocktail lounge on the first floor. (Despite Prohibition, which banned the sale of liquor until 1933, Dr. Earl Baum, who first visited Naples in 1922, recalled, "Naples was an easy place to run liquor into. It all came by boat from Bimini.") There was a large room for meetings and dances on the second floor.

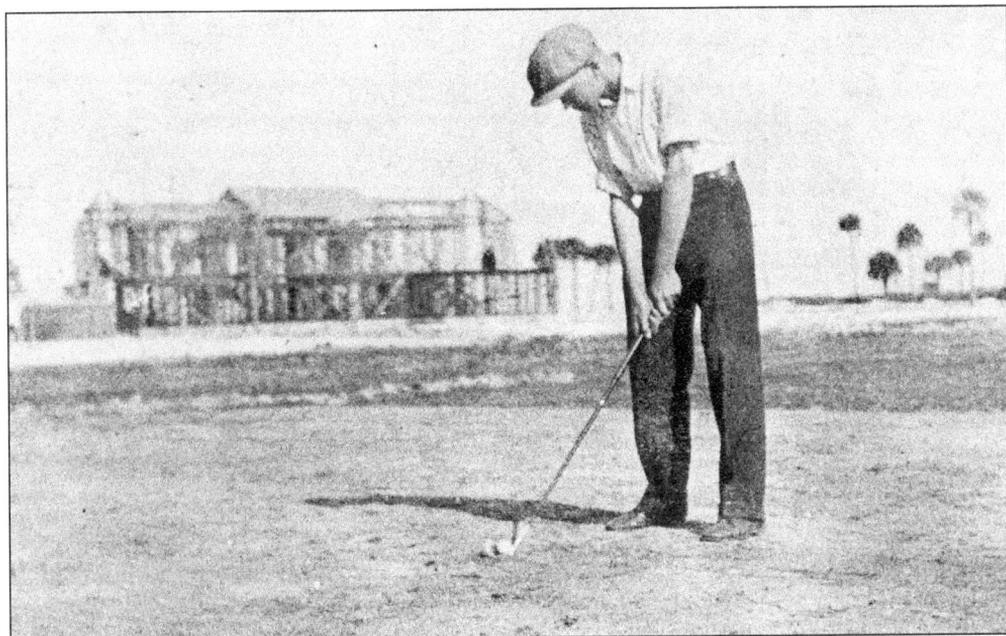

Robert Fohl Jr. helped with the construction of the new golf course, noting, "The Bermuda grass on the fairways came from nearby orange groves. I carried Bermuda grass in a burlap bag on my shoulders and dropped it into a furrow behind a mule and plow, as did several other high school students, working during summer vacation." In this 1931 photograph, Fohl hits the first shot on the course from a bare tee.

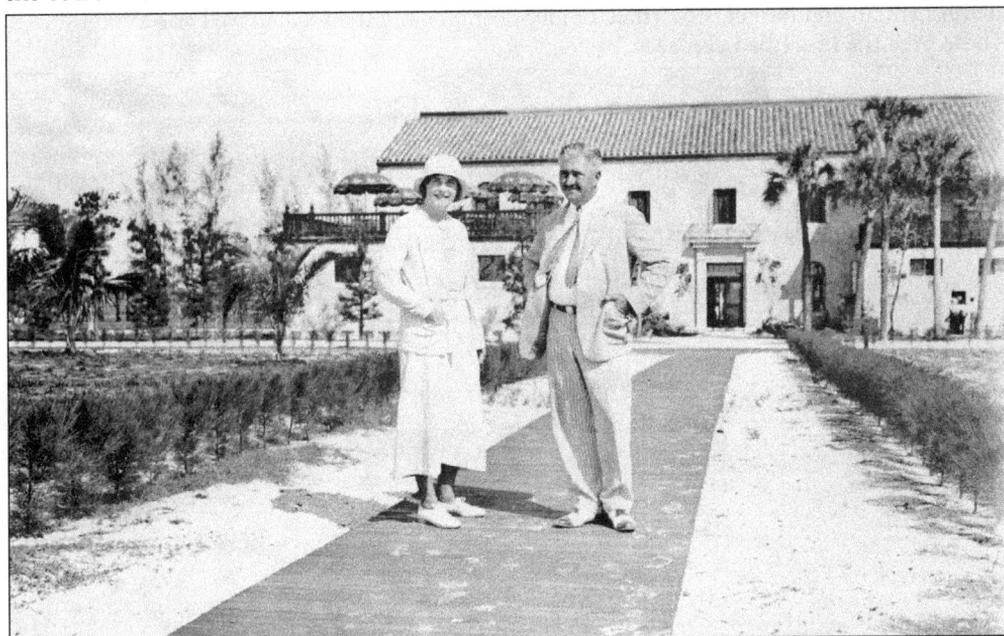

Mr. and Mrs. Allen Joslin were photographed in front of the newly completed clubhouse c. 1931. According to Dr. Earl Baum, "Once the clubhouse was up, it became the center of all social activity in Naples." Activities included dances, golf tournaments, and occasional all-day events for the entire community featuring foot races, golf, and pie-eating contests.

By the early 1920s, a Model T Ford bus and trailer transported Naples Hotel guests from Fort Myers to Naples along a rough shell road when the road was passable. In 1922, Elmer Weeks, who was driving the hotel's 10-person "bus" pictured below, picked up Dr. Earl Baum and his wife, Agnes, in Fort Myers. Dr. Baum remembered, "Most of the springs were sticking up through the upholstery." Because Weeks stopped frequently to deliver the mail, the return trip to Naples took four hours. During a stop at the Koreshan Unity community in Estero, Dr. Baum photographed Mrs. Baum (left) in the hotel bus. As the bus drove slowly to Naples, Baum, an avid fisherman and hunter, saw "three or four deer crossing the road, as well as several turkeys. These were the first I had ever seen."

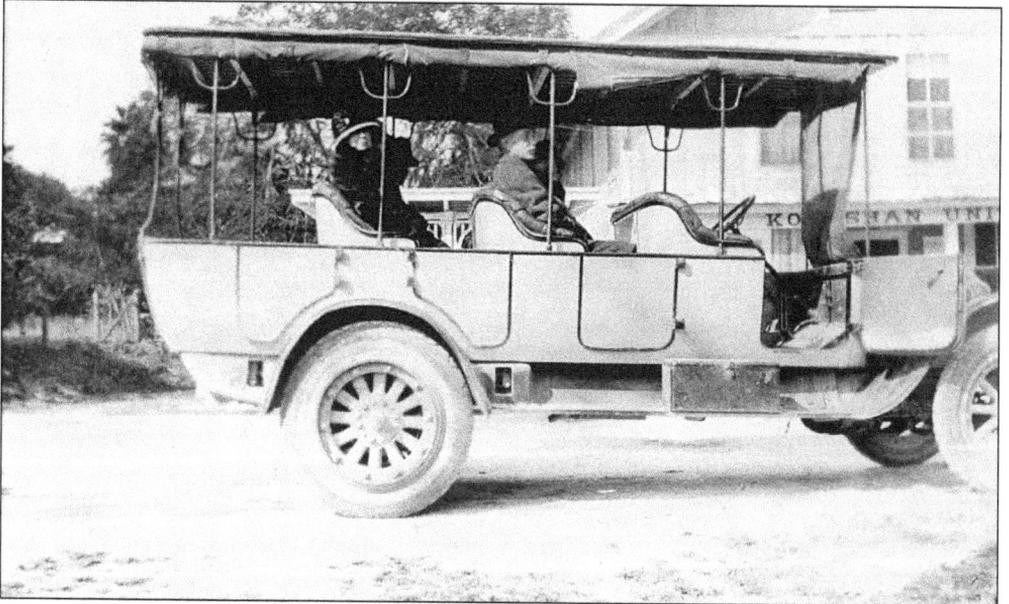

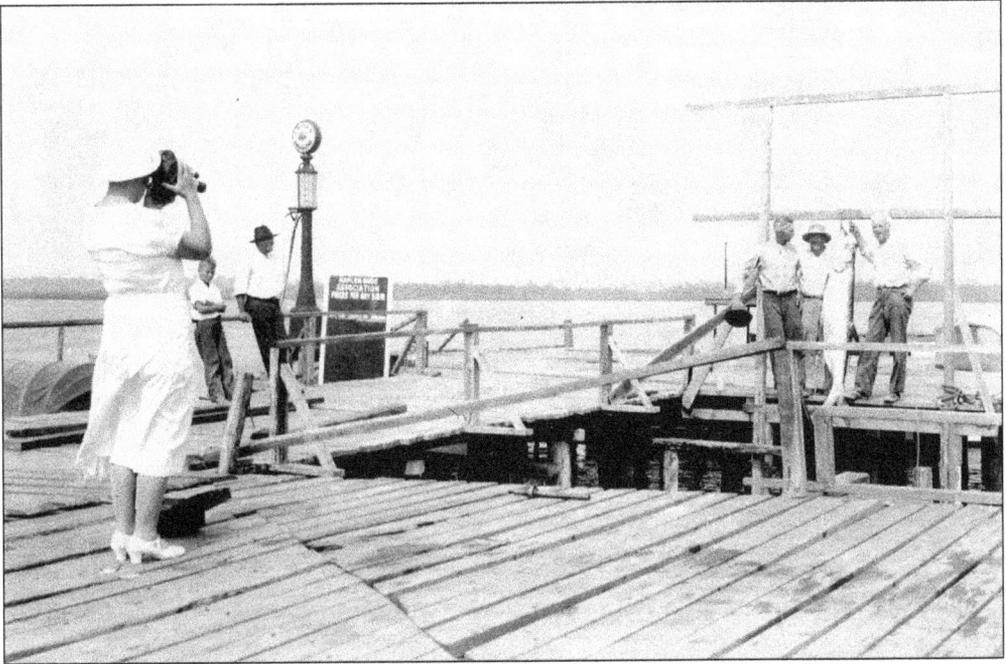

After their first visit in 1922, Dr. and Mrs. Baum visited Naples almost every year until they became permanent residents in 1946. In this late-1920s photograph taken on the Back Bay dock, Mrs. Baum is filming, from left to right, fishing guide Forrest Walker, Dr. Baum, and Dr. Echol. At the extreme left are Bembery Storter and his grandson, Hewett McGill. Storter operated a fish house and boat-building business on the 50-foot dock at the end of Twelfth Avenue South.

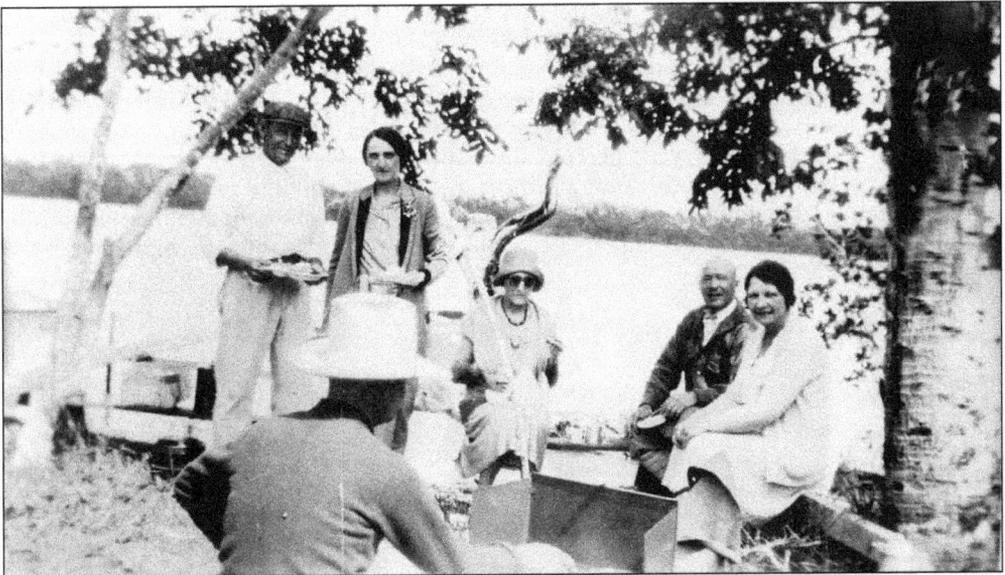

This 1926 photograph was taken during a picnic at Gordon's Pass. Forrest Walker, in the foreground, is cooking lunch for the group. Dr. and Mrs. Baum are on the right. Forrest Walker worked as Dr. Baum's guide for the next 20 years, assisting Dr. Baum, an avid sportsman, in his quest to acquire one of every species of bird, mammal, and fish in Collier County.

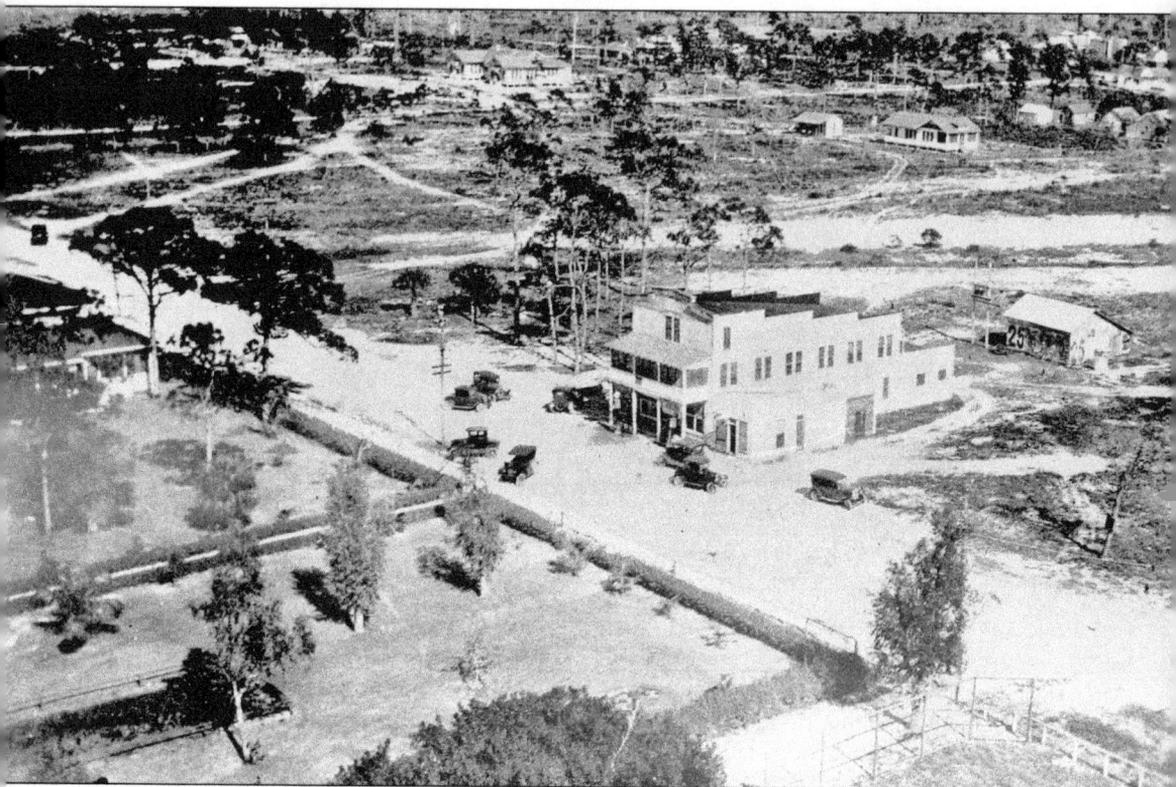

In 1926, Robert Fohl Sr. climbed to the top of the Naples Hotel water tower and took this photograph of the fledgling business district of Naples. The large building in the center, on what is now Third Street South, was the first commercial building of Naples, built in 1919 by the Naples Company to serve as a commissary. Capt. Charles Stewart managed it until the Robert and Lige Bowling purchased it in 1926. Leila Canant, who moved to Naples in 1928, remembered the kindness of the brothers who operated the only general store in town, "Since there was no bank in town, they would loan us money, record it on our grocery account, and then give us a 10 percent discount each month." The Naples Company building (left), built c. 1921, was a multi-purpose community building, serving as a company office, church, and beginning in 1925, the town hall. The second school building, built in 1920, is at the top, just left of center. The small structure attached to the right side of the commissary is the post office.

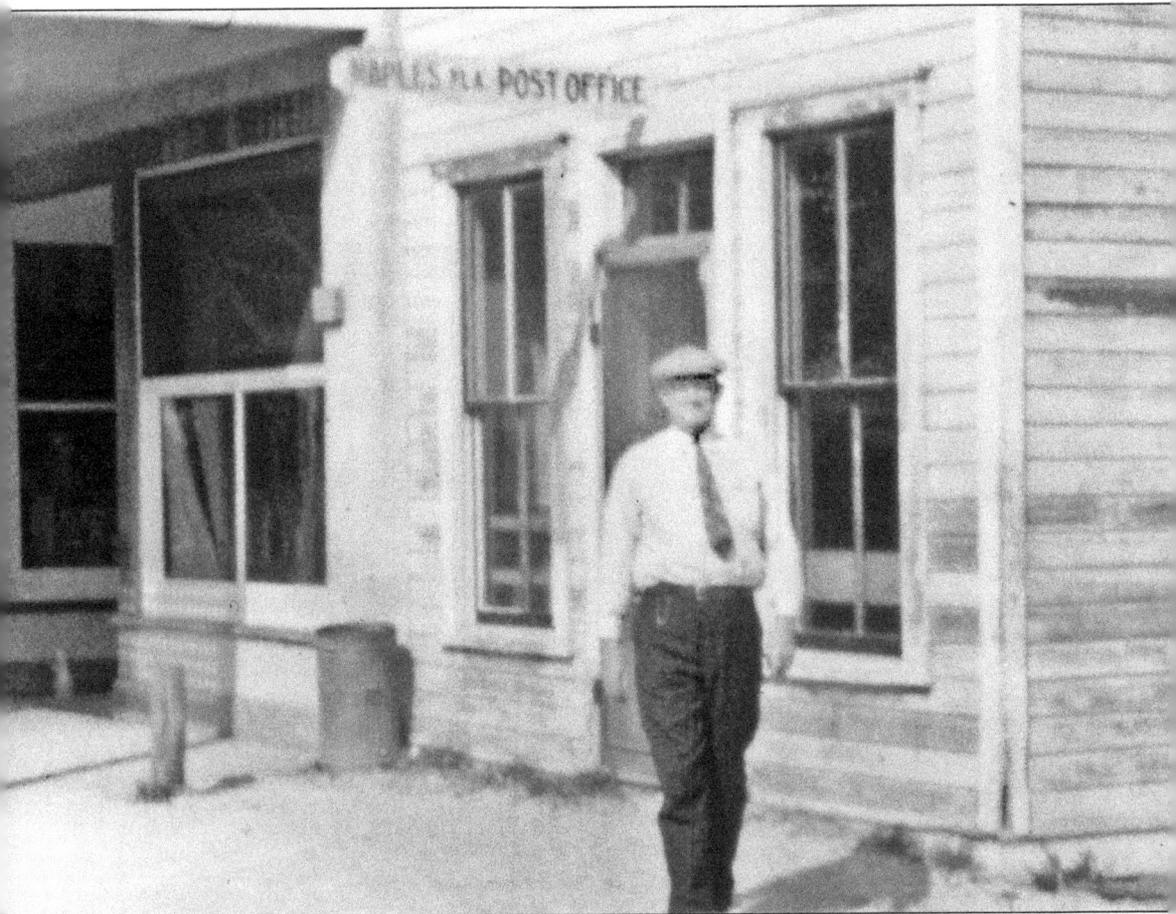

After the post office on the pier burned down in 1922, it was moved temporarily into the commissary. According to Arthur Stewart, son of the postmaster, Capt. Charles Stewart, "Not long afterward, Mr. E.W. Crayton built an addition out from the south side of the Commissary building, in order to get the Post Office out of the store where space was needed for shoes, yard goods, etc. That Post Office served Naples for many years." This *c.* 1931 photograph shows Capt. Charles Stewart outside the post office with the commissary building, also called the Mercantile Building, to the left.

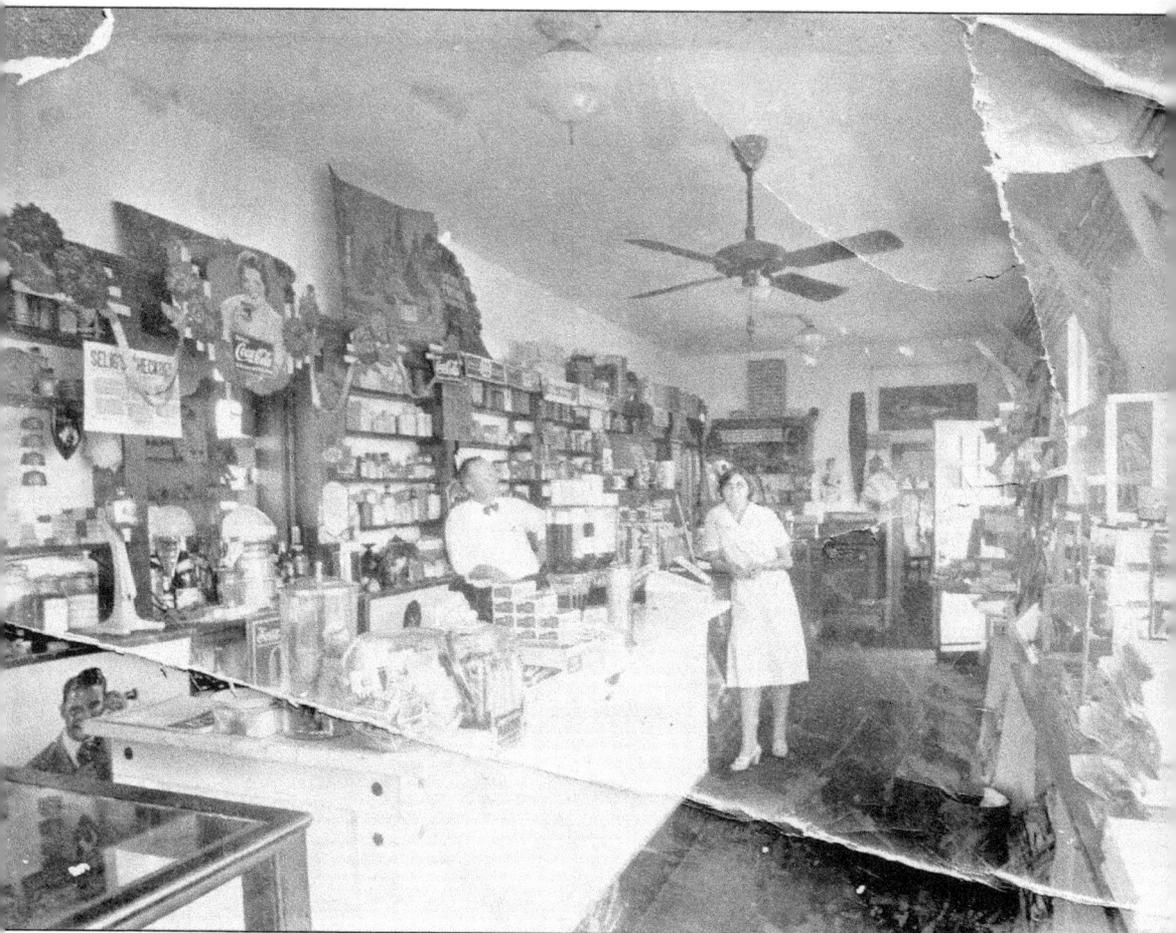

In 1928, John "Doc" Prince and his wife, Mary, opened the Naples Drug Store in the northern half of the Naples Company building on what is now Third Street South. Doc Prince had some pharmacy training and offered over-the-counter treatments for "dyspepsia, hangovers, and sweet tooth attacks." While those with serious injuries or problems had to go to Fort Myers for treatment, the store often served as the town's only emergency room for such minor injuries as the removal of fish hooks. Prince's daughter, Mary, remembered, "There was a counter with a marble top where the soda fountain was, and at each end of the fountain were glass showcases, a flat one to hold cigars, cigarettes and tobacco, and a taller cabinet to exhibit candy. Cokes were served in traditional coca-cola glasses. We carried newspapers, and there were little 'ice-cream tables' and wire-back chairs for fountain customers."

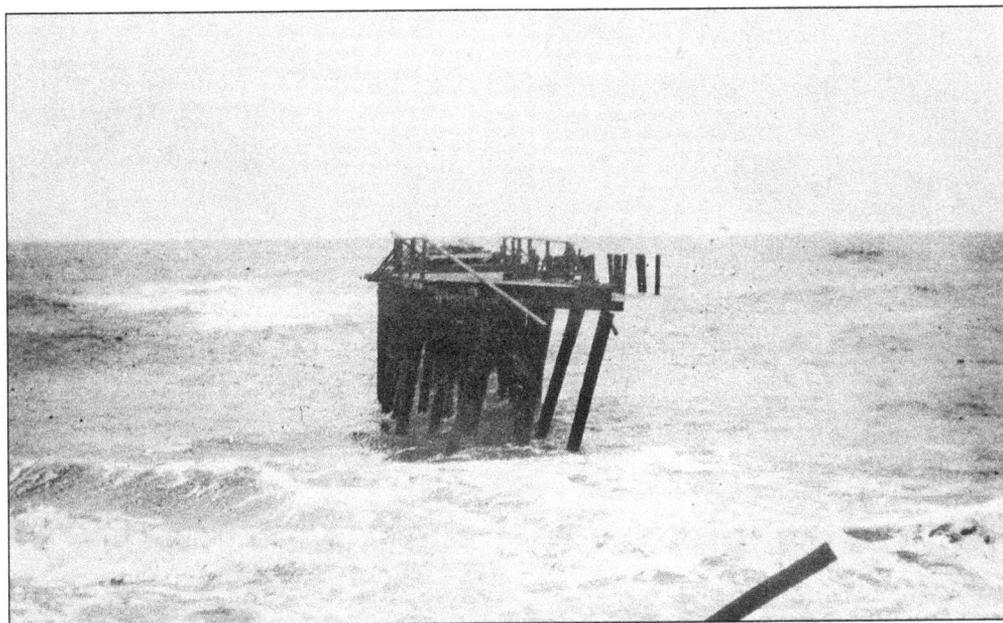

On September 18, 1926, a hurricane struck southwest Florida and severely damaged the Naples pier. A letter written two days later to a Naples Development Company executive stated, "Our pier is a sight! There is a strip of about 200 feet standing intact, then a gap of about 100 feet, and then piling the rest of the way. The beach is about 25 feet wider than it was and now nearly flat. The Hotel property stood it nicely with very little damage." Another letter noted, "All our wires were down, but Captain Stewart has patched up some of the light lines." Below, on the back of this early postcard view of the pier, a visitor wrote, "This is taken south of the pier. There is a new pier this year—due to the 'blow' of last fall." (Postcard courtesy of Nina H. Webber.)

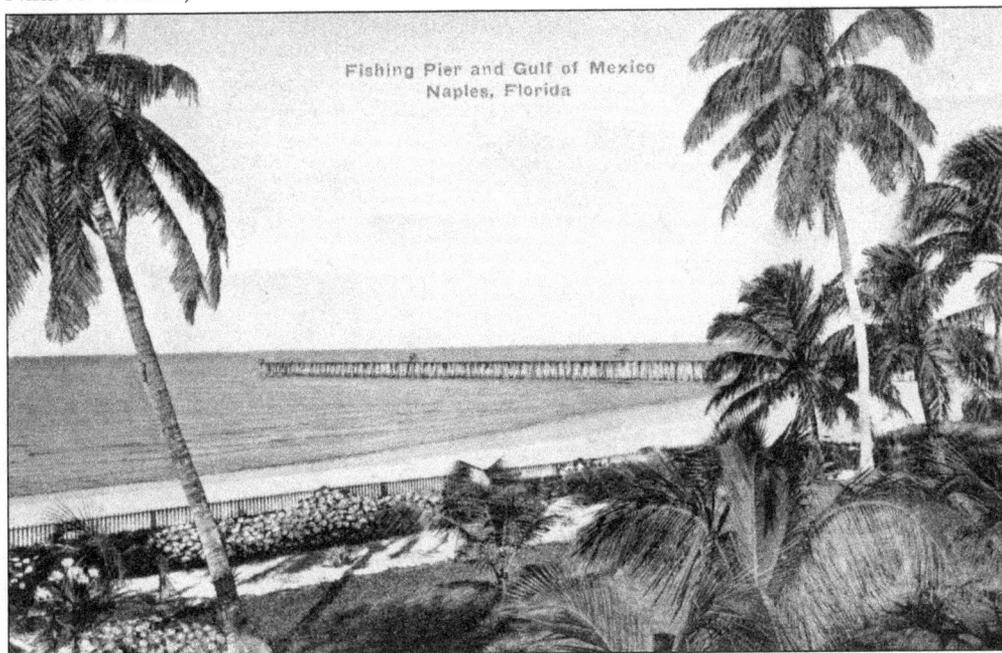

Fishing Pier and Gulf of Mexico
Naples, Florida

In 1920, the one-room school on Broad Avenue closed and a new school opened nearby on Fourth Street South, between Tenth and Eleventh Avenues. Originally, the school was two separate buildings, with one room for first through fourth grades and another for fifth through eighth grades. By 1928, the two rooms were connected by a large hallway, often used as an auditorium and additional classroom.

In 1928, the eighth grade graduates posed in front of the school. Pictured from left to right are Walter Stewart, Robert R. Fohl Jr, Francis Tuttle, Albert Surrency, and Curtis Bostwick. This was teacher Leila Canant's first year at the school and she remembered thinking that "the building looked more like a dwelling than a school."

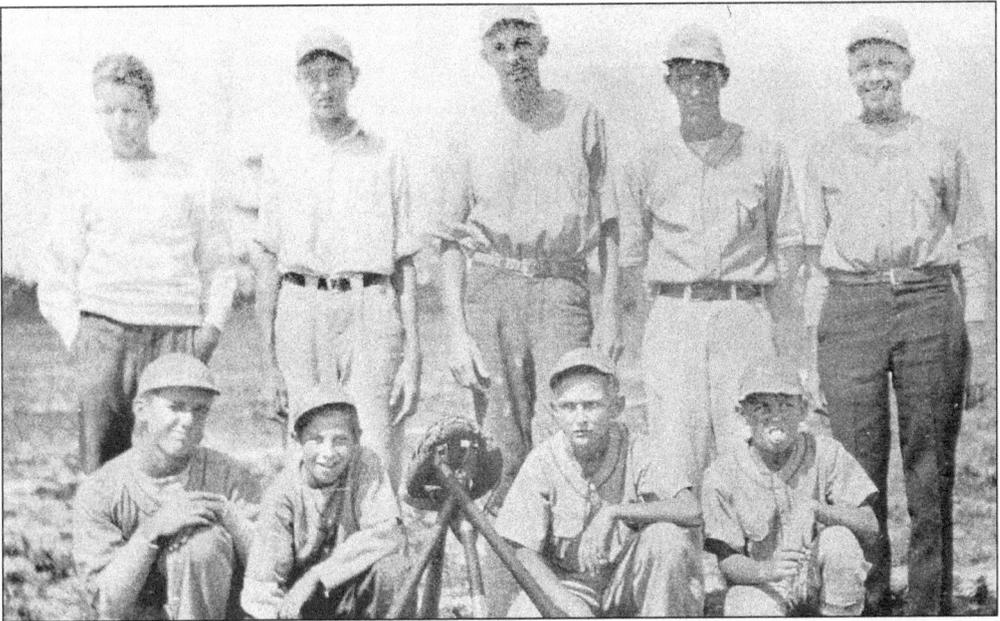

The 1930–1931 Naples school baseball team posed for this team photograph. From left to right are (front row) Stanley Fredrick, Bob White, Robert Dyches, and Wilson Tippons; (back row) Eddie Tomlinson, Roy Brack, Bernard Gouch, Walter Stewart, and Robert Fohl Jr. According to teacher Leila Canant, "The baseball team was coached by Mr. Smith, who had been a baseball player."

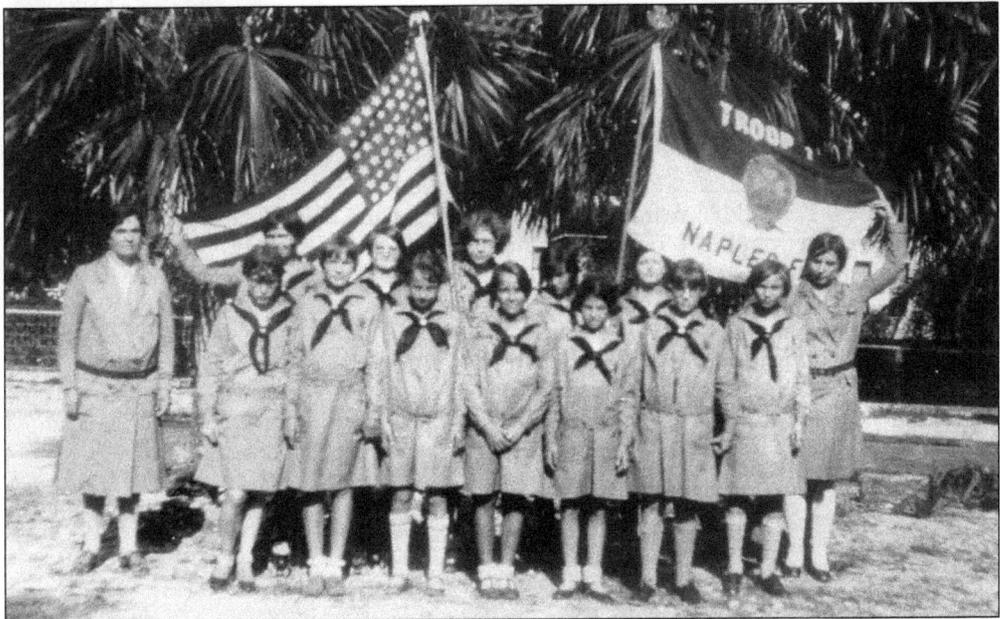

Although there was no girls' baseball team, girls could join a school basketball team or the Girl Scouts. This photograph shows the 1930 Girl Scout Troop of Naples from left to right: (front row) Mrs. Hall, Ioma Daughtery, Erna Klay, Montine Wombe, Lois Klay, Merle Surrency, Catherine Stevens, and Bessie Hill; (back row) Margaret Dyches, Evelyn Brack, Ruth Fohl, Elsie Johnson, Francis Tomlinson, and Alice Portner.

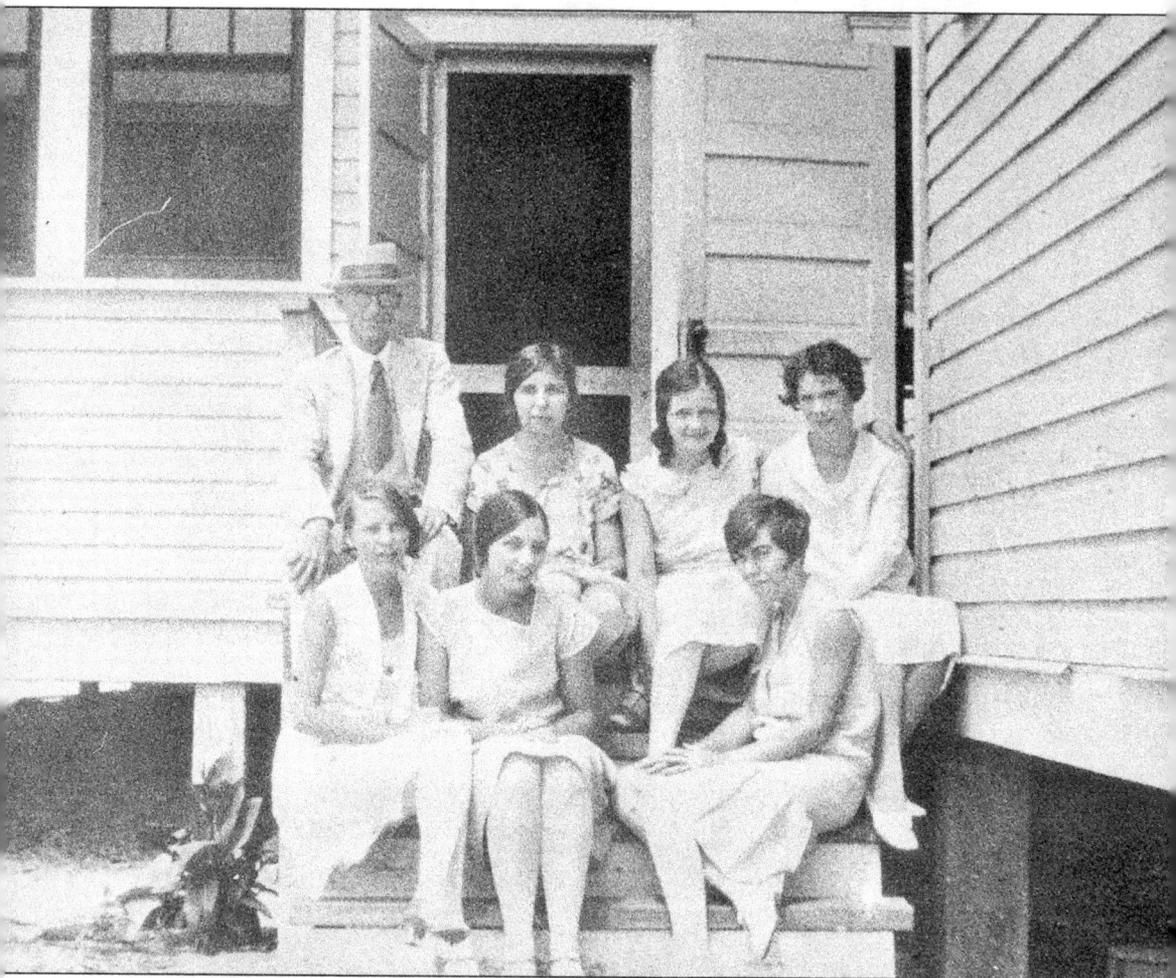

During the 1931–1932 school year, there were six teachers and one principal at the only school in Naples. Pictured from left to right are (front row) Leila Bryant Canant, Lucille Buckels, and Maxine Songer; (back row) Ernest Bridges (principal), Alice Portner, Inez Hall, and Mrs. Turner. According to Leila Canant, the school had a pot-bellied stove for heat and each classroom was "just a little square room, with desks for the children and the teacher's desk. There were no cabinets of any kind. Since the county didn't furnish any supplies at all, we didn't have anything to store. If we wanted construction paper, paper clips or thumb tacks, the teacher bought those herself." Since the school was not accredited, 12th grade students went to the Everglades school for the last two weeks of the year to graduate from an accredited school.

Three

ROADS TO SUCCESS

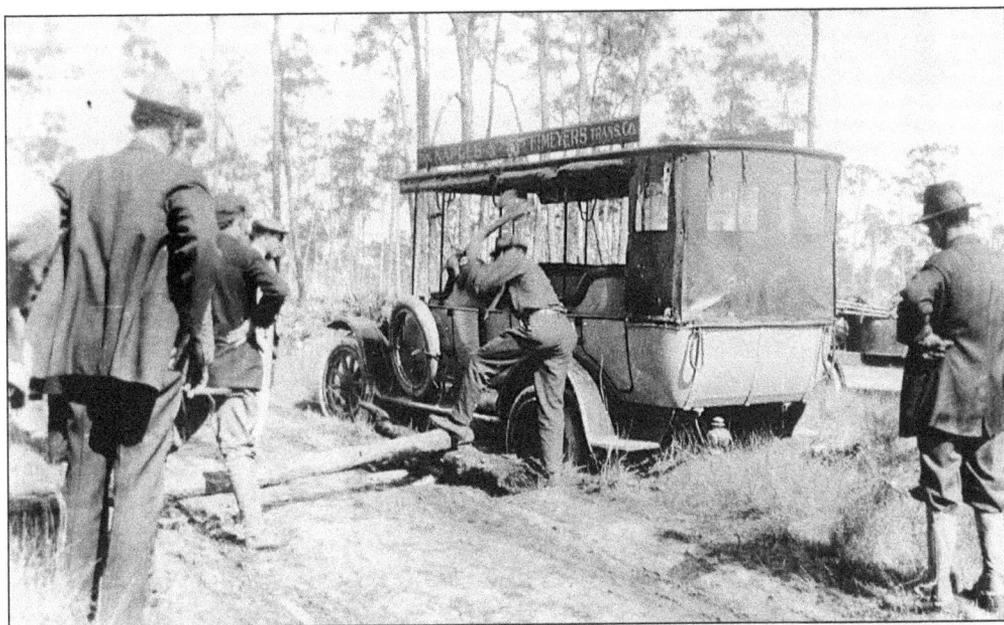

In 1909, the *Fort Myers Press* reported General Haldeman, Walter Haldeman's son, would pay one-third of the cost of a hard road from Naples to Fort Myers, but there were no offers to fund the other two-thirds. The Naples-Fort Myers Transportation Company attempted to operate a bus route during the winter of 1914, but the buses were frequently mired in the sand and mud on the one-lane road.

This early, pre-1921 map of "the semi-tropical resorts reached by the lines of the Atlantic Coast Line" shows Naples accessible only by boat from Fort Myers. In 1921, the line was extended from LaBelle to Immokalee, making it the first town with rail service in what would become Collier County in 1923. By 1926, the Atlantic Coast Line and the Seaboard Airline Railway were racing to be the first into Naples. The Atlantic Coast Line won the race by 10 days, steaming into its new depot at what is now the northeast corner of Airport Road and Radio Road on December 27, 1926. The line was later extended to Marco Island, where the trestle across the bay became the first bridge to the island.

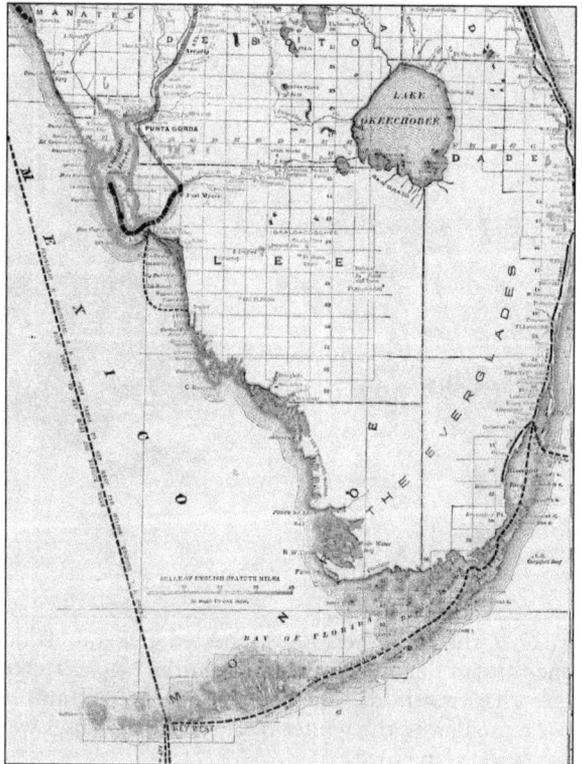

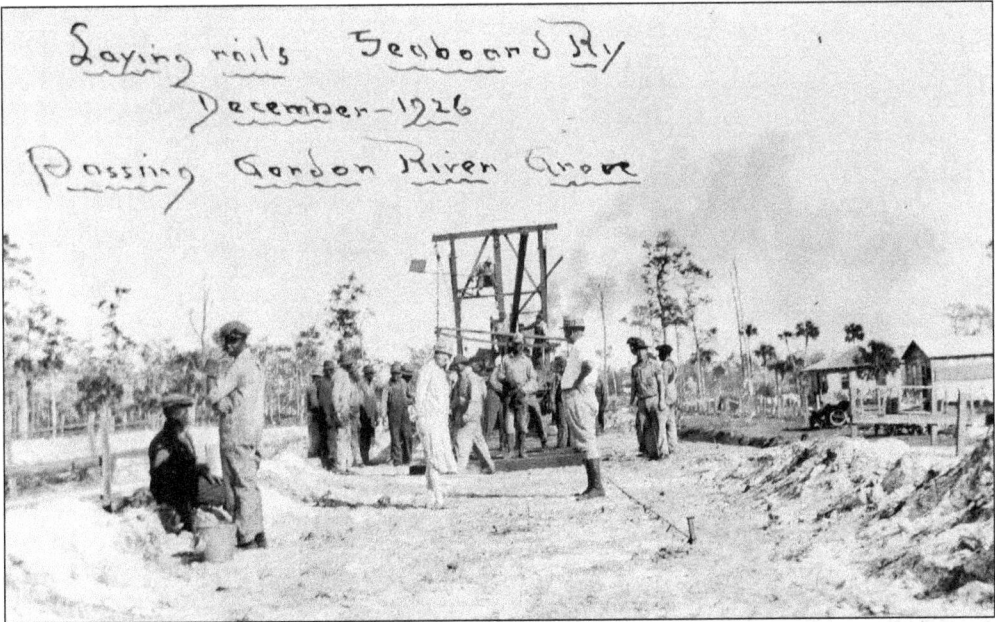

John Hachmeister documented construction of the Seaboard Airline railway into Naples and wrote on the above photograph, "Laying rails, Seaboard Ry, December 1916, Passing Gordon River Grove." He owned a 60-acre citrus grove "just outside Naples," which may have been near the rails. The depot, unfinished in the photo below, was built close to the center of the town, at the corner of what would become the Tamiami Trail and Tenth Street South. S. Davis Warfield, president of Seaboard, envisioned Naples as "Seaboard's Miami" and purchased 2,645 acres in Naples for right-of-way, terminals, station, and future development, including making Naples the terminal for a proposed boat line to Cuba.

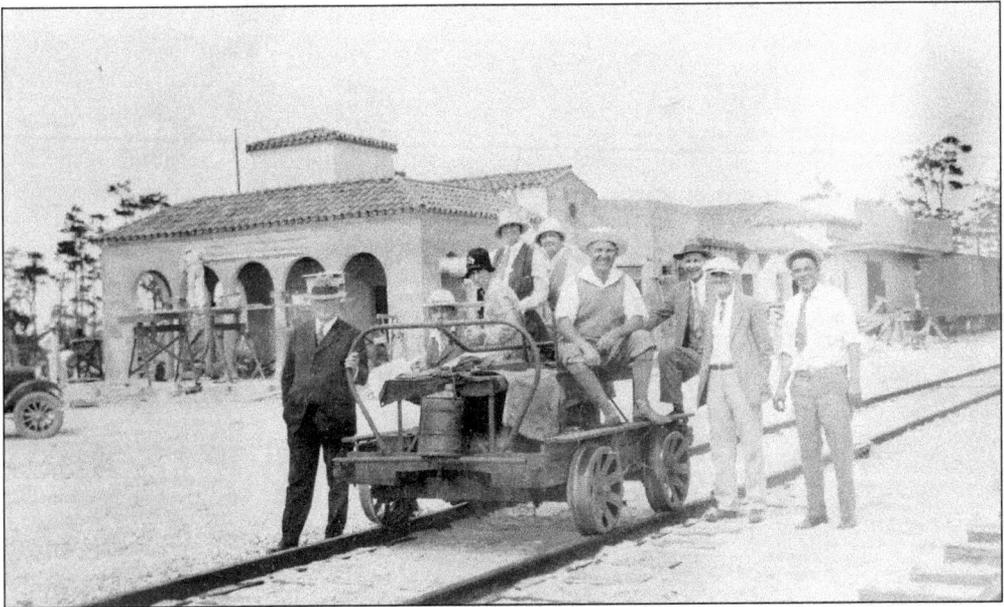

Shortly after 3 p.m. on January 7, 1927, the Seaboard Airline Railway's *Orange Blossom Special*, the pride of the line, steamed into the Naples Depot. According to the *Collier County News*, "Hundreds of gaily decorated cars lined the streets and railroad yards." The five-section train, which had left Pennsylvania Station in New York the evening before, stopped several times to pick up dignitaries and by the time it arrived in Naples it carried 580 VIPs, including the Seaboard president S. Davies Warfield and Florida governor John W. Martin. Also onboard were the Royal Scots Highlander and Czechoslovakian national bands, which played at the depot and later at a special late buffet luncheon held at the Naples Hotel.

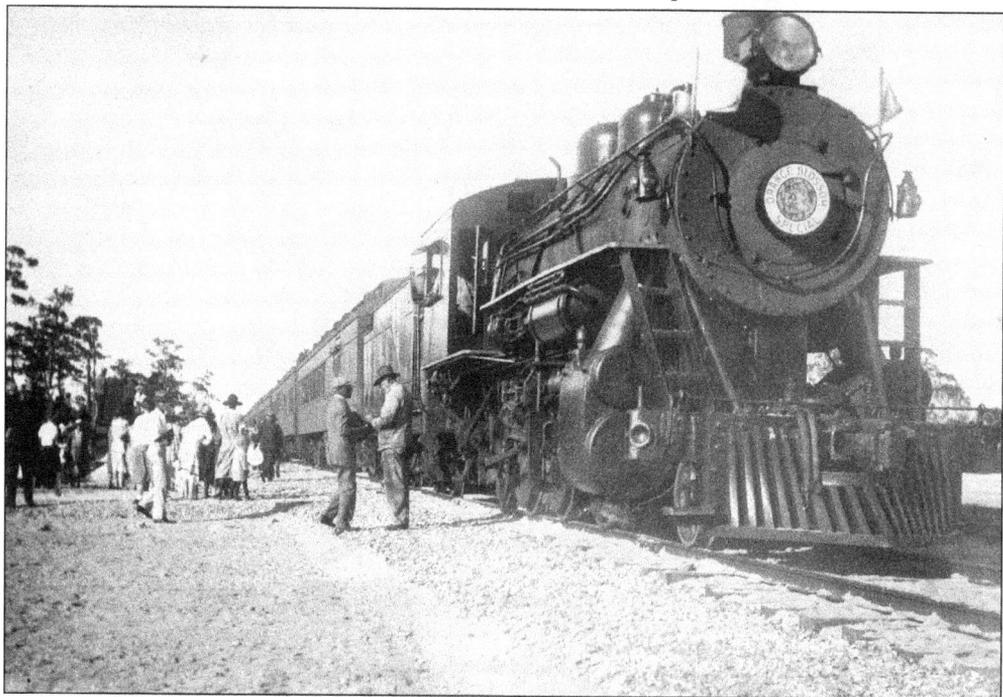

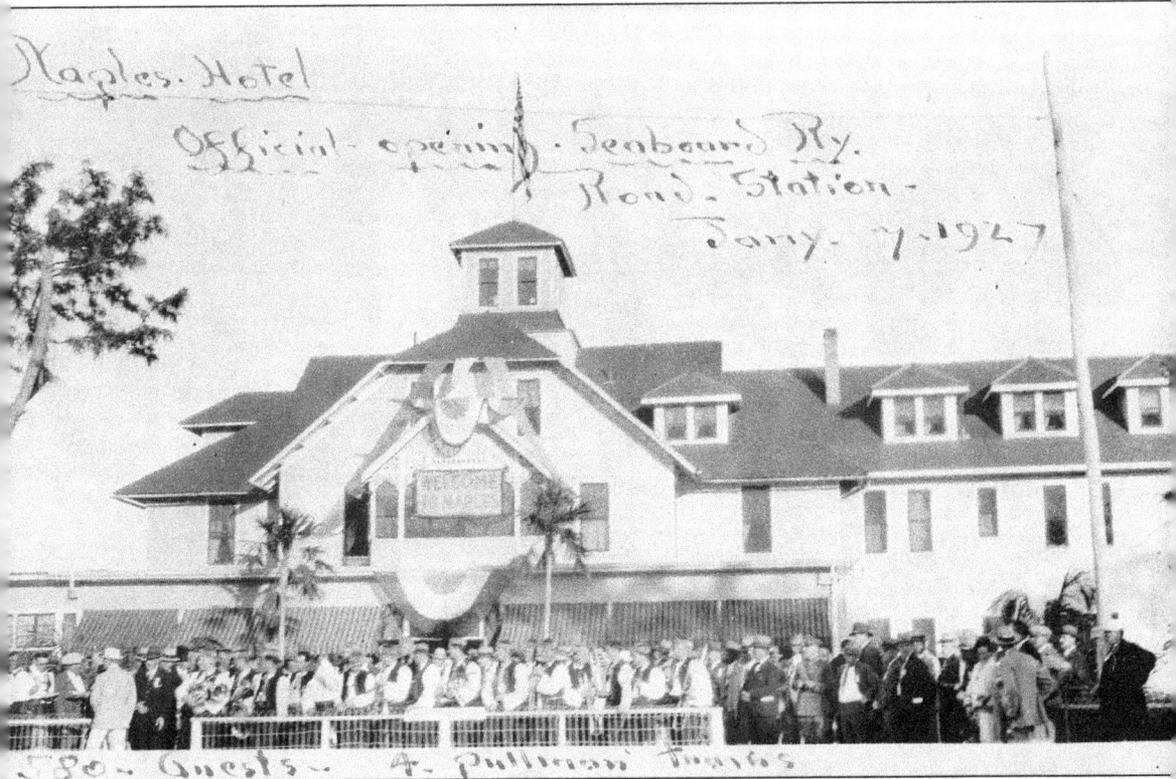

Naples Hotel
Official opening Seaboard Ry.
Rond Station
Jany 7 1927

80 Guests 4 Pullman trains

According to Merle Surrency Harris, who watched the *Orange Blossom Special* pull into Naples on January 7, 1927, "There were many introductions and speakers, with lots of pomp and ceremony popular in those days. Bouquets were presented to certain ladies and when the speeches finally ended, a parade formed with the VIPs and pretty girls in the lead, and the two bands providing music for the trip to the Old Naples Hotel." Seaboard's arrival was heralded by what the *Collier County News* called "the largest celebration in the honor of the opening of a new railroad line in the nation's history." Local dignitaries, including Mayor E.G. Wilkinson; Ed Crayton, president of the Naples Company; and Walter O. Parmer attended the banquet. The *Collier County News* reported, "The railroad president, the governor, the other members of the visiting party found many friends and acquaintances among the distinguished winter residents of Naples, and were shown the beauties and possibilities of the little gulfside city after pictures had been taken in the gardens of the hotel."

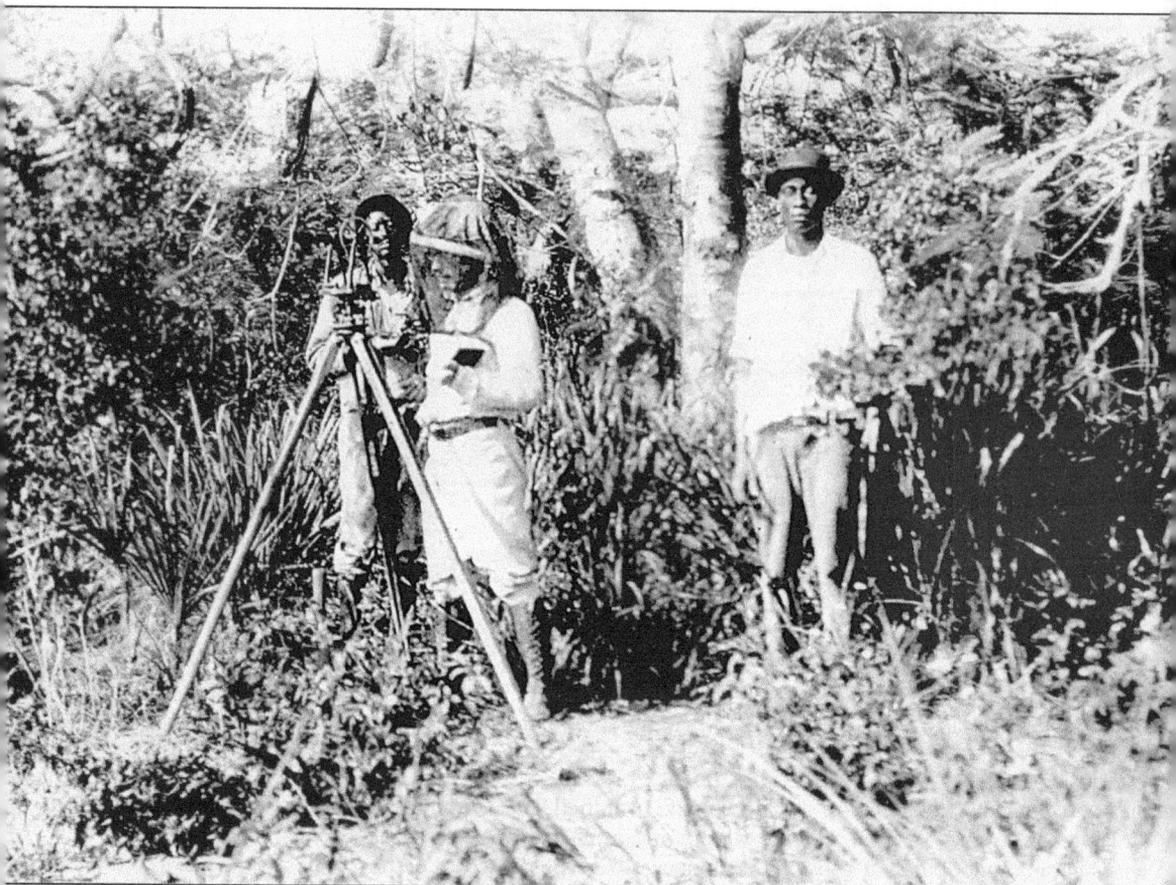

In 1926, nine surveyors were sent to survey the last 31 miles of the Tamiami Trail in Collier County. A cross-state road through the Everglades had been proposed as early as 1910, and by 1915 the project had been dubbed the "Tamiami Trail," a road that would link Tampa to Miami. An editorial in the *American Eagle* complained the name sounded "like a bunch of tin cans tied to a dog's tail and clattering over cobblestones," and continued, "Why not call the Jacksonville to Miami Dixie Highway 'Jackiami Joypath?'" Despite the complaint, the new name stuck, but by 1918, only 43 miles of the new road had been completed from Miami to the Dade County line. Barron Gift Collier, one of the largest landowners in southwest Florida, offered to revive the languishing project if the Florida legislature would create "Collier" County out of southern Lee County. The legislature complied and Collier County was created in 1923. Collier then faced the formidable task of constructing 76 miles of the road through the wildest part of the Everglades.

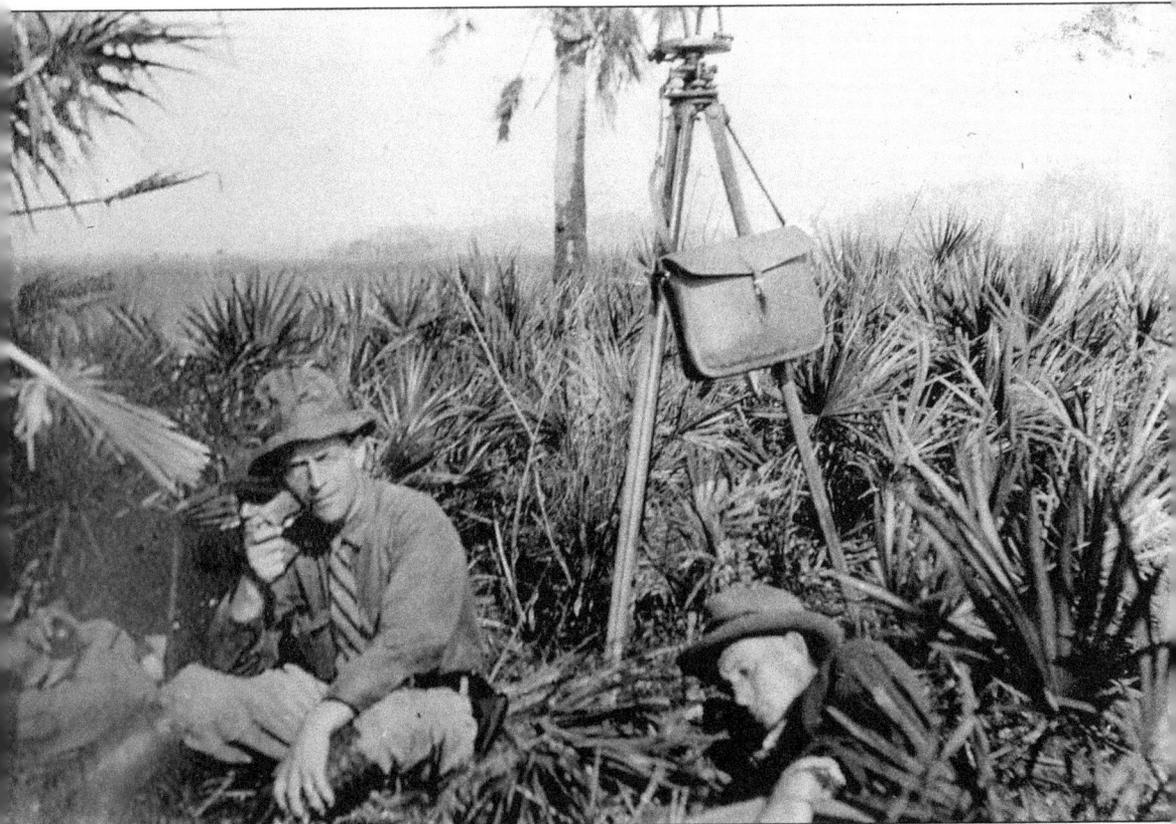

In this photograph, two surveyors rest in the Everglades. By 1926, Barron Collier had spent more than $1 million on completing the Tamiami Trail through Collier County. With 31 more miles to go, through some of the toughest terrain in the Everglades, the State of Florida took over the project with a pledge to complete it "come hell or high water." W.R. "Bob" Wilson, one of nine surveyors of the State's Road Department Engineering Crew, arrived in Naples on September 16, 1926. One of his first jobs was to walk from the end of the grade in Collier County to the Dade County line—alone—checking the previously marked centerline of the road. Flimsy lathe stakes had been driven into the muck years before, but had rotted, forcing Wilson to search in the sharp sawgrass for the stubs and re-mark each one with a new stake cut from the brush, an "almost endless job."

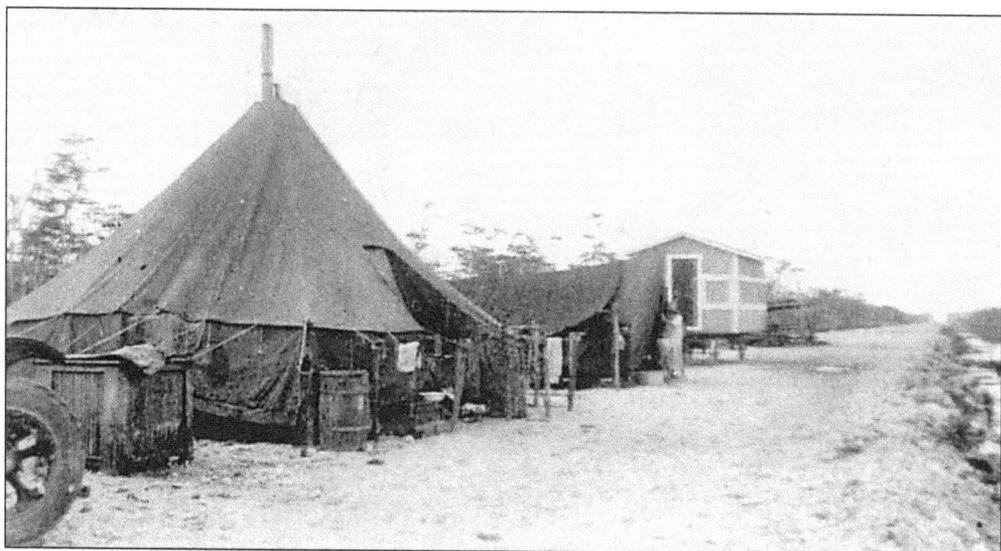

A rare 1928 photograph album put together to honor "Mr. Barron Collier and The Trail Builders" includes a collection of images most likely taken by Thomas L. Stephens, project engineer. This photograph is captioned "Far out ahead is this tent city of the Clearing Crew." After the surveyors had marked the centerline, the clearing crew was responsible for cutting a path through the Everglades using two-man handsaws and machetes.

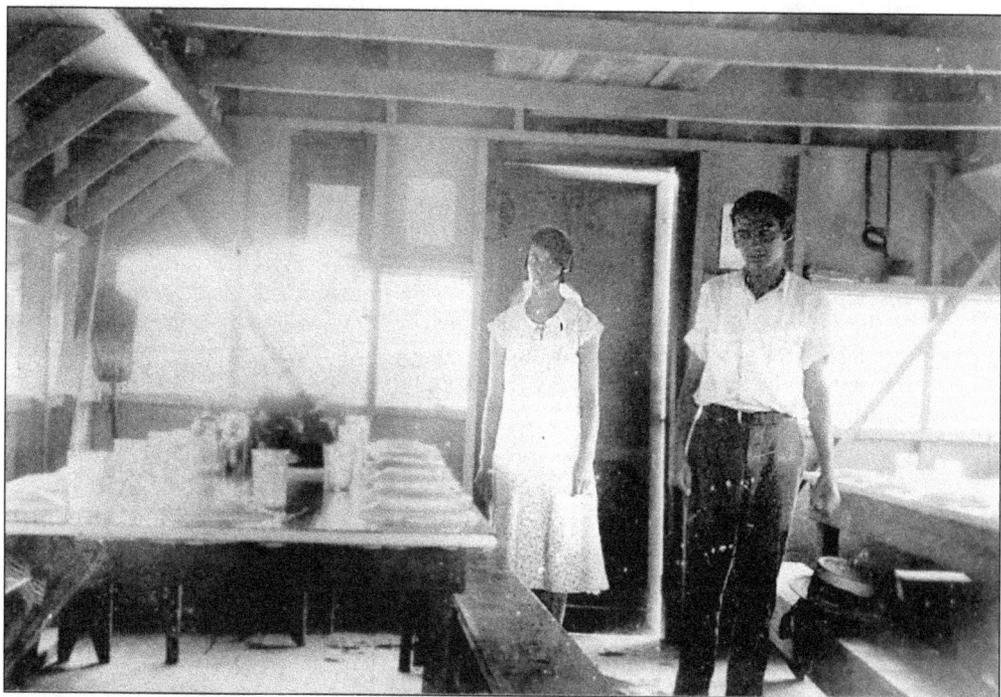

A mobile camp followed the workers and three dining cars provided meals around-the-clock. According to Bob Wilson, surveyors paid $1.25 to stay at any of the camps. Fresh food and ice, delivered daily to the camps, was supplemented by venison and wild turkey purchased from the Native Americans. This photograph was captioned in the Trail Builder's album, "Napoleon said 'An army moves on its belly.' Far more truly does this apply to the Trail Builders."

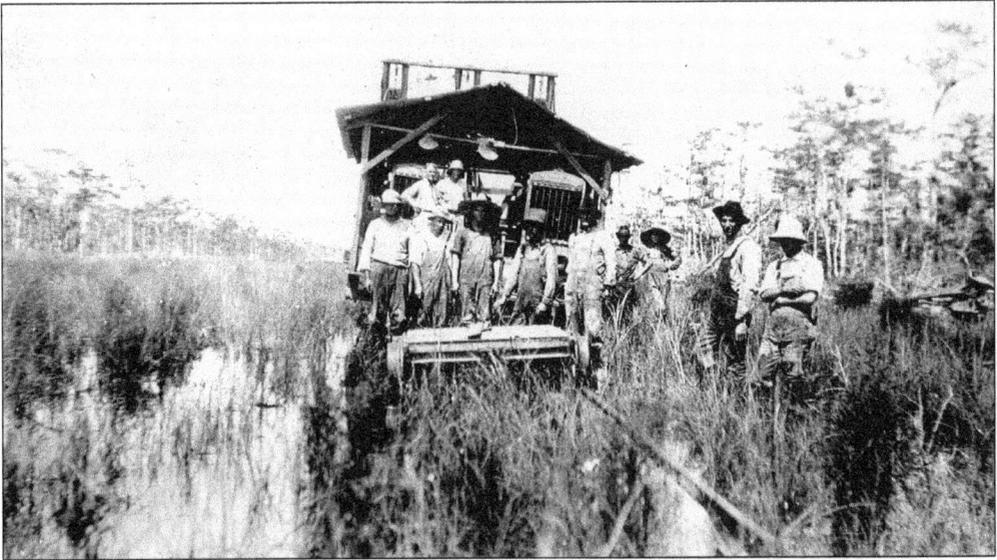

Captioned "Through muck and water 'Onward to Miami' is their cry," this photograph shows the "drillers" using a special machine designed to drill dynamite holes into the solid rock base of the Everglades. The machine was mounted on rails that were taken up and re-laid as it advanced. The drilling machine ran continuously, night and day, for 28 months, averaging about 250 feet of progress per day.

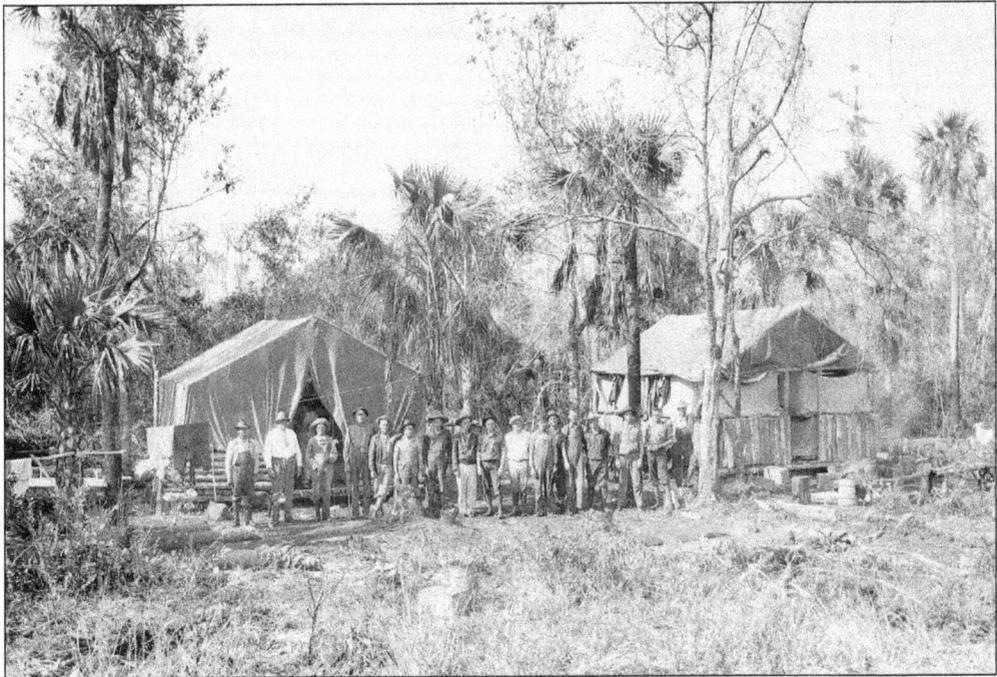

This photograph of the "blasters" camp shows the isolation of the work crews deep in the Everglades. The blasters followed the drillers, placing 10 to 40 sticks of dynamite into the holes left by the drilling machine. An entire freight-car-load of dynamite was used every three weeks for nearly three years to complete this section of the Tamiami Trail—an estimated 2,584,000 sticks of dynamite.

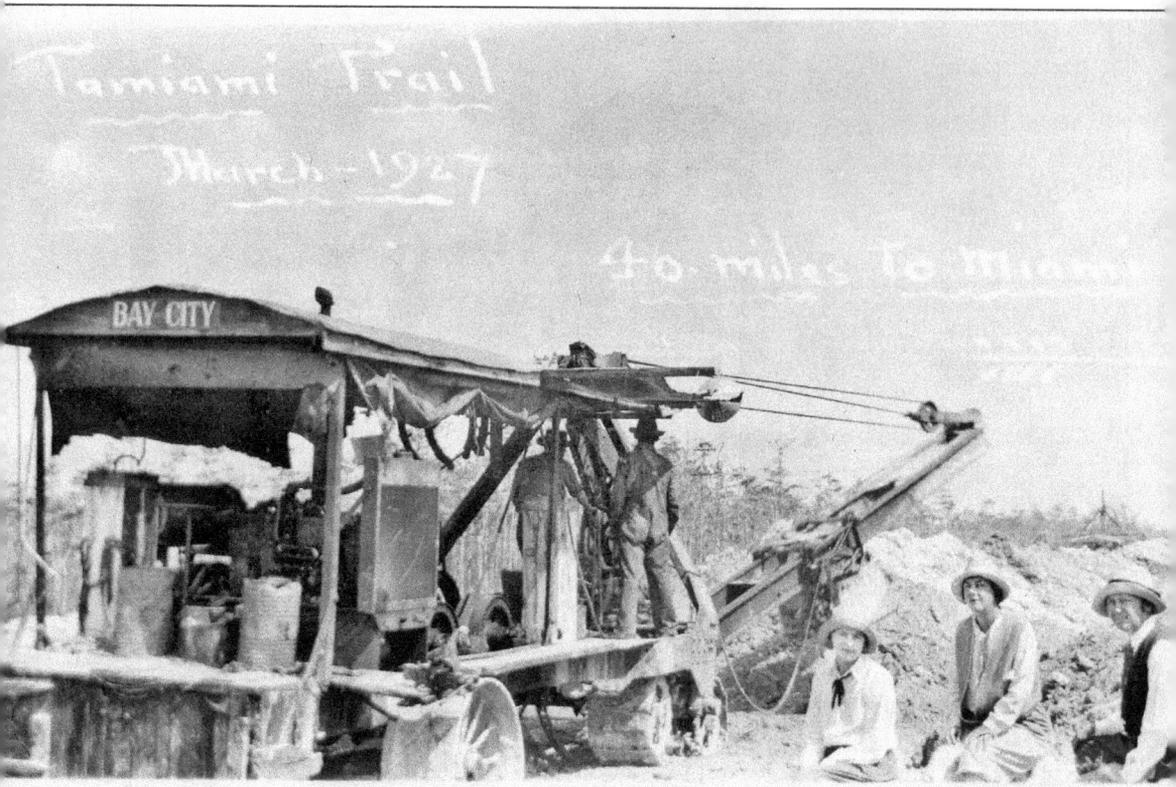

The "Bay City Dredges" followed the blasters, creating a 20-foot-wide canal as they scooped up the rocks broken by the blasters. The rocks were lifted from the canal and placed alongside to form the roadbed. The "Bay City Skimmer Scoop," pictured above, followed behind, leveling the pile of rocks left by the dredges, "doing the work of 50 men." Like the drilling machine and the dredges, the Skimmer Scoop worked night and day and was considered one of the most critical pieces of equipment on the frontlines, leaving a nearly level and drivable road bed in its wake. As the builders moved towards Miami, the cost of building the Trail steadily increased with the discovery of harder rock under the Everglades muck. The total cost of completing the last 31 miles in Collier County was almost $8 million, approximately $25,000 per mile.

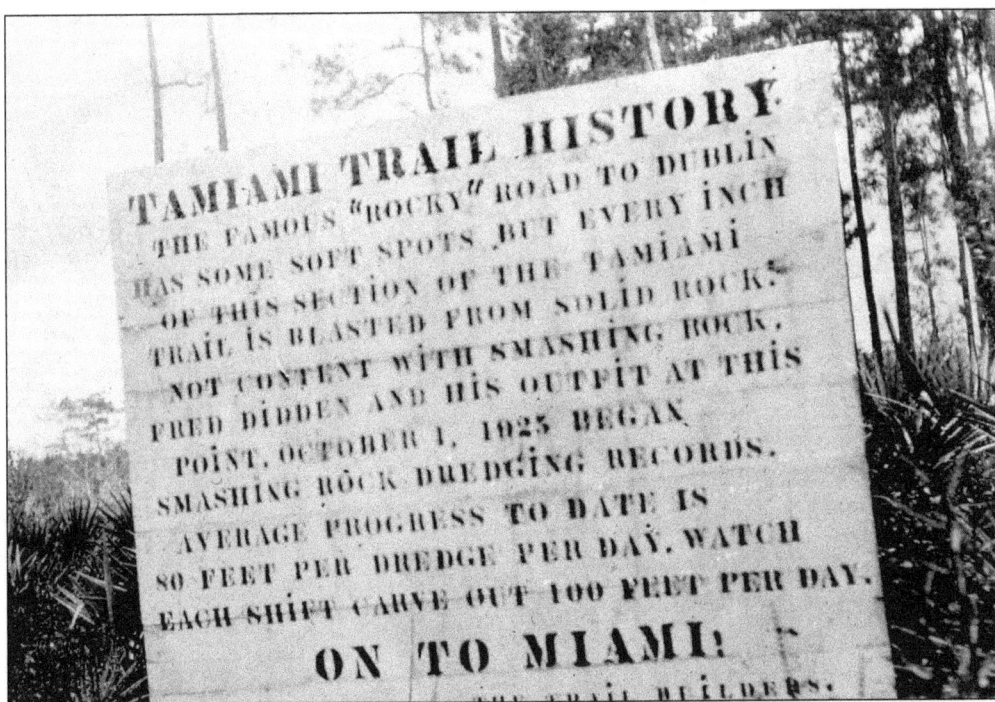

TAMIAMI TRAIL HISTORY

THE FAMOUS "ROCKY" ROAD TO DUBLIN HAS SOME SOFT SPOTS BUT EVERY INCH OF THIS SECTION OF THE TAMIAMI TRAIL IS BLASTED FROM SOLID ROCK. NOT CONTENT WITH SMASHING ROCK, FRED DIDDEN AND HIS OUTFIT AT THIS POINT, OCTOBER 1, 1925 BEGAN SMASHING ROCK DREDGING RECORDS. AVERAGE PROGRESS TO DATE IS 80 FEET PER DREDGE PER DAY. WATCH EACH SHIFT CARVE OUT 100 FEET PER DAY.

ON TO MIAMI!

THE TRAIL BUILDERS.

This "efficiency slogan" was posted along the partially finished trail. The sign was designed to encourage the workers to complete the road as soon as possible. Common laborers received 20¢ per hour, while drivers received 25¢ per hour. Surveyor Bob Wilson received $150 per month, while his supervisor received $200 per month.

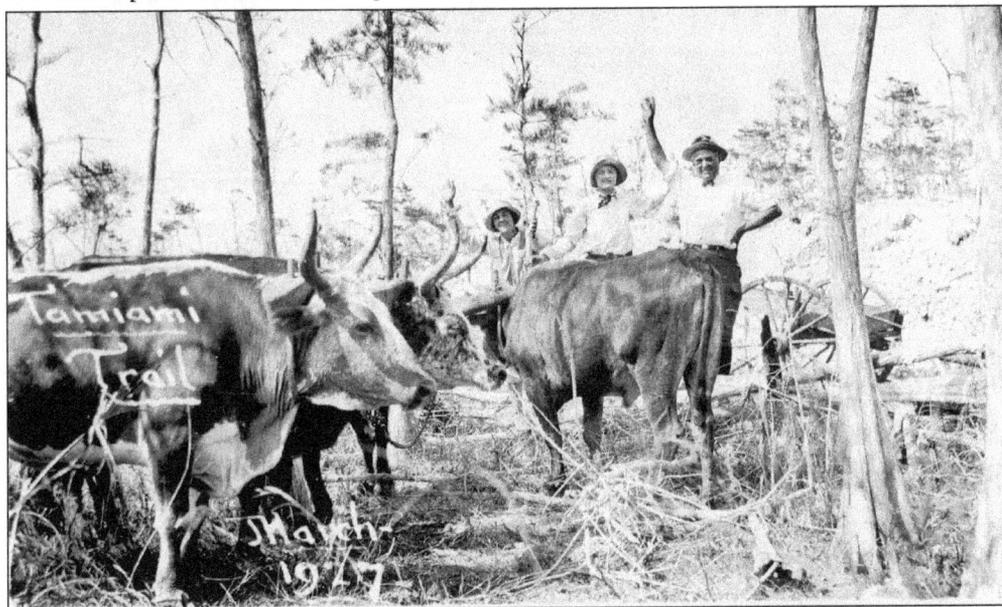

By March 1927, when John Hachmeister took this photograph, the Tamiami Trail was almost a year from completion and the drilling, blasting, and dredging crews were still moving towards Miami. Oxen were the only animals strong enough to work in the thick muck and marl of the Everglades, estimated by one engineer to be up to three feet thick in some places.

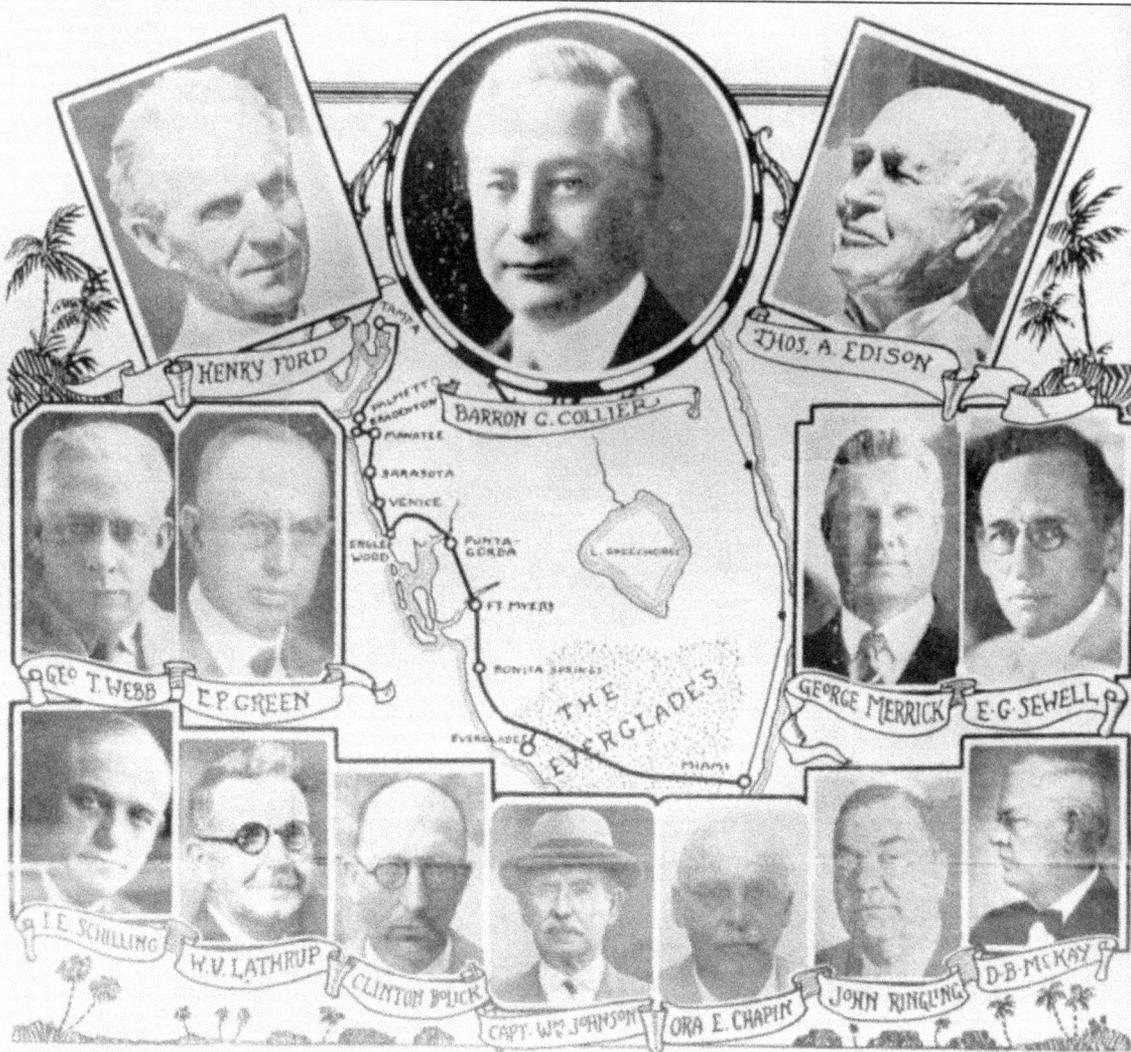

FAMOUS CROSS-STATE HIGHWAY TO BE OPENED TO TRAFFIC APRIL 25

The Tamiami Trail officially opened on April 25, 1928, nearly 13 years after construction began. This promotional flyer shows the key dignitaries responsible for sponsoring the opening celebrations, including Barron G. Collier, chairman; and Henry Ford and Thomas A. Edison, directors. Three days of celebrations began April 24, with ceremonies in Fort Myers on April 25 and a county fair at the county seat of Everglades on April 26. In a letter written on May 11, 1928, to herald Florida's new cross-state highway through the mysterious Everglades, Morgan ? wrote, "One week before the opening of the trail, I made a count of all the cars going north and south on the trail, and also a week after the opening. Three times the number of cars on the second count." Naples was now accessible by car.

78

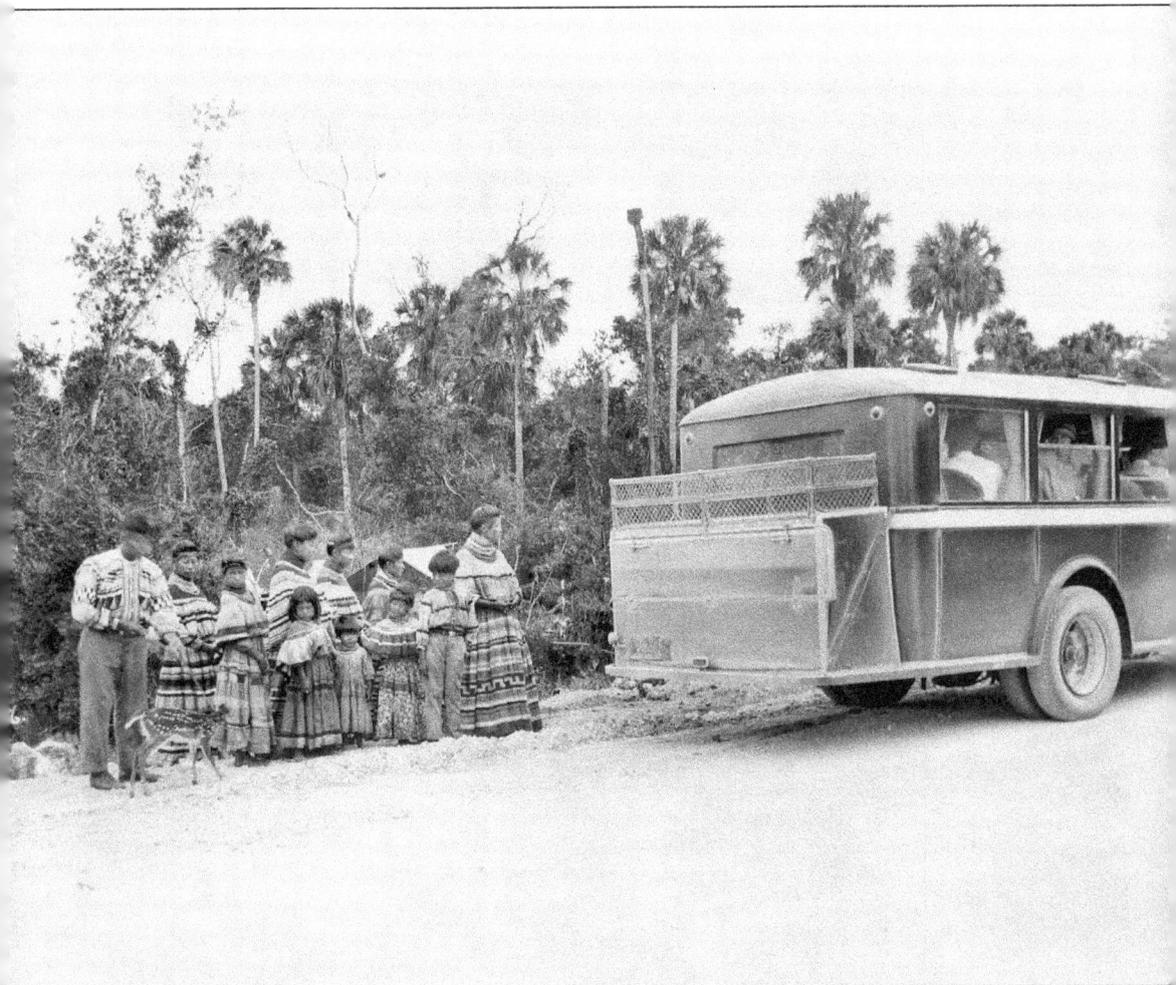

In a 1965 interview about his father, Barron G. Collier, Barron Jr. discussed the building of the Tamiami Trail: "There were many skilled engineers in those days who said building a road through the Everglades couldn't be done. I can tell you this, if my father had not managed to establish very good relations with the Seminole Indians, that road would never have been built. White men with trucks and engineers could build the road, but they couldn't clear the way for the road, and the Indians could. My father made a deal with the principle Seminole leader, Josie Billie, that when that road was built and his buses were running on it, any Seminole Indian could ride on the bus for free. And for a long time they did." Note the Seminole man on the left with a pet fawn. A special invitation was also sent to the Seminoles to attend the Tamiami Trail opening ceremonies in Everglades.

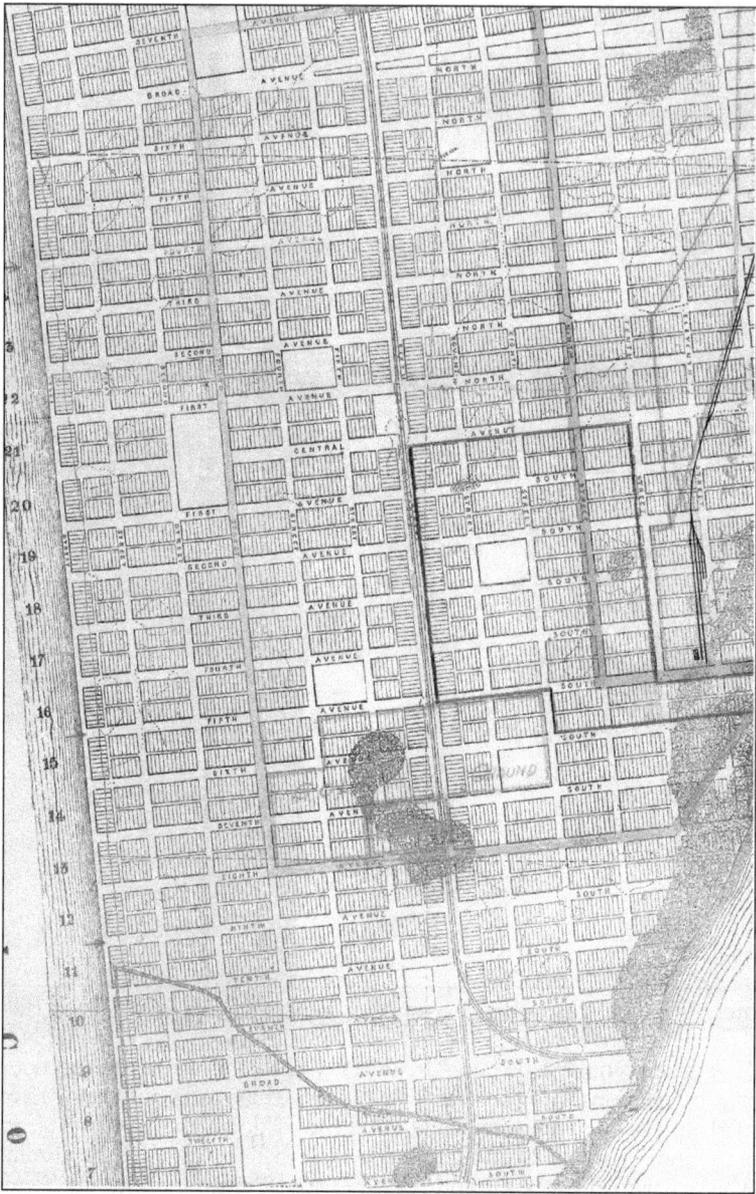

This early Plan of Naples, modified *c.* 1922 by the Naples Development Company, shows the "existing" and "proposed" Tamiami Trail routes. From the north, the original route passed along Seventh Street and turned west onto Seventh Avenue. The road then turned south onto Third Street South, with an eastward turn at Eighth Avenue South. The dogleg into the town proved unwieldy and the route was moved to its current position on Ninth Street South, with the road turning towards Miami at Fifth Avenue South. The original platting shows the beachfront "Gulf Street" and a proposed, but never-used, right-of-way area for a future railroad on Sixth Street South. The dark areas represent mangrove swamps. The Naples Hotel plot is on the lower left. Note the line near the bottom marked "Old Canal," the mysterious canal was described in the 1888 Naples Company brochure as "an excellent piece of engineering work, but by whom built, or for what purpose, is a matter of conjecture." It was filled in as a "traffic hazard" in 1934.

80

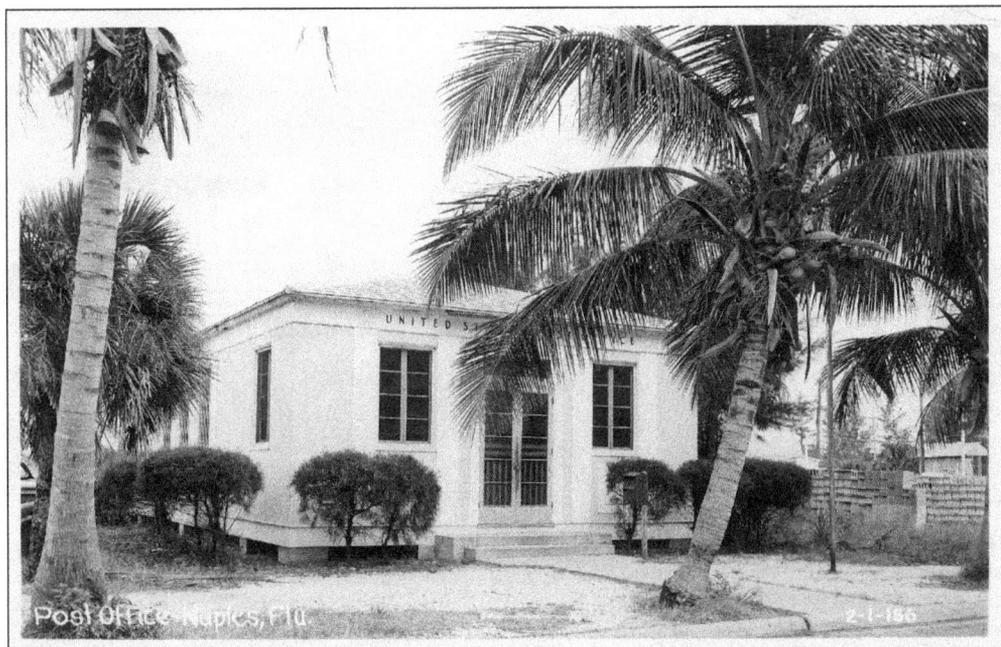

By the early 1930s, the post office was moved to the corner of Broad Avenue South and Third Street South. On the back of this postcard mailed in 1931, the writer grumpily complained, "The mail box in front of this post office needs a blueprint furnished to find where to put the mail." (Courtesy of Nina H. Webber.)

The Naples School was moved into a new building in the mid-1930s. All 12 grades were taught in the new building, which would one day become Gulfview Middle School. According to Mary Prince Evans Lipstate, who attended the new school, "We had a basketball court—this was the big athletic event at that time. The teachers still handled two grades in a room, totaling about 20 to 25 students." (Courtesy of Nina H. Webber.)

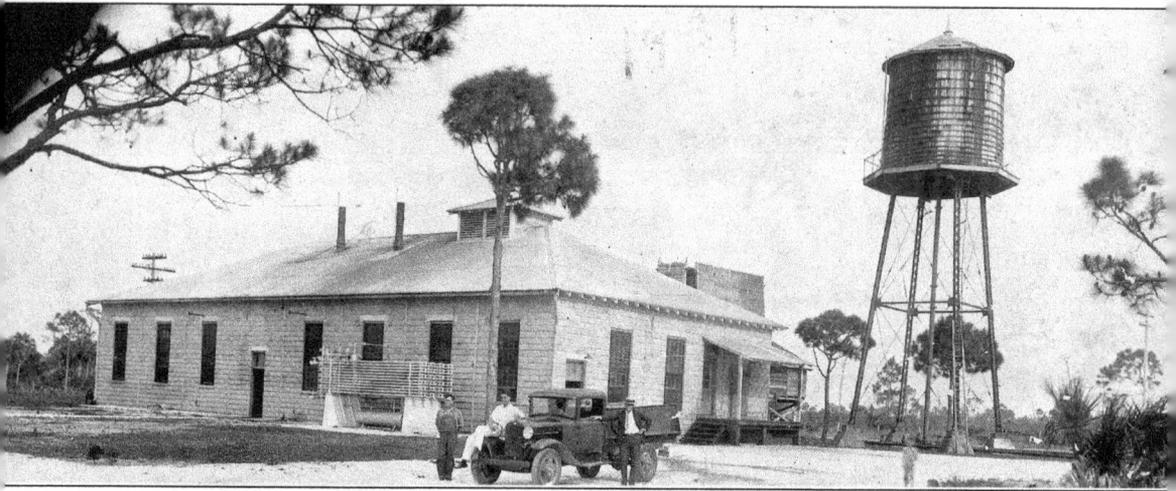

This 1931 photograph shows the Power Plant and Ice House at the corner of Tenth Avenue South and Sixth Street South. Robert Fohl Jr., who grew up in a house just two blocks away, remembered, "When we first arrived in Naples in 1925, I could not go to sleep because of the 'chug-chug-chug' of the diesel engines." Three Fairbanks-Morse engines supplied power to the town, but at 10 p.m. each evening, the lights would blink, signaling power would be turned off in 15 minutes. Florida Power and Light Company purchased the Power Plant and Ice House in 1930, and A.E. Canant was hired as manager. He married Leila Bryant in 1933, and she remembered, "The demand for electricity was almost more than those three engines could generate. I remember Canant coming home and having us turn off the stove, water heater and all unnecessary lights to try to keep the peak load from stalling the engines." The building was demolished in the early 1970s. Pictured from left to right are A.E. Canant, B.L. Williams, and D.L. Trayler.

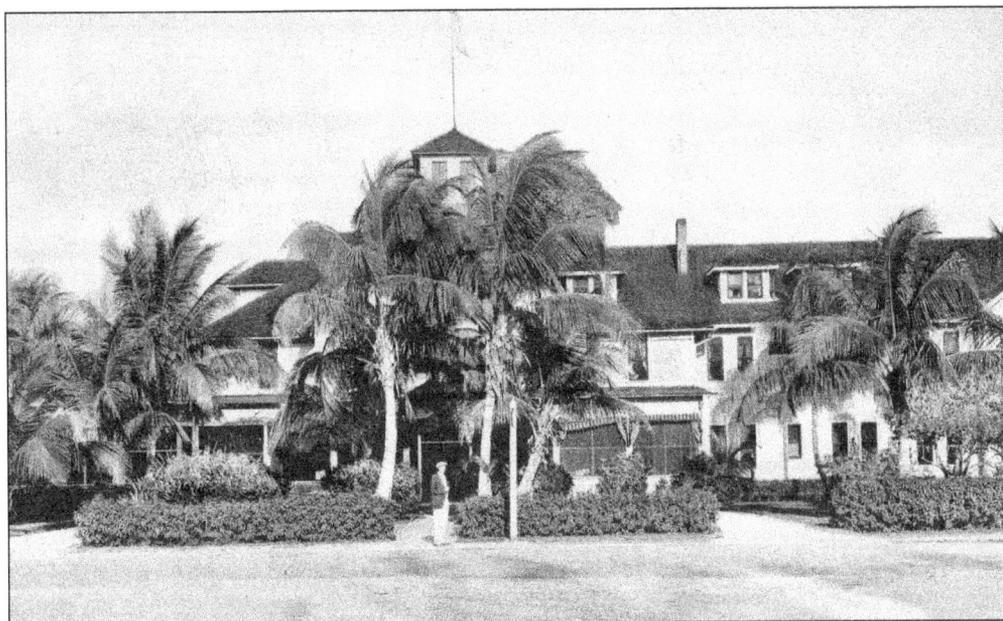

By 1939, when this postcard was mailed, the Naples Hotel lawn was lushly landscaped. On the back of this card "R" wrote, "Here for the night. 100 miles from Miami. The last place before going through the Everglades. Only 1,500 people here, but a very pretty place. Miami, tomorrow noon, I expect." (Courtesy of Nina H. Webber.)

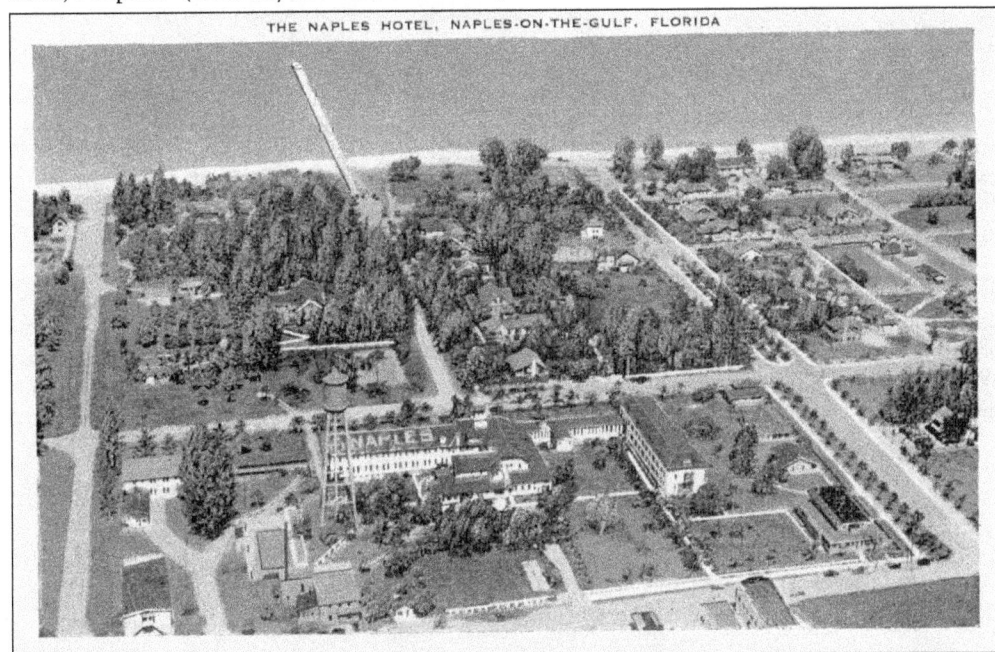

By 1926, the Naples Hotel had expanded to include another large annex to the north, visible on the right. According to J. Arthur Stewart, "When they built the northern annex, it was a full three stories high, near the corner of Gordon Drive and Broad Avenue South, right behind the Company offices," known as the Community Building or Naples Company Building, visible on the lower right. (Courtesy of Nina H. Webber.)

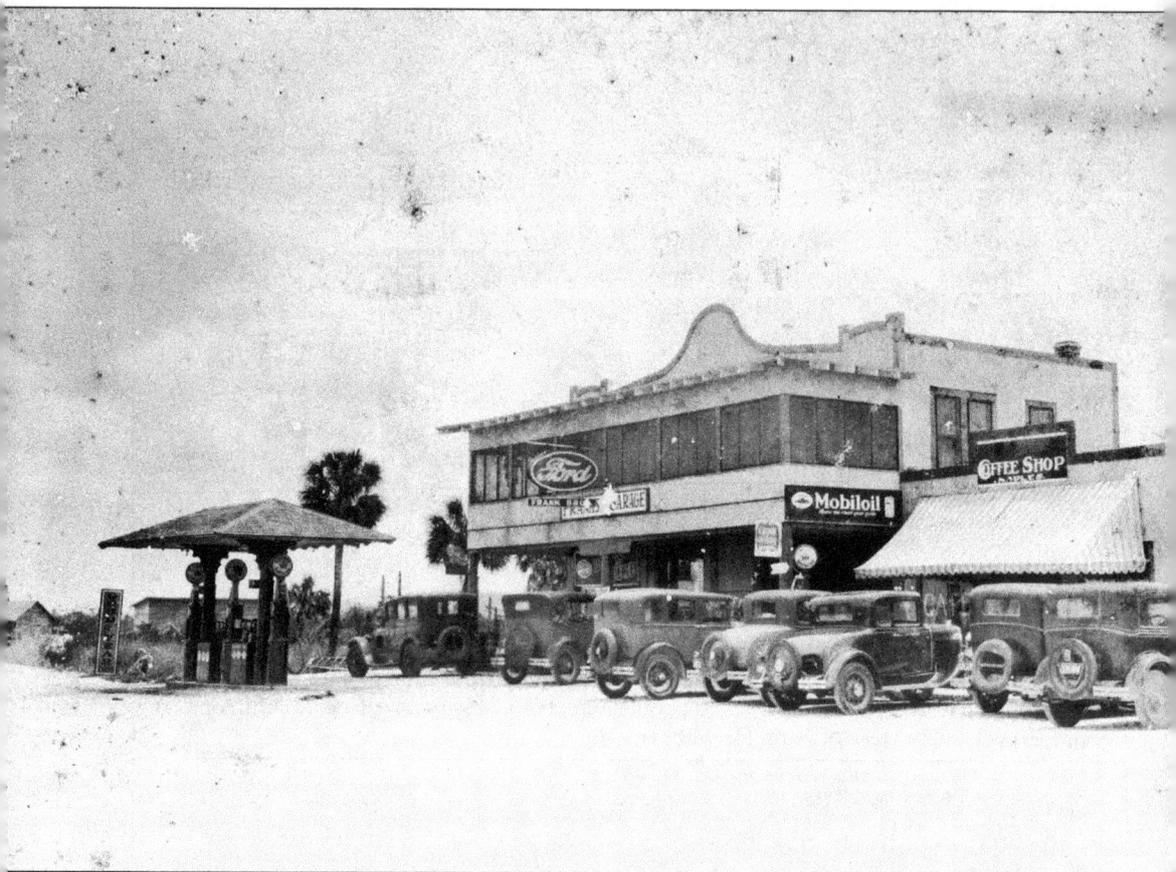

Ed Frank, an expert mechanic who would later develop the "swamp buggy," opened his first garage in Bonita Springs in 1921. By 1927, he had moved south and opened the first garage in Naples. During a 1973 interview, Frank noted, "The only lot available at the time was a gator hole at what is now the southeast corner of Eleventh Street and the Trail. I had to bring in four or five feet of fill before we could start construction. Even after we completed our garage in 1927, my wife could feed the alligators by throwing bread out of our west window on the second floor. Later, we filled in the rest of the gator hole." Frank's Garage was the first commercial building on the Tamiami Trail in Naples. With the increase in traffic after the opening of the Trail in 1928, Frank opened an attached coffee shop in 1931, the first restaurant on this portion of the new highway. The coffee shop is visible on the right.

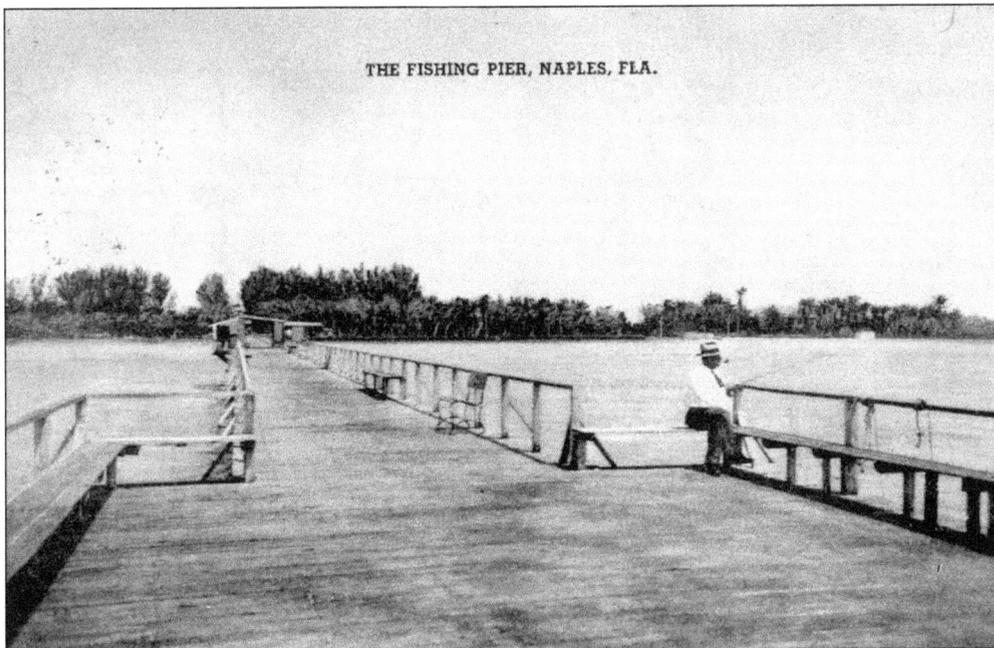

THE FISHING PIER, NAPLES, FLA.

The pier, now dubbed the "Fishing Pier," continued to be a popular place for fishing and swimming. On the back of this postcard written on March 10, 1941, a visitor wrote, "This is the pier on which Dad does most of his fishing. He helped pull in a 350-pound black sea bass (Jewfish). They used block and tackle to land it." (Courtesy of Nina H. Webber.)

In the 1920s and 1930s, the pier offered a diving board for swimmers. According to early Naples resident Merle Surrency Harris, "There was a diving board and ladder about halfway down the length of the pier. This was worn slick from use by young swimmers. A drop dock at the head of the pier, served as a loading dock at low tide, or a place for lovers to hold hands at night."

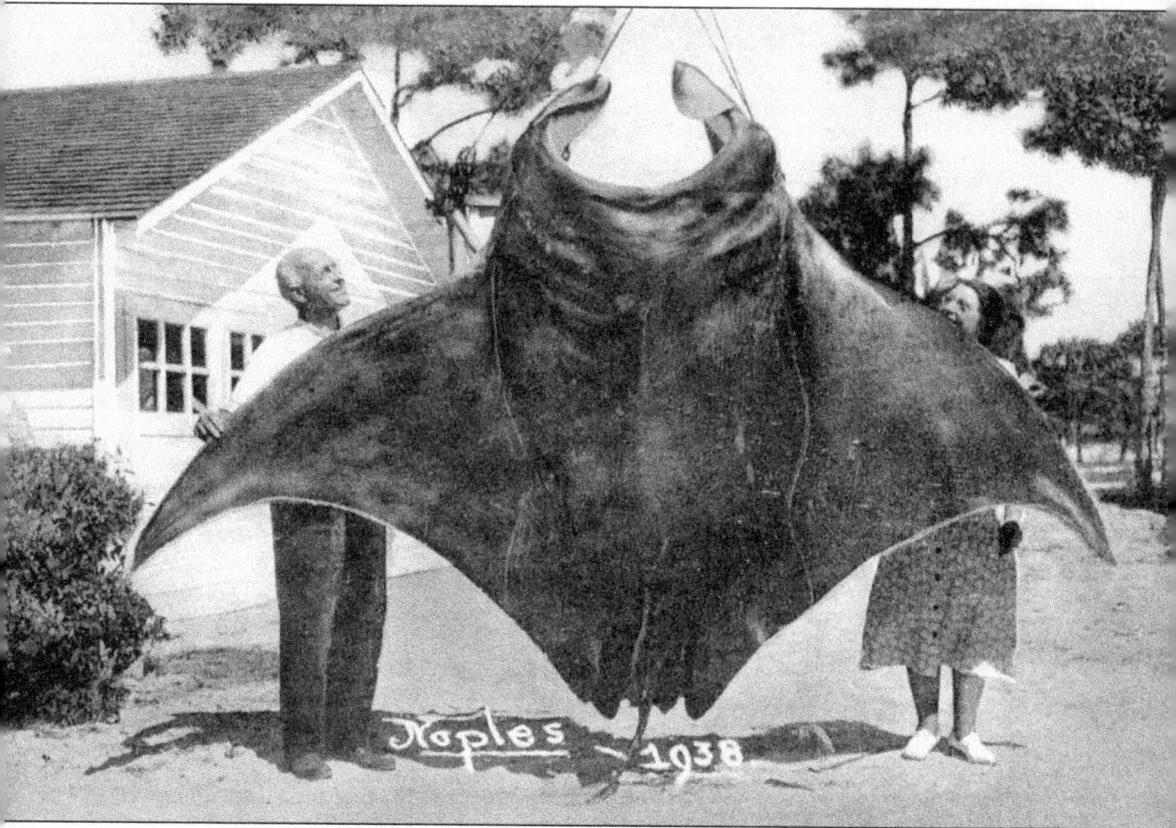

In this 1938 postcard, Dr. Earl Baum and his wife, Agnes, stand next to a large manta ray, captioned on the back as "Devil Fish, weight 1,200 pounds, caught by Dr. Earl L. Baum. Guide, Forrest Walker, Naples Florida." Dr. Baum first visited Naples in 1922 after reading an article in *Field and Stream* about a man who had caught 32 varieties of fish during a two-week stay in Naples. He told Ed Crayton at the Naples Hotel his visit was for only one purpose—"to fish." During his first fishing trip, with Willie Tomlinson as his guide, he recalled, "By the time we reached Gordon Pass, we had 29 fish, all caught trolling with an old Wilson spoon about the size of your hand. I don't believe there was one fish that weighed under five pounds. The cost for the entire day was $15." (Courtesy of Nina H. Webber.)

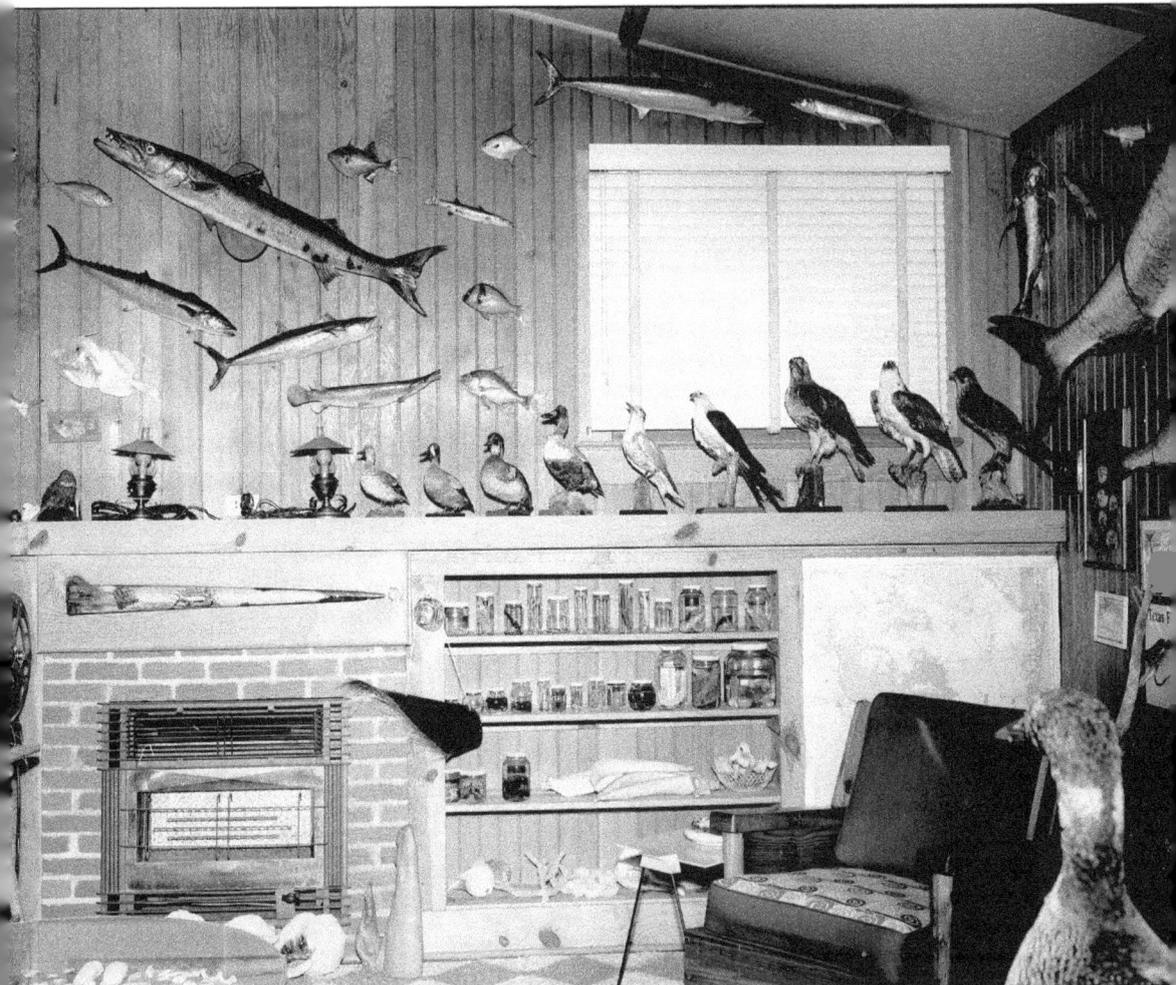

Dr. Baum was also an avid hunter and during his first visit in 1922 he killed an alligator, which he had mounted by a taxidermist in Fort Myers. The specimen attracted so much interest in his Milwaukee office that he decided the next year to begin collecting one "of every different kind of bird, fish, reptile, etc. I could find in Collier County." He eventually collected more than 180 specimens, which were displayed in a specially designed trophy room in his Naples house, built in 1947. This photograph shows just a small portion of the trophy room, with Dr. Baum's movie projector on the left. Also an avid photographer, Dr. Baum eventually filmed an estimated 6,000 feet of movie footage in Naples in the 1920s and 1930s, including a 1931 melodrama called *Naples-on-the-Gulp*, which he described as "a party typical of prohibition days, where booze was poured from a hip flask into coffee mugs."

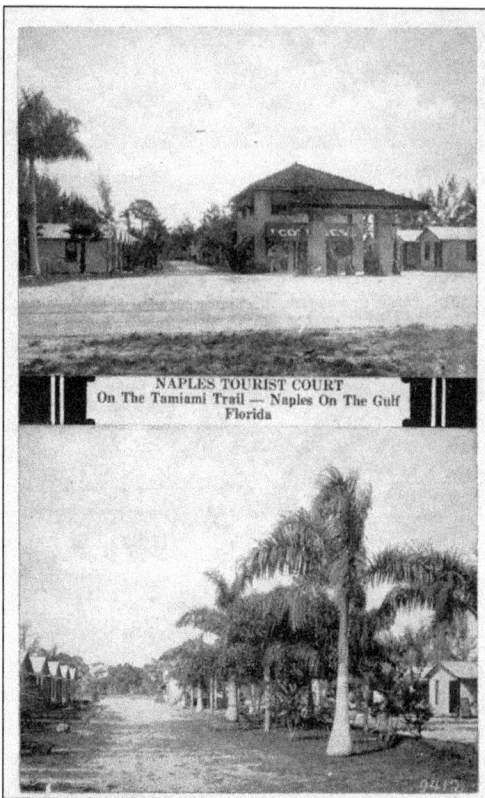

NAPLES TOURIST COURT
On The Tamiami Trail — Naples On The Gulf
Florida

With the opening of the Tamiami Trail in 1928, the business district of Naples slowly began to move from the Naples Hotel area, once the center of town, towards the new highway. In 1932, the hotel faced new competition from the Naples Tourist Court and the Naples Trailer Court, both located on the highway and appealing to a new type of visitor traveling by car. According to the captions on the back of these c. 1935 postcards, the Naples Tourist Court offered, "26 clean, modern, gas heated cottages. Every room with private bath and gas cooking equipment. Excellent fishing and swimming." (Courtesy of Nina H. Webber.)

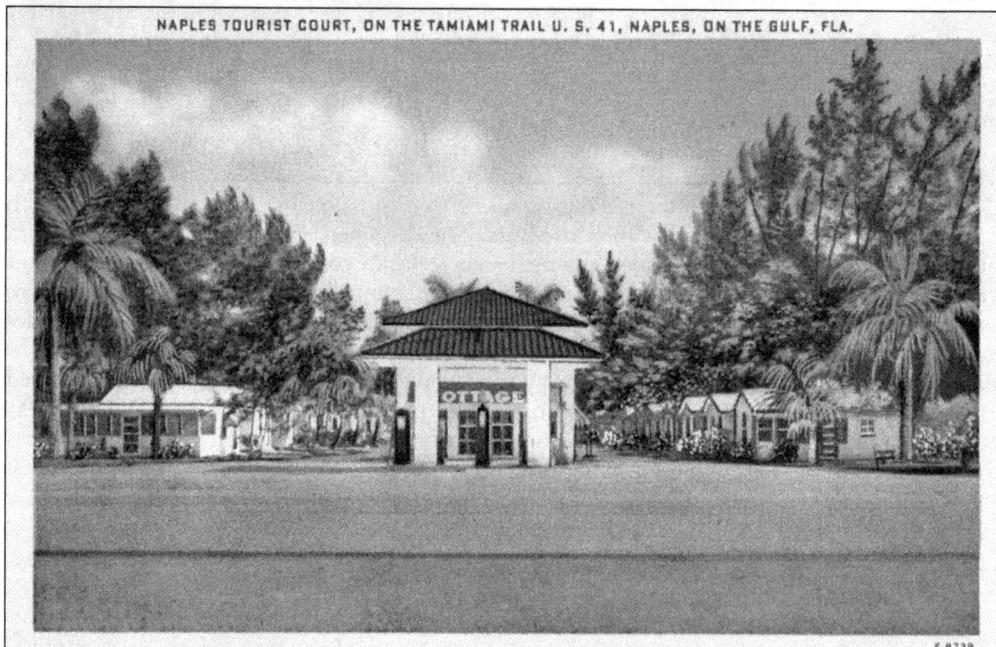

NAPLES TOURIST COURT, ON THE TAMIAMI TRAIL U. S. 41, NAPLES, ON THE GULF, FLA.

E-8739

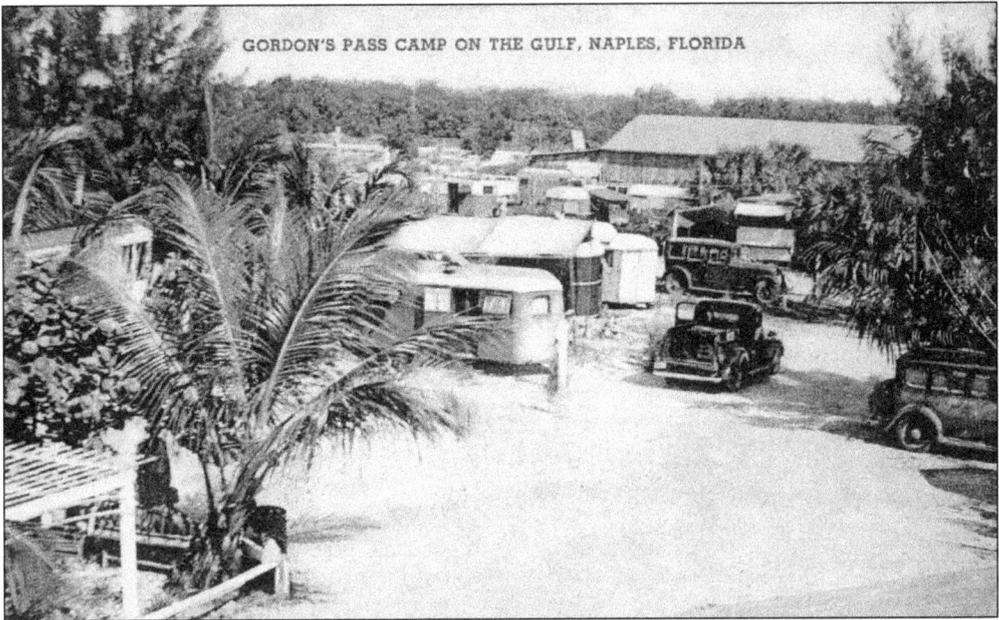

GORDON'S PASS CAMP ON THE GULF, NAPLES, FLORIDA

Despite the Depression, the appealing winter climate of Naples continued to attract visitors and by the 1930s the town offered a growing number of tourist and winter season visitor accommodations, including the Gordon's Pass Fish Camp, located at the southern tip of the Naples peninsula. Once the site of squatter Roger Gordon's fish camp in the 1870s, the new Gordon's Pass Fish Camp offered easy access to both the Naples Bay and the Gulf. The caption on the back of the top post card states, "Gordon's Pass Tourist and Fishing Camp—on the Gulf at South Naples, Florida. A good place to fish. Guide boats, cabins, boats, camp space, bathing, shelling on the Gulf. B.J. Schoentag, Prop." By the 1950s, the camp included approximately 40 travel trailers, three mobile homes, plus an office building, showers, and restroom facilities. (Courtesy of Nina H. Webber.)

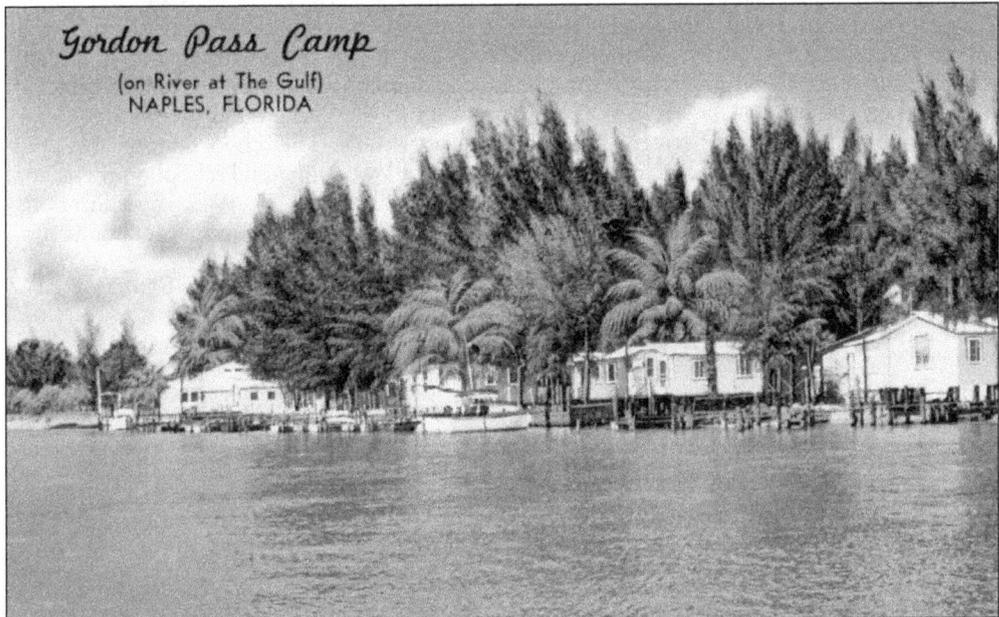

Gordon Pass Camp
(on River at The Gulf)
NAPLES, FLORIDA

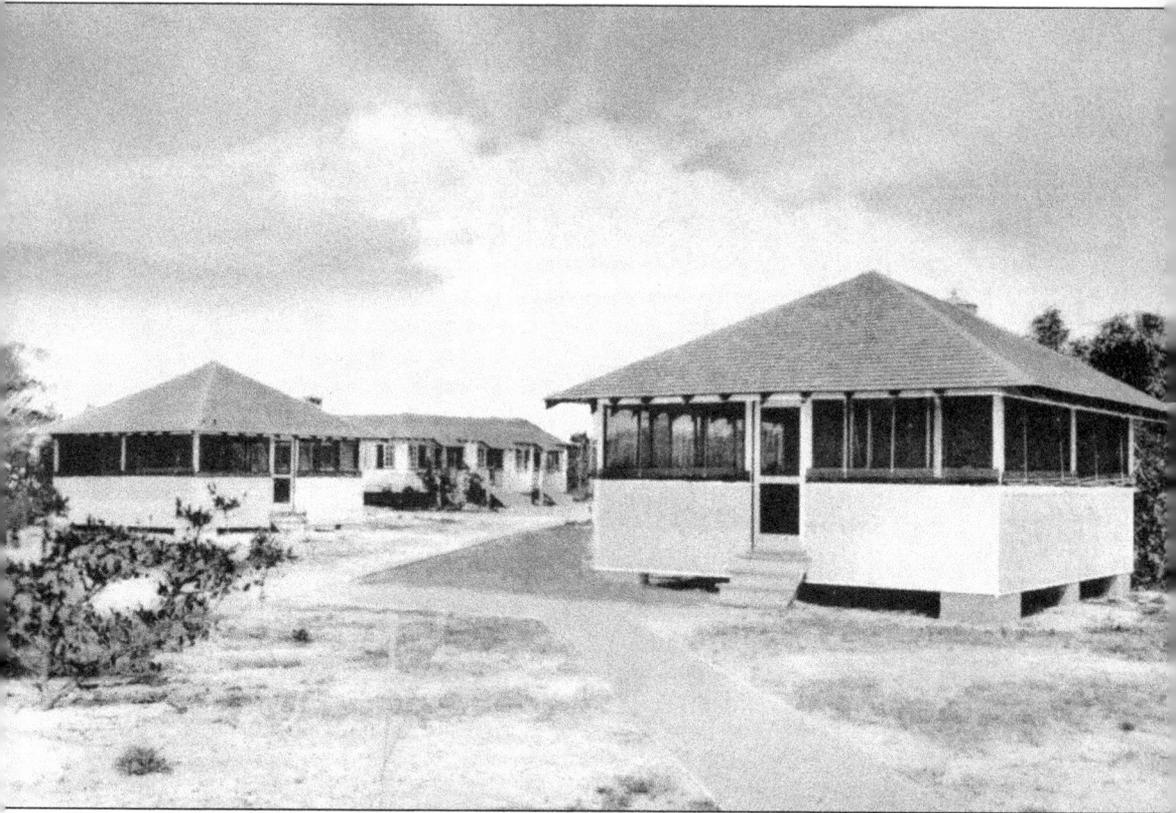

In 1934, Chestman Kittridge, a member of the Board of Directors of the Keewaydin Camps, proposed a Keewaydin Camp in Florida. The first Keewaydin Camp, a name taken from Henry Wadsworth Longfellow's "Song of Hiawatha," was held in Maine in 1894 and offered a summer wilderness camping experience for boys; by the early 1930s 14 Keewaydin camps were scattered throughout the United States and Canada. Kittridge selected a site on a sandy barrier island on the southern side of Gordon's Pass and designed his winter camp as a "club" where children of parents wintering on the island could attend school. In this c. 1938 postcard, captioned on the back, "Class Rooms, Girls Dormitory in the background, Keewaydin Camp, Naples, Florida," both of the screened-in classrooms are visible. The school concept was not a success and eventually a few children from Naples were allowed to attend school on the island, transported across Gordon's Pass onboard the club ferry *Kokomis*. By 1943, the educational program was discontinued and the buildings were converted to guest accommodations. (Courtesy of Nina H. Webber.)

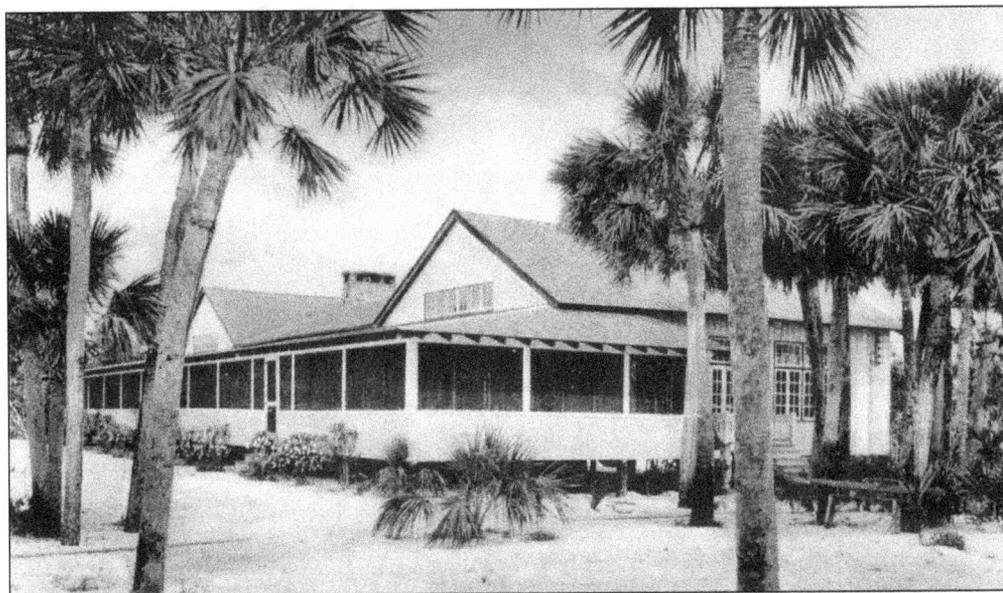

This *c.* 1938 postcard shows the Main Lodge of the Keewaydin Club. According to Gladys Schlesinger, who visited the club in 1938, "The Main Club House had a large screened porch across the front, lined with the proverbial 'Resort Rocking Chairs,' and a ping pong table at the south end. It also had a separate dining room for children with nurses." (Courtesy of Nina H. Webber.)

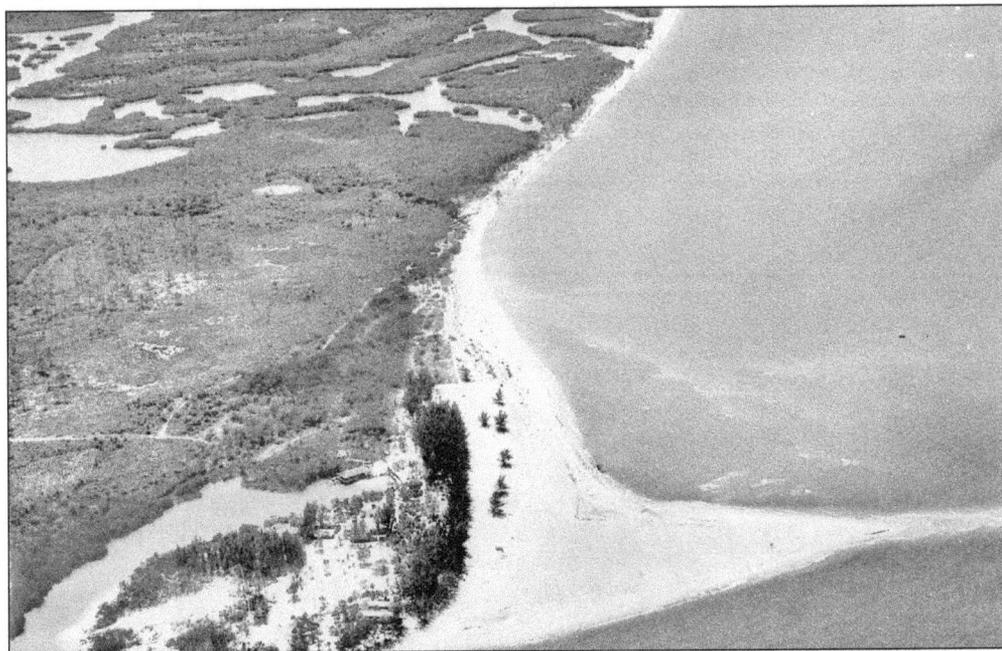

This aerial photograph shows the Keewaydin Club *c.* 1960, after Hurricane Donna moved new sand to the northern tip of the island. The first club buildings are barely visible under the Australian Pines. The Gordon Pass Fish Camp was located on the other side of Gordon's Pass. During World War II, a lack of supplies, including limited gas for the ferry, forced the use of smaller powerboats, which landed at the Gordon Pass Fish Camp.

On the back of this postcard mailed in 1941 and captioned "View from Dining Room, Keewaydin Club," a club guest wrote, "This is the place to come to do nothing. I spend my time reading and knitting while Pere fishes for tarpon with no luck yet." During World War II, all the cottages were required to have blackout curtains on windows facing the Gulf. According to early guests Gladys Schlesinger and Sping and Lucy Mead, authors of the *Early History of Keewaydin Club*, "The few guests who continued to come to Keewaydin during those years were obliged to get permits from the Coast Guard to leave the mainland! These were in the form of cards carrying fingerprints and pictures, and we were obliged to have them with us whenever we left the island and especially when taking a fishing trip." (Courtesy of Nina H. Webber.)

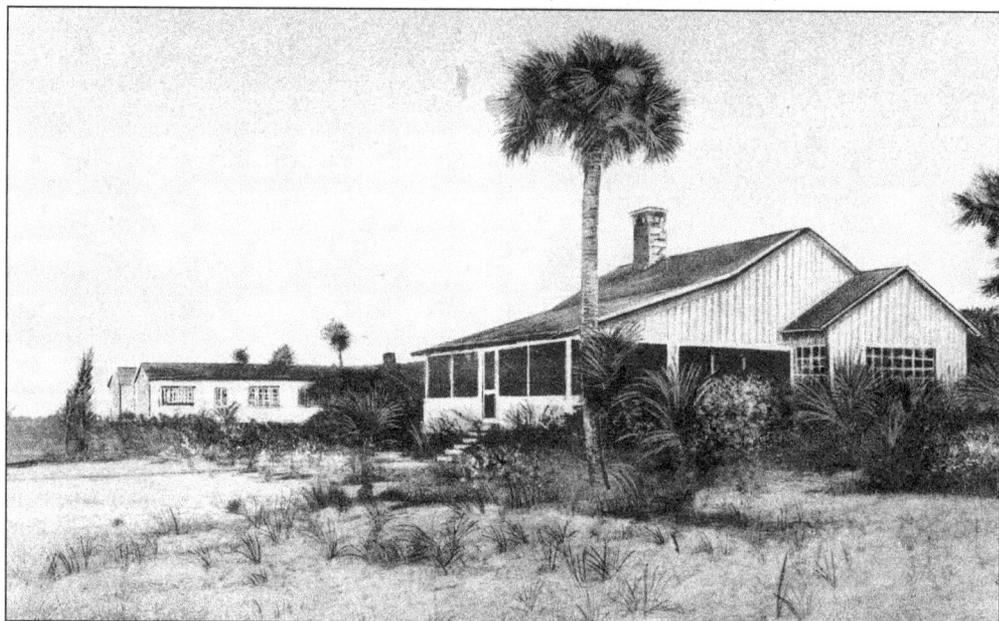

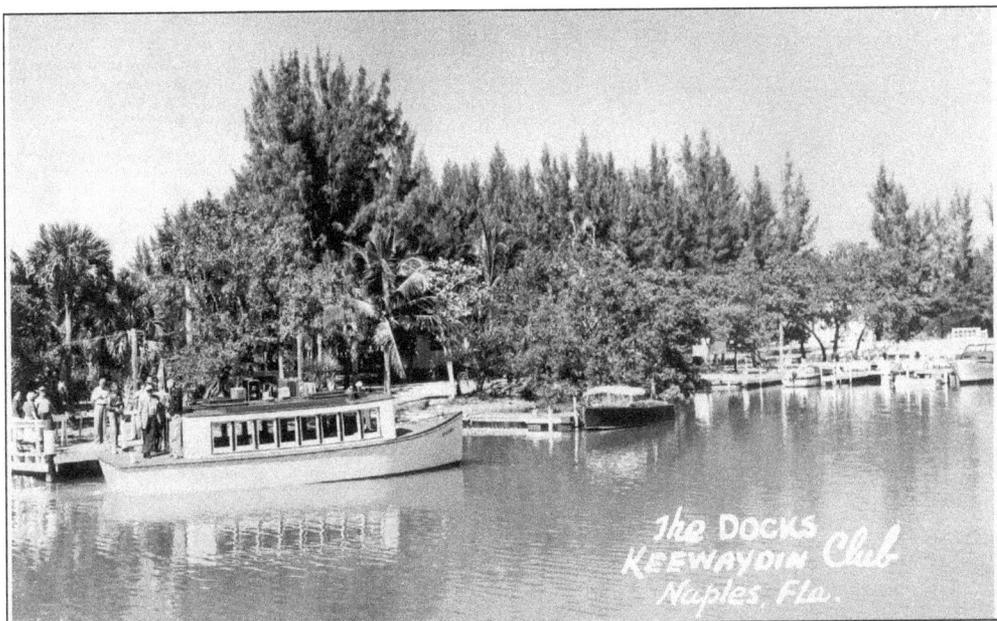

This c. 1950 postcard shows *Kokomis*, the Keewaydin Club ferry. Chestman Kittridge, owner and builder of the club, admired the flat-bottomed boats used at Silver Springs in Ocala and commissioned Walter Surrency to build a similar boat to transport guests across Gordon's Pass. Surrency, along with his son, Albert, built the boat out of yellow pine (dubbed "Florida mahogany" by the early pioneers). It was launched in 1935. (Courtesy of Nina H. Webber.)

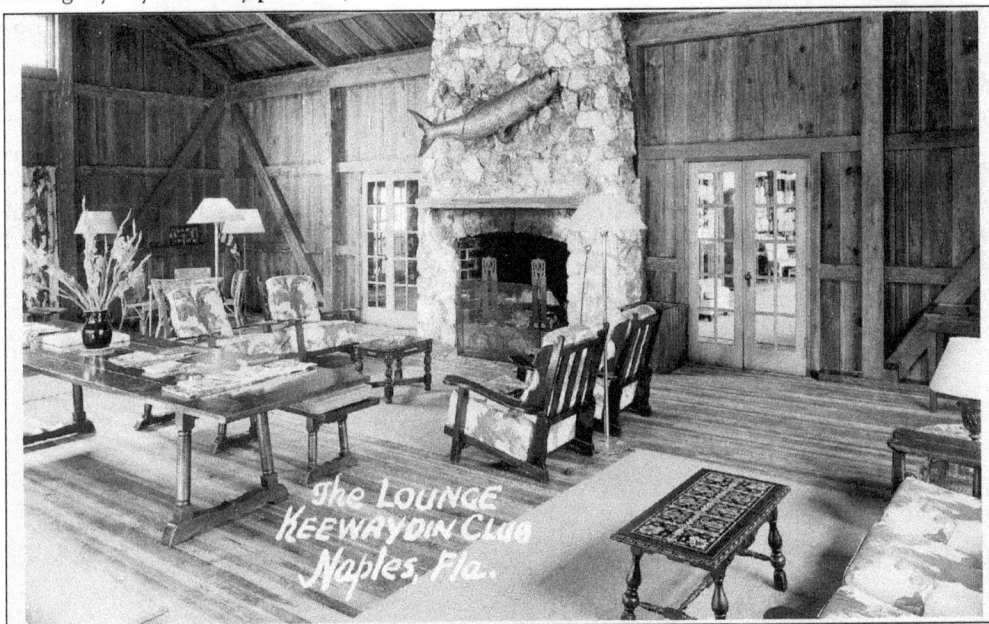

In 1945, the Keewaydin Club was sold to Lester and Dellora Norris, who steadily improved the resort. By the 1950s, the lodge included a lounge or great room, library, dining room, kitchen, chef's quarters, and manager's office. On the back of this postcard mailed on March 12, 1954, a guest wrote, "Hope you weren't too disappointed! The Club is full! It's a five mile drive and 15 minute ferry to Keewaydin." (Courtesy of Nina H. Webber.)

Beach Club - 45

Allen Joslin's Beach Club opened in 1931 to serve as the clubhouse for the new 18-hole golf course. The second-floor meeting room often doubled as a dance floor, and according to Lucy Storter, "The Naples High class of 1939, all five strong, had a wonderful Senior Prom. This, my first dance, was held at the Beach Club." In 1946, Henry B. Watkins Sr., W.D. McCabe of Columbus, Ohio, and several other partners purchased the assets of the Naples Improvement Corporation, the Naples Development Company, and the Naples Tropical Realty Company, which included the Naples Hotel, and formed a new Naples Company. At the suggestion of Watkins, an avid golfer, the partners announced plans to renovate both the Naples Hotel and the newly acquired Beach Club.

The Beach Apartments were built by Larry McPhail, former general manager of the New York Yankees, c. 1948, and were eventually acquired by the Naples Company. The Naples Company also remodeled the old Joslin clubhouse and added 70 rooms to accommodate prospective property buyers. In January 1949, the company announced a "Gala Opening" in the *Collier County News* to celebrate the "newly decorated club and the recently completed apartments." In April 1949, a room with a double bed cost $6 per night, a room with twin beds cost $8, and a one-room kitchenette apartment cost $10.

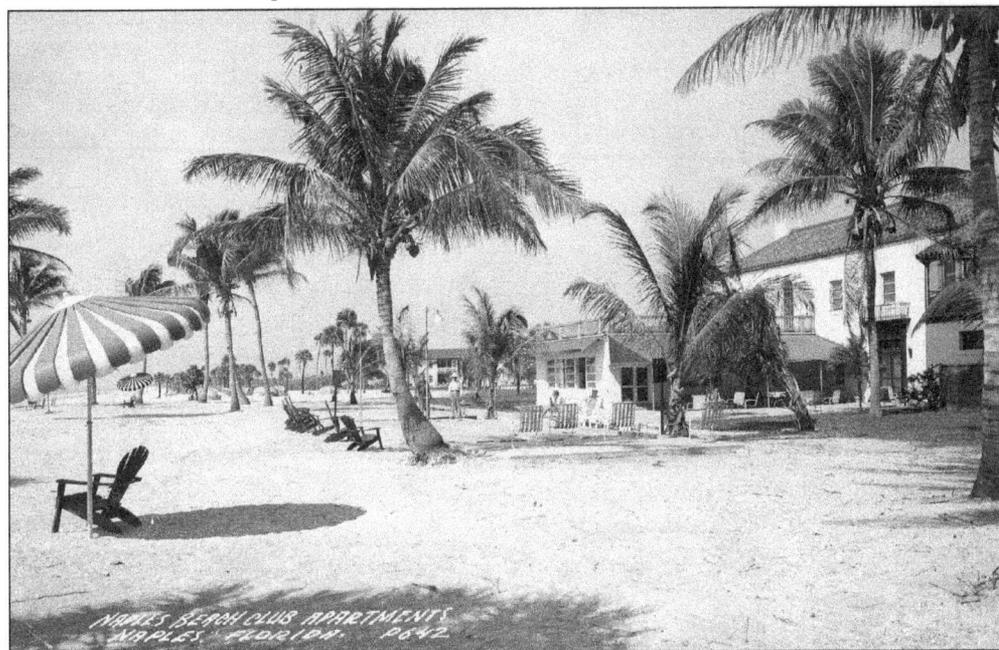

NAPLES GOLF AND BEACH LINKS, NAPLES, FLA.

On the back of this postcard mailed on March 9, 1942, a visitor wrote, "We are now addicted to bridge and cocktail parties." After completely renovating and redecorating the Naples Hotel in 1946, the Naples Company began updating the Beach Club, and an article in the November 7, 1947 issue of the *Collier County News* reported, "The Naples Golf and Beach Club is next in line for renovation and the Naples Company will be rebuilding two fairways and installing an automatic sprinkler system covering all the more arid spots. An additional skeet range will also be added." (Courtesy of Nina H. Webber.)

Four

A CITY FOR
ALL SEASONS

The tourist industry began to slowly recover after World War II and on November 7, 1949, the *Collier County News* reported, "The last 18 months have resulted in a post-war burst of activity." Even the traditionally slow summer season was busy that year, and the newspaper noted, "more than 1,000 tourists poured into Naples for the 4th of July holidays, the biggest in history." (Courtesy of Nina H. Webber.)

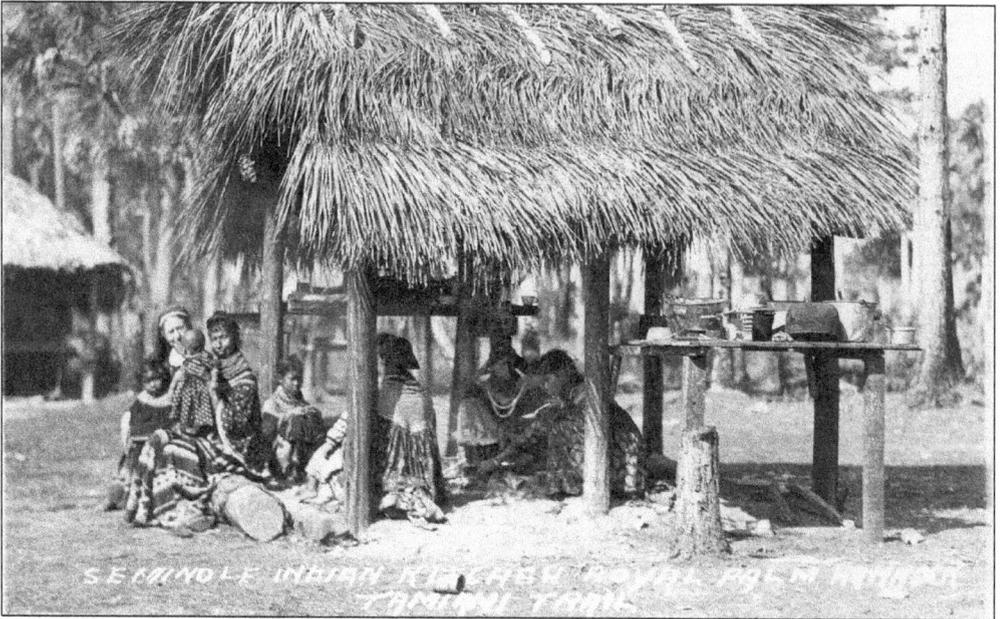

Deaconess Harriet M. Bedell, an ordained Episcopal minister, was nearly 60 years old when she moved to Collier County in 1933. Pictured on the left, she re-established the Glades Cross mission in Everglades and regularly visited all the Seminole villages in Collier County, teaching basic medicine to the native families. She often transported sick children to hospitals in Miami or Fort Myers, traveling on the Tamiami Trail in her Model T Ford. (Courtesy of Nina H. Webber.)

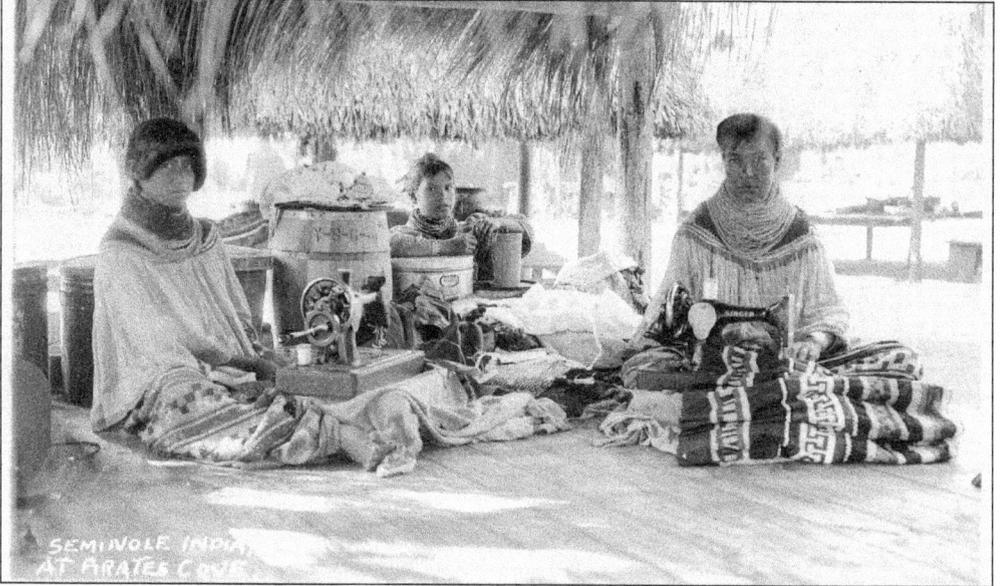

Deaconess Bedell encouraged the Seminoles to preserve their traditional crafts, including the production of their highly decorated patchwork clothing, wood carvings, and dolls, and coordinated the sale of these items to winter visitors as a way for the Seminoles to earn money. This 1930s postcard shows Seminole women using hand-cranked sewing machines to produce the patchwork. (Courtesy of Nina H. Webber.)

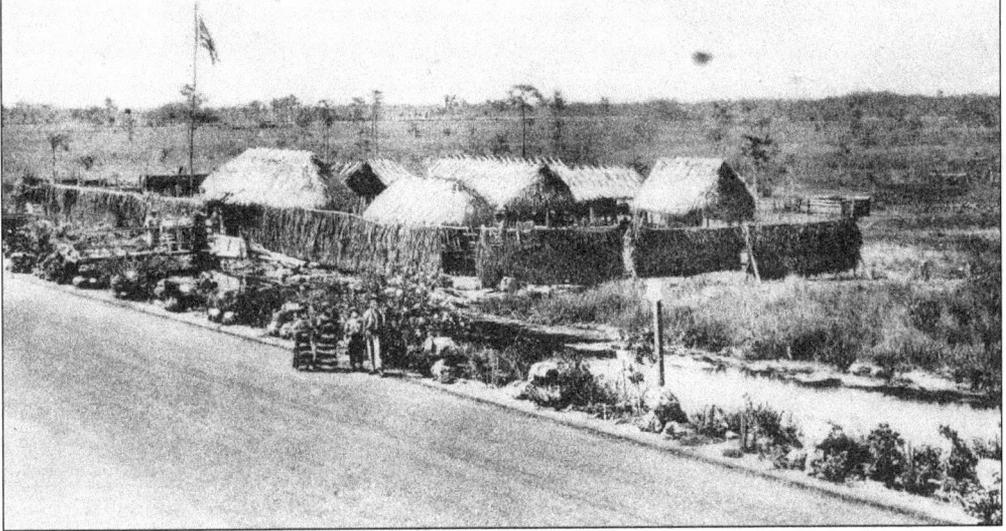
Seminole Indian Village near Naples, Florida

The Tamiami Trail opened the land of the Seminoles to a new touring public, and in 1928, Rev. James A. Glenn stated, "Their own private folkways have a cash value that must be bewildering to the Seminole." Villages were opened as tourist attractions, featuring alligator wrestling and displays of "typical" Native American life. Deaconess Bedell vehemently opposed these tourist villages as demeaning to the Seminoles, and even presented her case to the Miami Woman's Club, hoping to gain their support for stopping the practice. She did not succeed, but continued to encourage the production of native crafts as an alternative way for the Seminoles to earn money. (Courtesy of Nina H. Webber.)

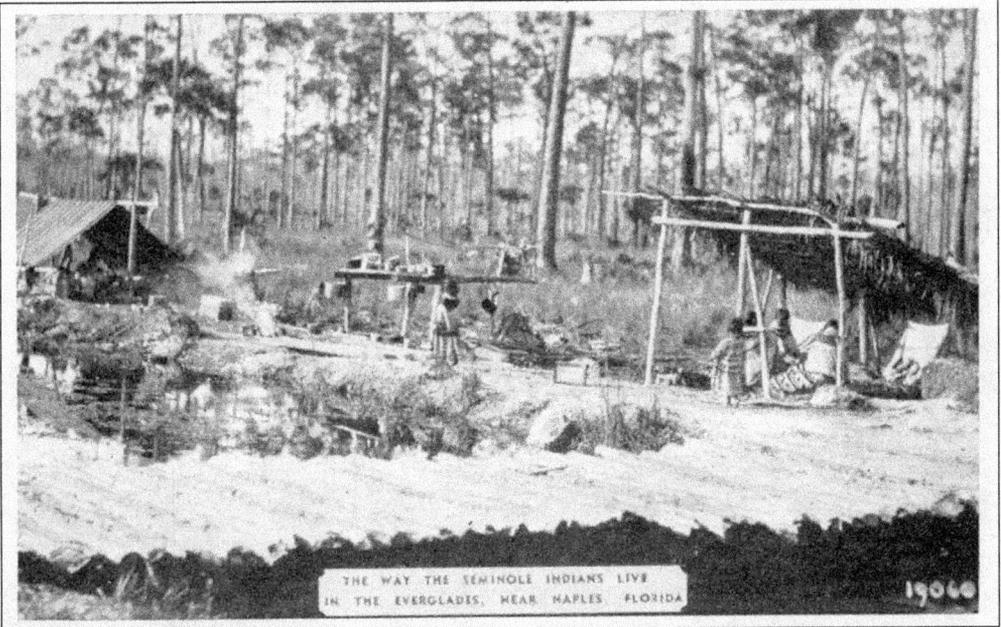
THE WAY THE SEMINOLE INDIANS LIVE IN THE EVERGLADES, NEAR NAPLES FLORIDA

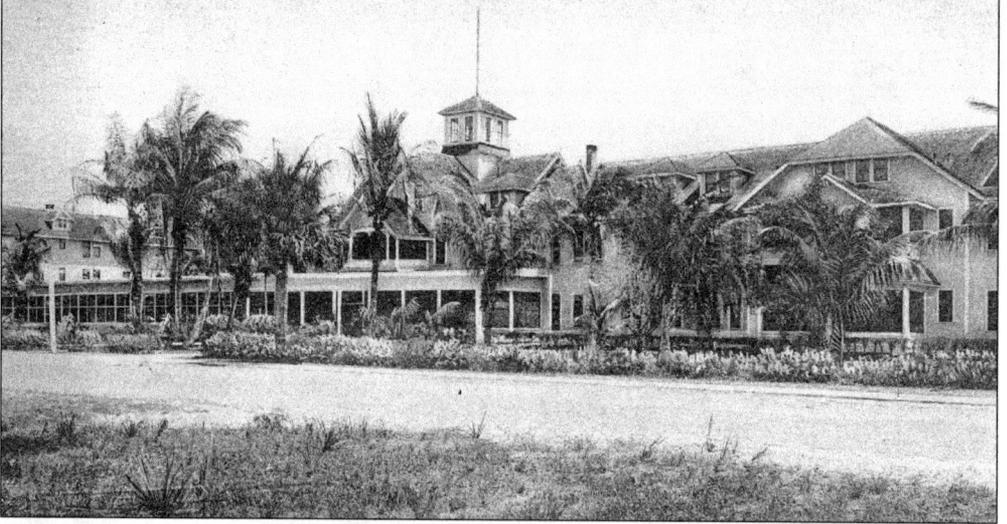

THE NAPLES HOTEL, NAPLES, FLA.

After its 1946 renovation and redecoration, management of the Naples Hotel announced plans to operate the hotel year-round. By this time, the Naples Company had acquired the former George Hendrie estate, The Pines, and converted it into another hotel annex, adding 20 new rooms to the growing complex. In the November 7, 1947 issue of the *Collier County News*, hotel manager H.G. O'Keefe announced, "While the Naples Hotel always has been noted for its famous guests, last season's list of celebrities was outstanding, including Hope Williams, stage and screen actress, and Frank Lloyd Wright, noted architect." The pier continued to be an important amenity for hotel guests and on March 12, 1948, the *Collier County News* reported, "Three guests of the Naples Hotel, with Hewitt McGill, landed 33 big kingfish, together weighing 223 pounds, the largest haul this season." (Courtesy of Nina H. Webber.)

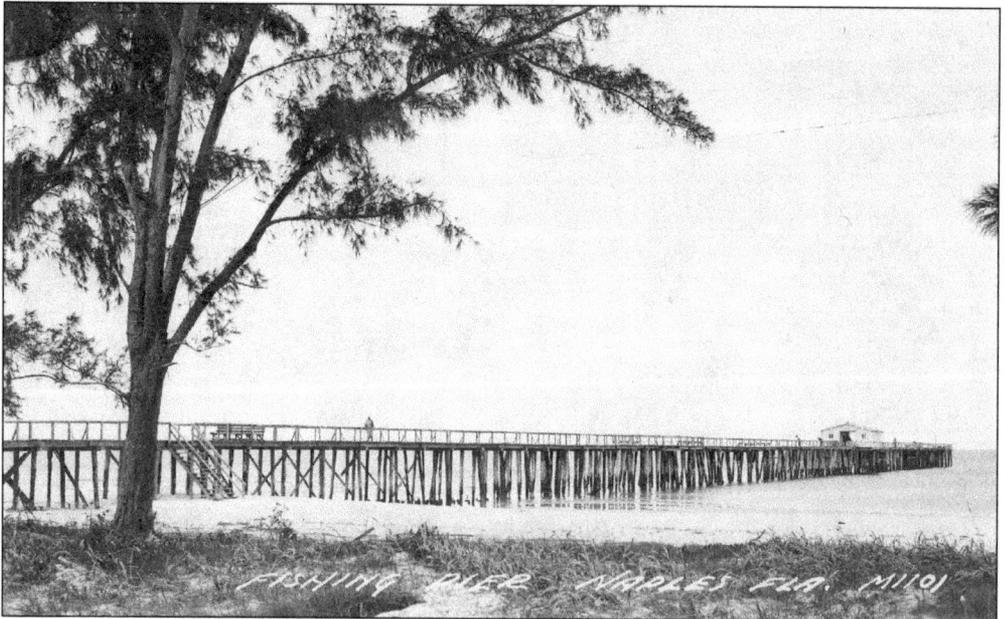

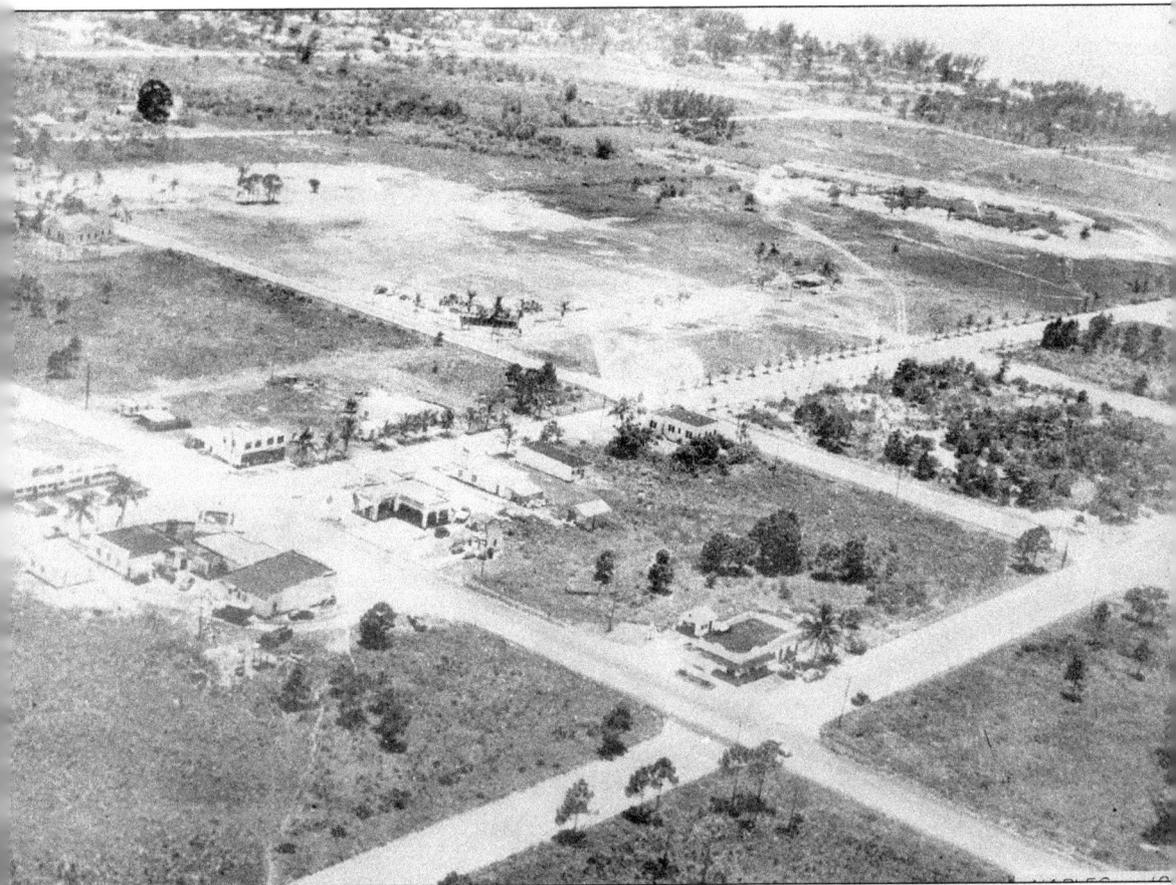

This 1948 photograph shows a southwest view of the intersection of the Tamiami Trail and the palm-lined Fifth Avenue South. By 1948, the intersection, dubbed "Four Corners," featured commercial buildings on every corner, including a Gulf service station and Club 41 on the northeast corner, and the one-story Redington building, home to Frank's Hardware, Fritz Hoewischer's electric store, Jack's Diner, and the Trail Tours bus station and depot on the southeast corner. A two-story building owned by "Doc" Prince was on the southwest corner. In 1935, he sold his drug store on Third Street South to Mr. Hixon and bought the IGA grocery store located on this corner. Prince obtained the first liquor license in Collier County after Prohibition was repealed and part of the grocery store was converted into a liquor store. A Sinclair gas station operated by Ansel McSwain occupied the northwest corner.

In 1942, the Seaboard Airline Railway stopped service to Naples and eventually sold most of its Naples property to the Atlantic Coast Line. During World War II, the Naples Depot was used as a USO-type club for the United States Air Force personnel stationed at the new Naples Airfield (now the Naples Airport). After the war, the Atlantic Coast Line began using the old Seaboard Airline depot, launching its new air-conditioned Pullman service to Naples with *The Champion*. Mrs. Merle Harris attended the opening ceremonies and noted, "This celebration was not as elaborate as the one in 1927, but we were all very excited to learn that Gloria Swanson would be aboard the first train. Orlo Carson was the Station Agent and he had the depot lit up like a Christmas tree for this gala occasion." Nearly 26 years later, Mrs. Harris was part of a Collier County Historical Society group to ride onboard the Atlantic Coastline's last train into Naples on April 21, 1971.

In 1926, William Cambier was appointed town engineer, a position he held for the next 25 years. Devoted to Naples, he once turned down the council's offer to raise his $150 per month salary, stating, "That's all the city can afford." By 1947, he was responsible for implementing the Naples Plan, an ambitious community development plan to raise $300,000 in outright donations to the town for street paving, beach reclamation, the establishment of a park and playground, and mosquito eradication. According to an article in the December 19, 1947 issue of the *Collier County News*, "The idea is to provide long-needed improvements without bond issue, higher taxes and street assessments." On September 10, 1948, the new park, paid for out of the successful Naples Plan funds, was dedicated as Cambier Park, and Mayor William L. Clarke Jr. announced, "We name this park in honor of one of the best friends Naples ever had." The new $68,000 park and playground included a baseball diamond, grandstand, barbeque pit, and restrooms. A fish fry was held on the new park grounds after the dedication.

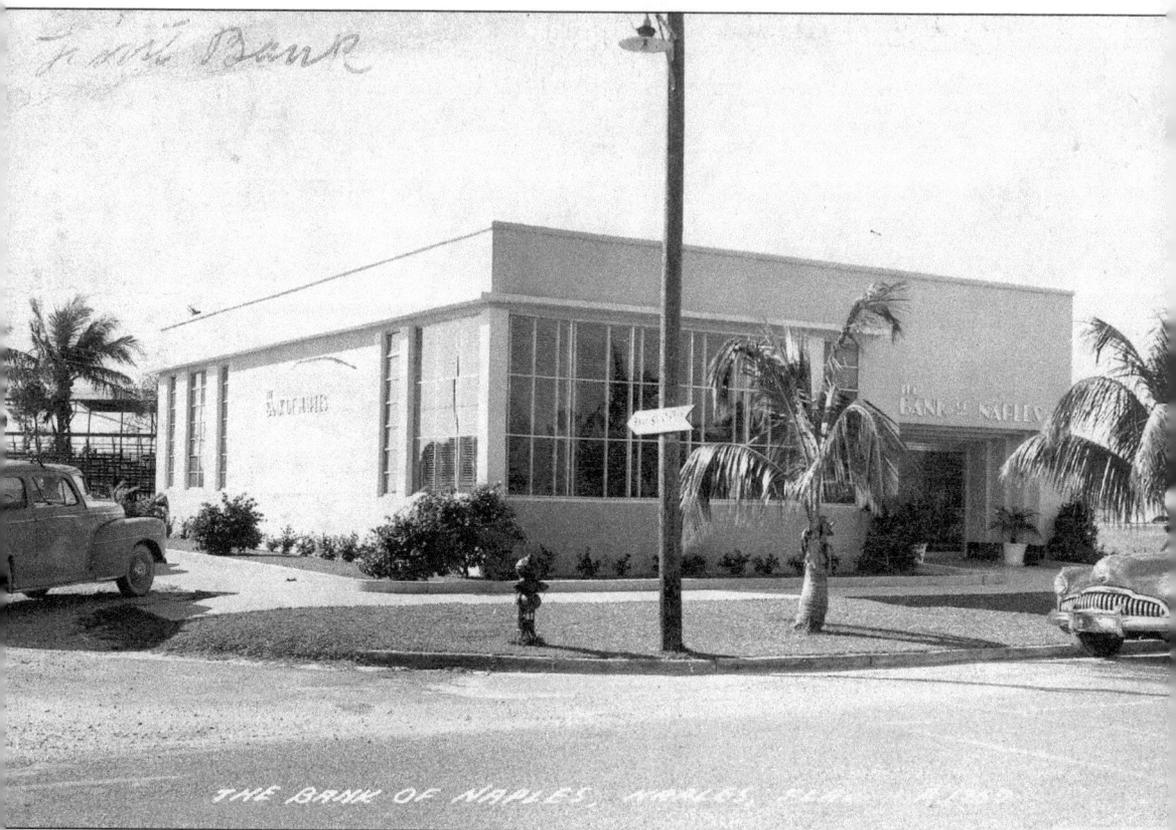

The town's first bank, The Bank of Naples, officially opened for business on February 15, 1949. It began operation with an initial capital stock of $50,000 and a surplus of $25,000. The new bank's officers included Roy Smith as president, Clarence Tooke as executive vice president and cashier, and Mrs. Tooke as assistant cashier. An August 13, 1948 *Collier County News* editorial raved about the badly needed bank, "Every merchant who has run out of cash, every citizen who has carried his paycheck wearily from store-to-store, every depositor who has carried over his receipts for days until he could get 'into town' [Fort Myers], will rejoice that a Naples bank is about to become a reality. The diverse ownership of the stock has made the bank virtually 'owned by Naples.'" A site was selected on Fifth Avenue South, diagonally across the street from the telephone company. In this postcard, the grandstand of the new Cambier Park is visible behind the bank.

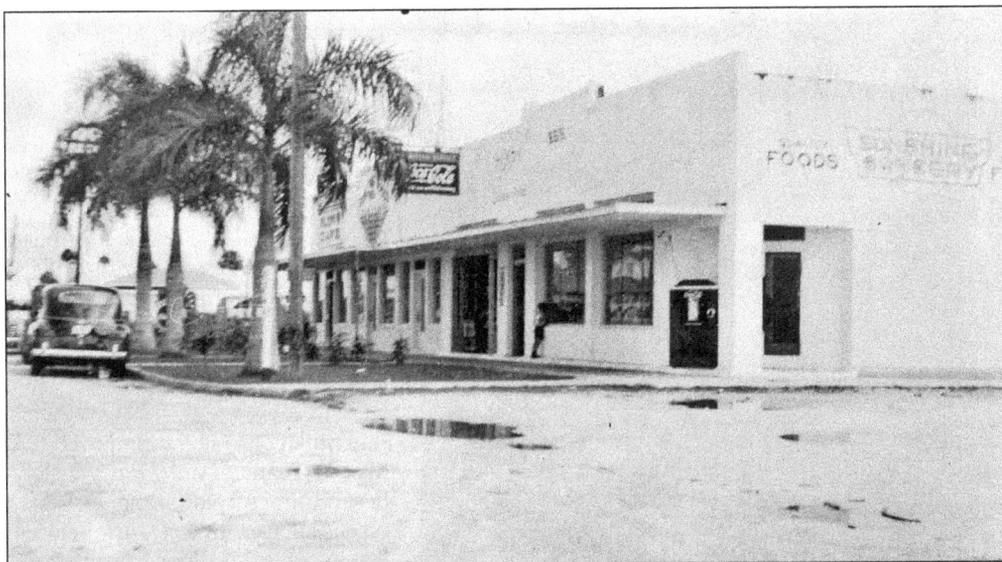

This photograph shows the southeast corner of Four Corners. Note Hixon's Sundries in the center. By late 1948, the first traffic light in Naples had been installed at Four Corners and a Hixon's advertisement in the *Collier County News* stated the business was located "at the stoplight."

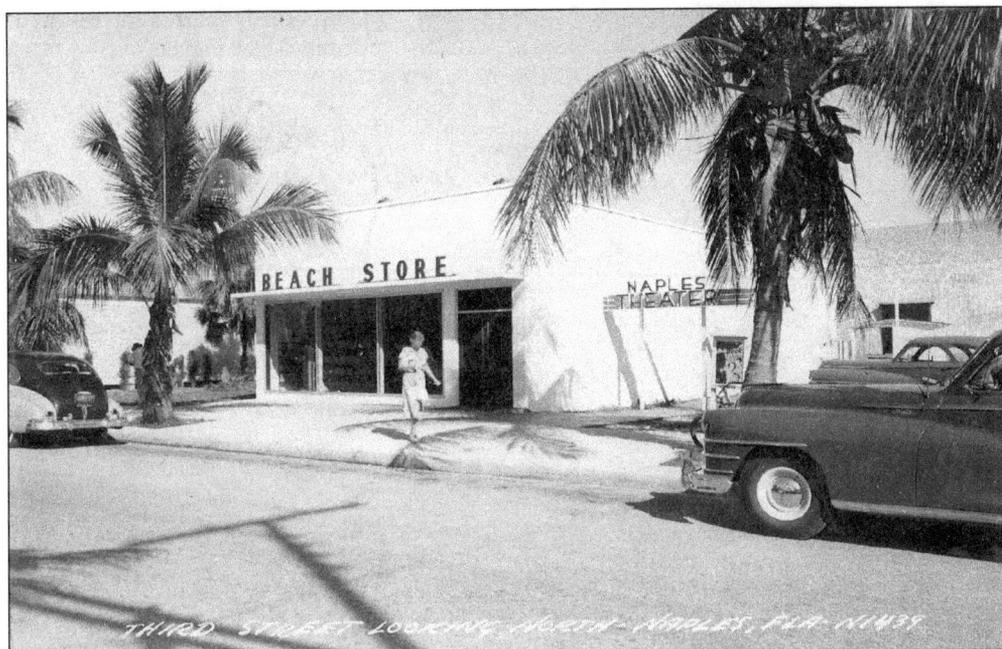

In 1948, the Beach Store moved from the Naples Company Building to a new building on Third Street South. Owners Arnold and Margaret Haynes installed a sandwich bar and grill and a new soda fountain. The Haynes also owned and operated the Naples Theater, the Quonset hut building visible on the right. The tin roof was notoriously noisy during downpours, often drowning out the movie soundtrack.

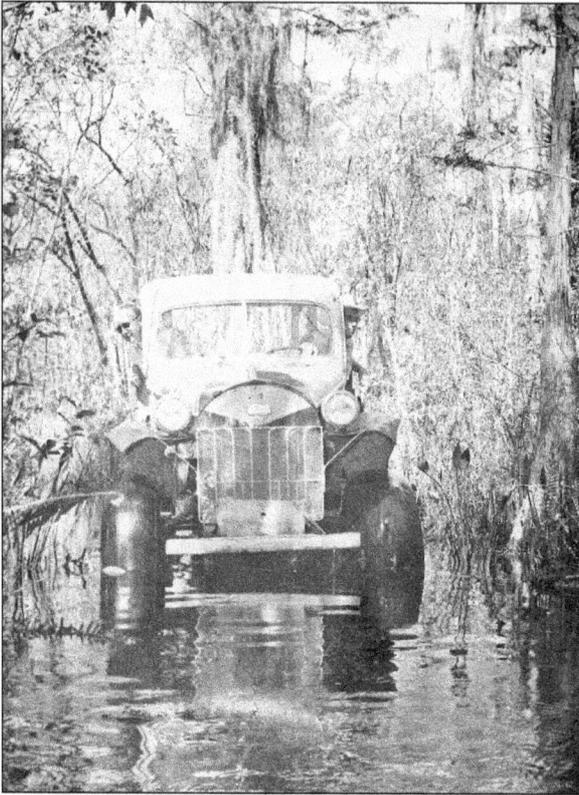

By the time Ed Frank opened his first garage in Naples in 1927, he had already created his first "skeeter" buggy, a stripped-down Model T designed to traverse the tough terrain of the Everglades. Along with his brother-in-law, George Espenlaub, Frank continued to perfect the design, noting, "We improved something every time we got stuck." Eventually, Frank's strange-looking design was dubbed the "swamp buggy."

Ed Frank continued to improve his design and after World War II began using surplus airplane tires on his buggies. In 1947, just before leaving on a weeklong hunting trip, Frank posed with his newest buggy "High Notch." From left to right are Paul Frank, Henry Espenlaub, Ed Frank, and W. Roy Smith. The photograph ran in the next week's *Collier County News* and eventually spurred interest in a "Swamp Buggy Parade."

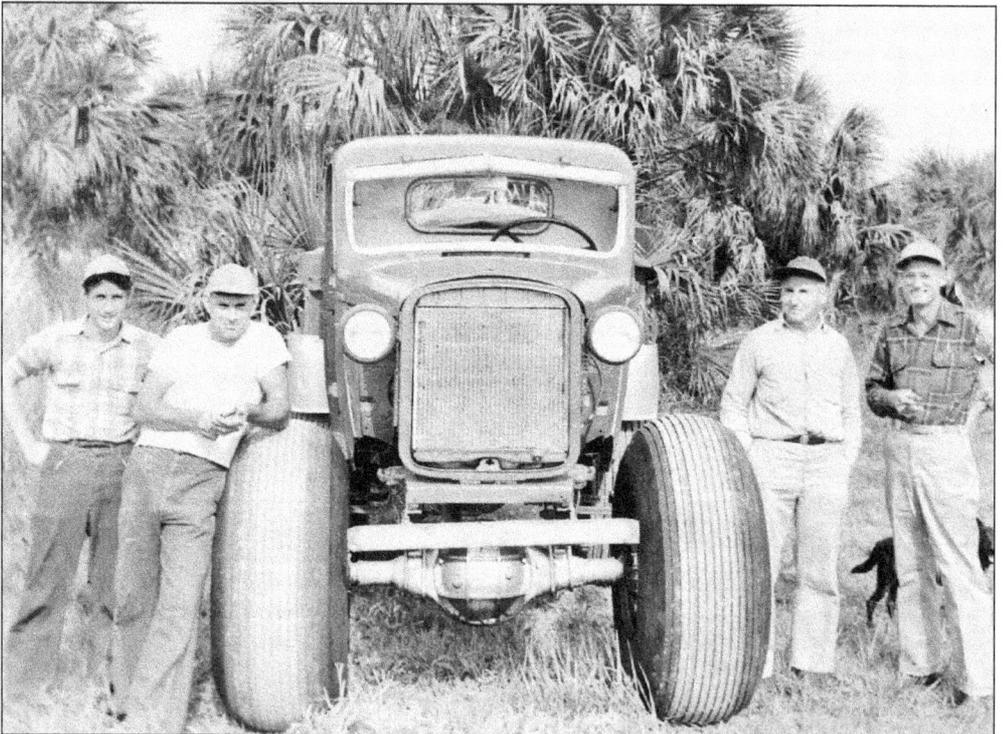

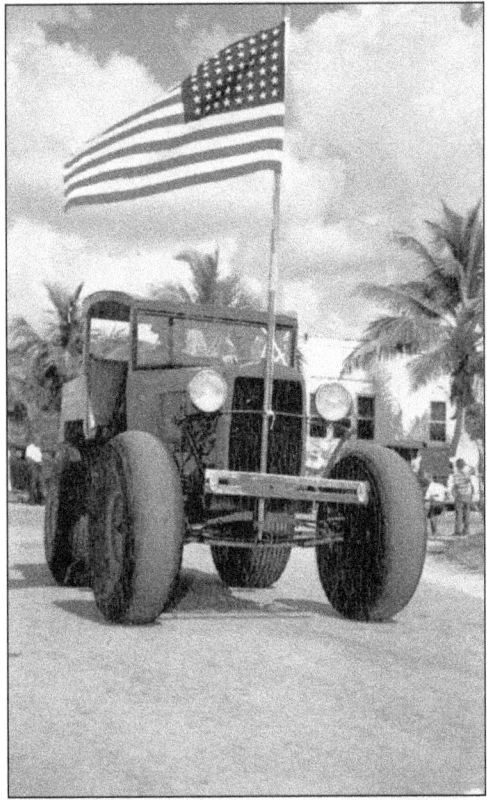

On October 14, 1949, the *Collier County News* reported, "So far as anybody can find out, 'Swamp Buggy Day' in Naples on November 12 will start something new in southwest Florida celebrations. Already owners of swamp buggies are painting their vehicles and getting them ready for the parade, as well as running up the motors for the obstacle race." A week later, the newspaper reported, "Any type vehicle may be entered except half-tracs, Weasels, tractors and other factory-built jobs. Swamp buggies may use chains, but no cleats and buggies may carry passengers to help push or otherwise extricate the vehicles." More than 4,000 people attended the daylong event, which was covered by four major newsreel companies, including Pathe, Fox Movietone, Paramount, and Universal. Johnny Jones, a Miami auto dealer, won the first prize, a 16-gauge Remington automatic shotgun. (Courtesy of Nina H. Webber.)

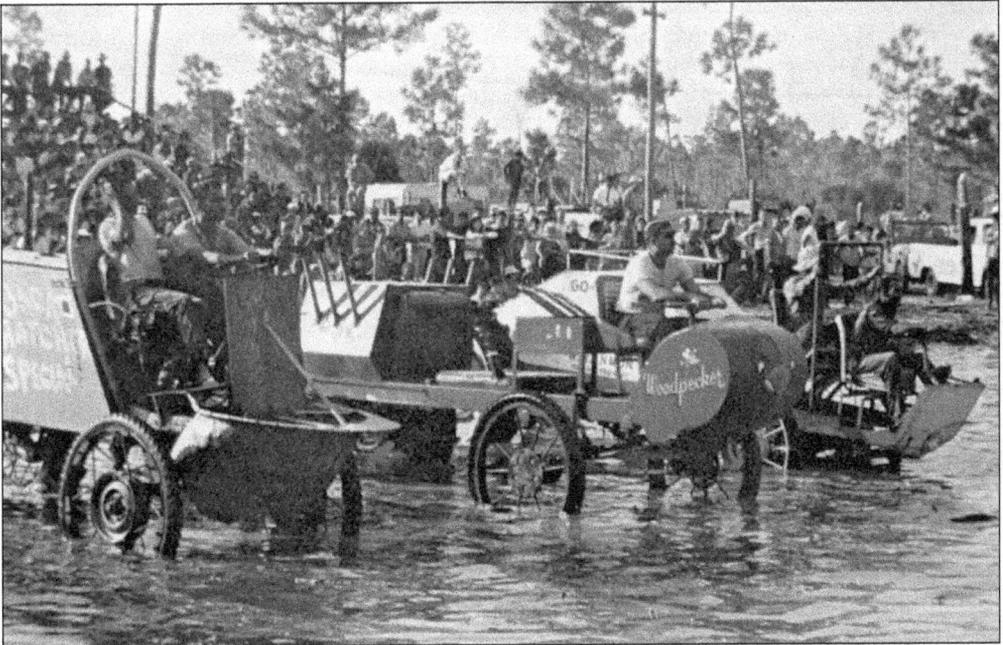

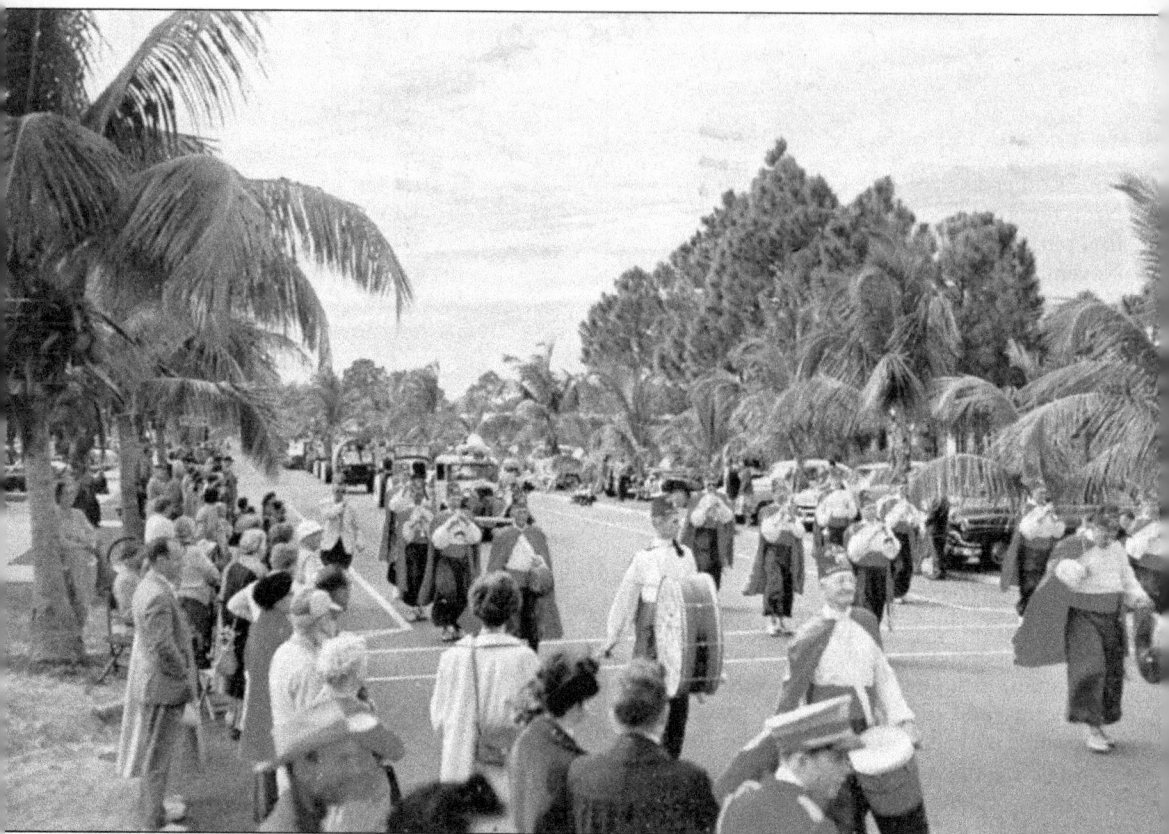

After the first successful Swamp Buggy Day on November 12, 1949, the event was held annually, and by 1952 had expanded to include a Turkey Shoot and beauty contest. The *Collier County News* reported on October 31, 1952, "Work on the 'mile of mud' race course near the Naples-America airport is moving along, with the course purposely 'unimproved' to make the race even tougher. This year there will be foot races in the mud between the other events. Plans are being made to have a 20-piece Shrine band from the East Coast take part in the parade before the main event. The parade will line up at 10 a.m. near the Naples Beach Hotel (the old Naples Hotel), and head for the race grounds. A fish fry on the grounds will also get underway about the same time." (Courtesy of Nina H. Webber.)

A TASTE OF FLORIDA LIVING

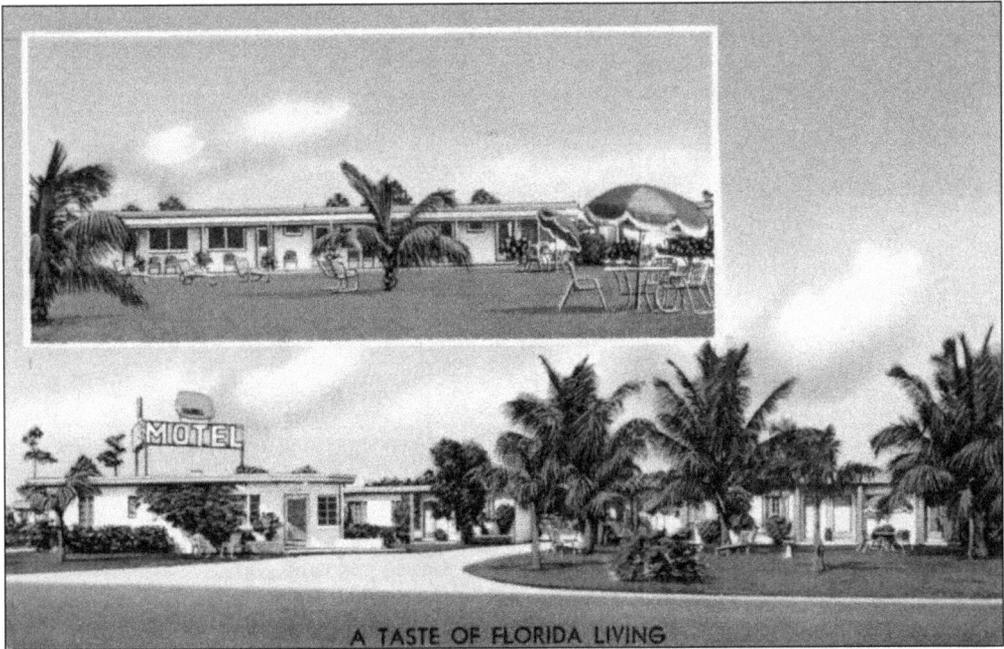

After World War II, the tourism industry slowly began to revive in Naples and, by 1949, four new motels opened on the Tamiami Trail, including the Seashell Motel, built by the Naples Construction Company for Mr. and Mrs. Carl Prasil. By 1957, when this postcard was mailed, the Seashell Motel offered a "Taste of Florida Living," with each room offering "tiled shower or tub bath, electric heat and air conditioning optional." (Courtesy of Nina H. Webber.)

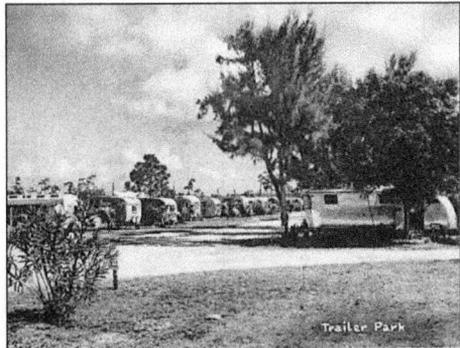

Greetings from Naples Trailer Park, Cottages and Grill, Naples, Fla.

Most of the new motels and trailer parks, including Naples Trailer Park, Cottages, and Grill, were built along the Tamiami Trail. By 1950, Naples had a year-round population of 1,500 and the fledgling Chamber of Commerce, incorporated in 1946, began to actively promote the town as a tourist destination. (Courtesy of Nina H. Webber.)

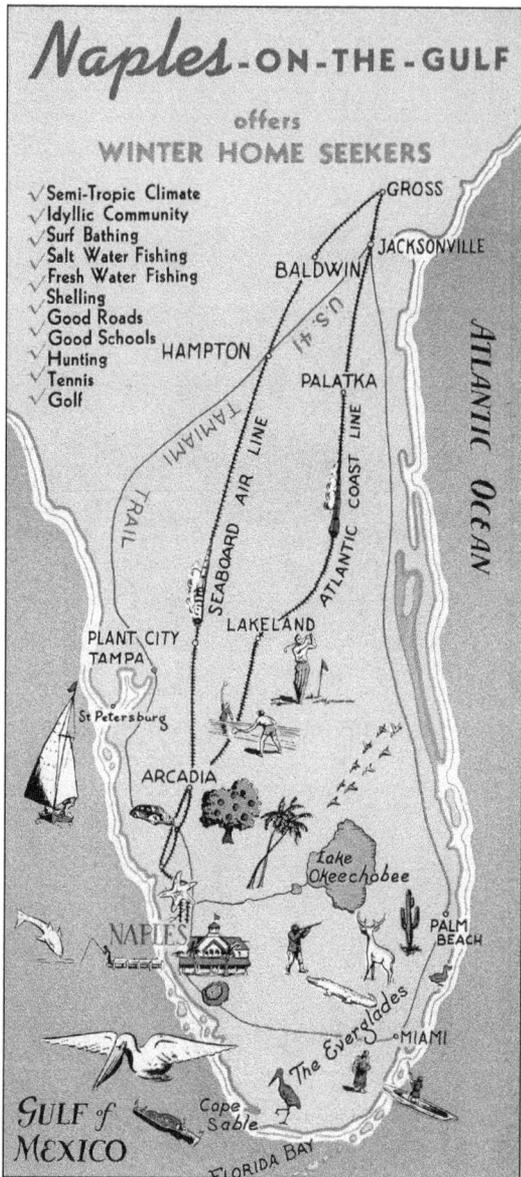

Naples-ON-THE-GULF

offers

WINTER HOME SEEKERS

√ Semi-Tropic Climate
√ Idyllic Community
√ Surf Bathing
√ Salt Water Fishing
√ Fresh Water Fishing
√ Shelling
√ Good Roads
√ Good Schools
√ Hunting
√ Tennis
√ Golf

GROSS

JACKSONVILLE

BALDWIN

HAMPTON

PALATKA

U.S. 41

TAMIAMI TRAIL

SEABOARD AIR LINE

ATLANTIC COAST LINE

Atlantic Ocean

LAKELAND

PLANT CITY
TAMPA

St Petersburg

ARCADIA

Lake Okeechobee

NAPLES

PALM BEACH

The Everglades

MIAMI

GULF of MEXICO

Cape Sable

FLORIDA BAY

Unlike earlier Naples Improvement Company brochures designed primarily to promote the Naples Hotel, this c. 1942 brochure was designed for "winter home seekers." It stated, "With shrewd investors in the United States seeking real estate as the safest place for funds, it is obvious south Florida property in Naples is well worth considering. If improved, it will have an immediate rental value and every prospect of enhancing. Decide now to avail yourself of this opportunity to establish an enjoyable winter home of your own and thereby make an attractive investment." Note the two railways into Naples. The brochure advised, "The Atlantic Coast Line Railroad serves Naples and the Seaboard Air Line Railway maintains freight service to Naples. It is expected the passenger service over that railroad also will be resumed in due time." Ed Crayton, owner of the Naples Improvement Company, was notoriously reluctant to sell any of his property in Naples, but died in 1938 before implementing his plans for large planned developments.

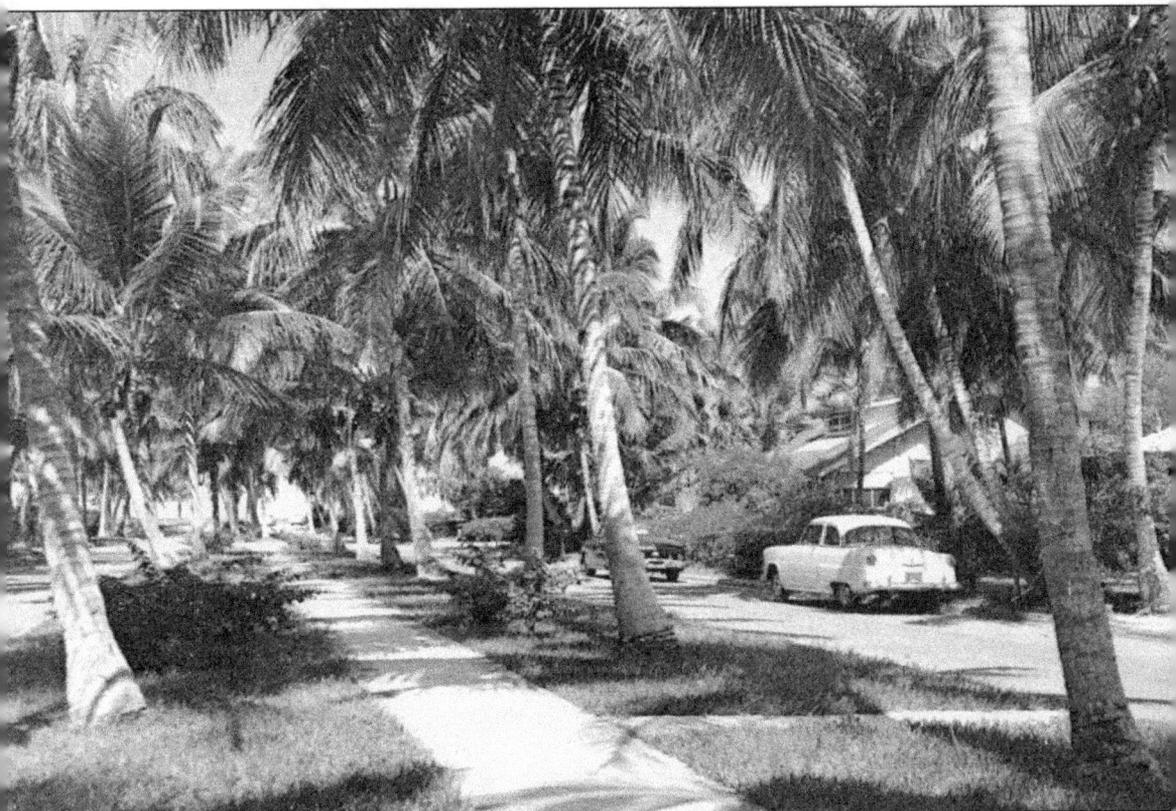

As owner of the Naples Improvement Company, Ed Crayton strictly controlled the development of Naples. Not everyone agreed with his vision, however, and John "Hack" Hachmeister, who lived on Broad Avenue South, decided to ignore Crayton's proposal of standard grid streets for the town. According to his nephew, John R. Hachmeister, "Uncle John said the town needed a parkway street, so he built his own—two lanes with a walkway and trees in the center. I believe it was around 1930 when Uncle John and his crew transplanted some 3,000 coconut palm trees in Naples streets, which he brought in his boat from Marco and other islands south of Naples." A decade earlier, at the other end of the street, near Fifth Street South, the Youngman's operated the first dairy in Naples. By the 1950s, Hachmeister's Broad Avenue South was often selected as a postcard scene. (Courtesy of Nina H. Webber.)

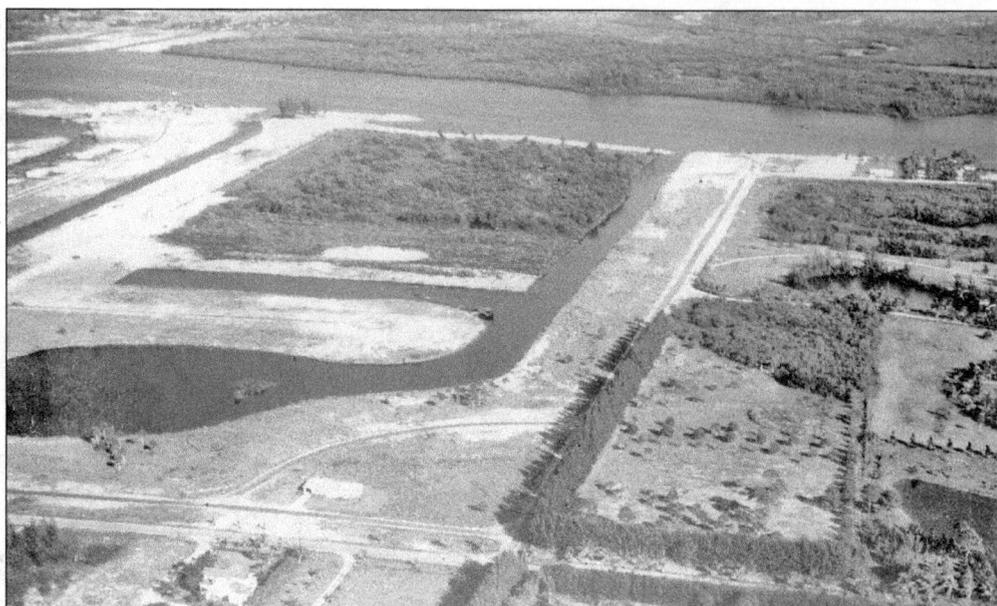

Forrest Walker shrewdly saw the potential of waterfront real estate in Naples and, in 1946, went into business with his sons James and R.L. Walker to begin implementing his idea of dredging and filling the mangrove swamps on Naples Bay to create canal-front house lots. They purchased the mangrove-covered land south of the Back Bay dock and began construction of the first dredge and fill operation in Naples—Aqualane Shores. Above, looking east, this 1950 photograph shows the formation of the first canals, with Gordon Drive on the lower left, intersecting with Twenty-first Avenue South. When the completed lots went on sale, the Walkers required $100 down and $50 a month until the lot was paid off. Lots on narrow canals sold for $4,000, while larger lots on Naples Bay sold for $7,000. (Bay of Naples postcard courtesy of Nina H. Webber.)

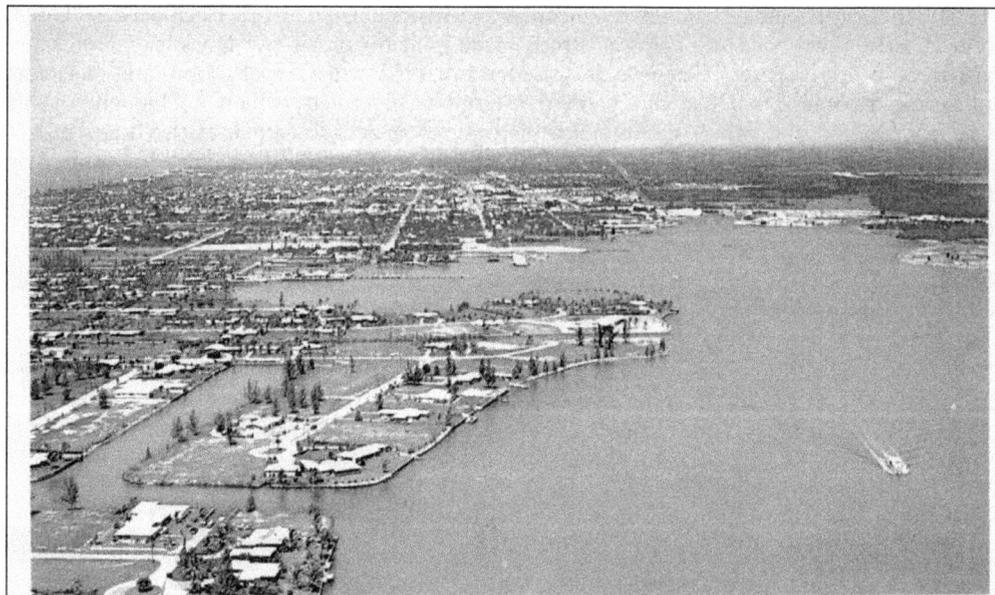

Bay of Naples, Naples, Florida

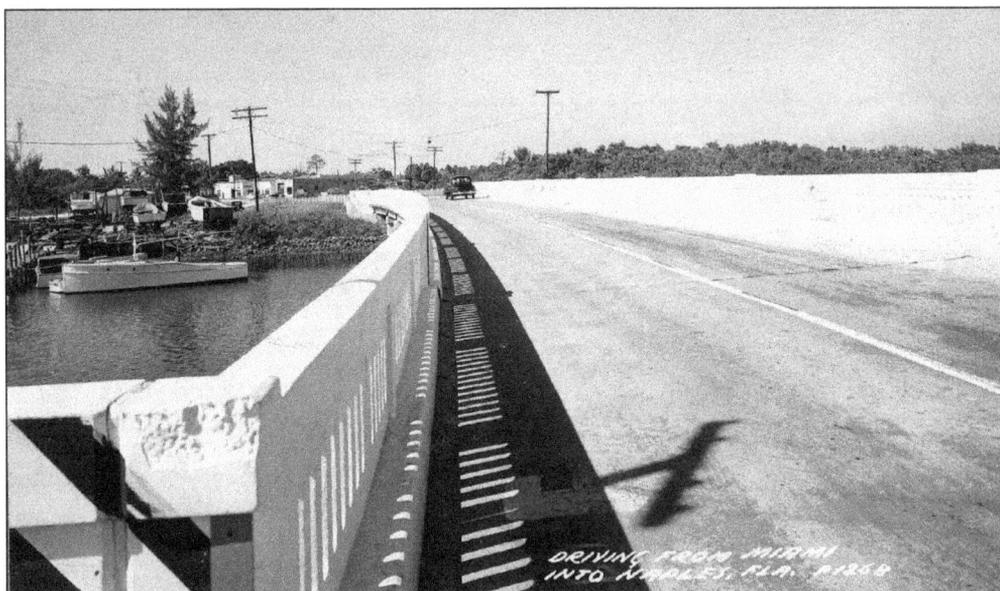

This c. 1940s postcard shows the Gordon River Bridge and a westbound view of the Tamiami Trail. The first bridge over the Gordon River and Naples Bay was built in 1921. According to early resident Rob Storter, "It was only wide enough for one car. If two cars met on it, one had to back up. It was a wooden bridge with pine pilings that had to be repaired often because they rotted easily in the salt water."

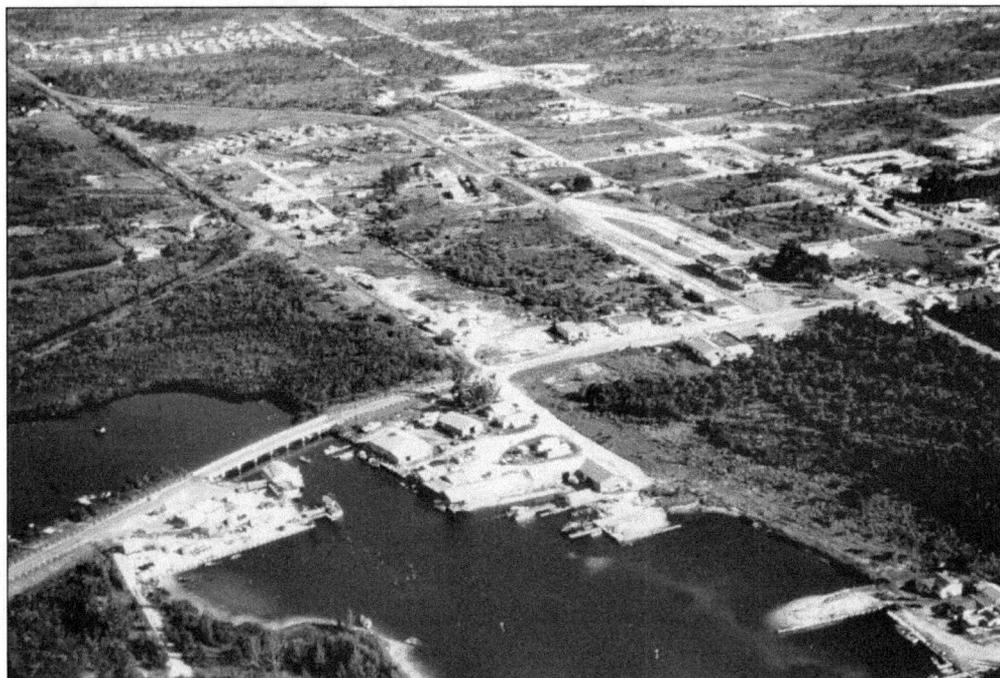

In this aerial view looking east, the Gordon River Bridge is visible in the lower left. According to Mary Prince Evans Lipstate, "We sure didn't have a traffic problem in those days. I recall looking out a window in the apartment over our store and seeing buzzards attack a chicken in the middle of Four Corners."

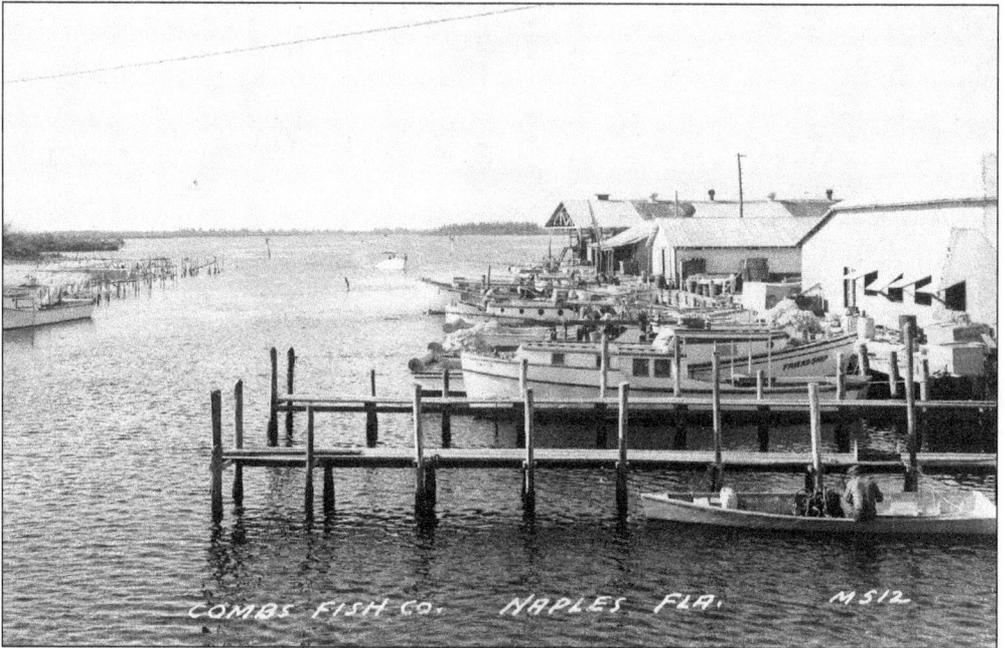

COMBS FISH CO. NAPLES FLA. M512

By the early 1950s, commercial fishing was becoming an important industry in Naples. On January 27, 1950, the *Collier County News* reported, "Promise of a great new shrimp fishery in the Gulf off Collier County—coupled with the announcement that two large shrimp companies already have leased fish houses at Naples—this week gave the fishing industry its greatest news in years." The fish houses were located on Naples Bay right next to the Gordon River Bridge. According to the caption on the back of the bottom post card, "The home port of commercial fishing boats, Naples is the center of some of the finest fishing in the world." By 1955, commercial fishermen in Collier County brought in more than seven million pounds of fish, mostly to fish houses in Naples and Everglades. (Courtesy of Nina H. Webber.)

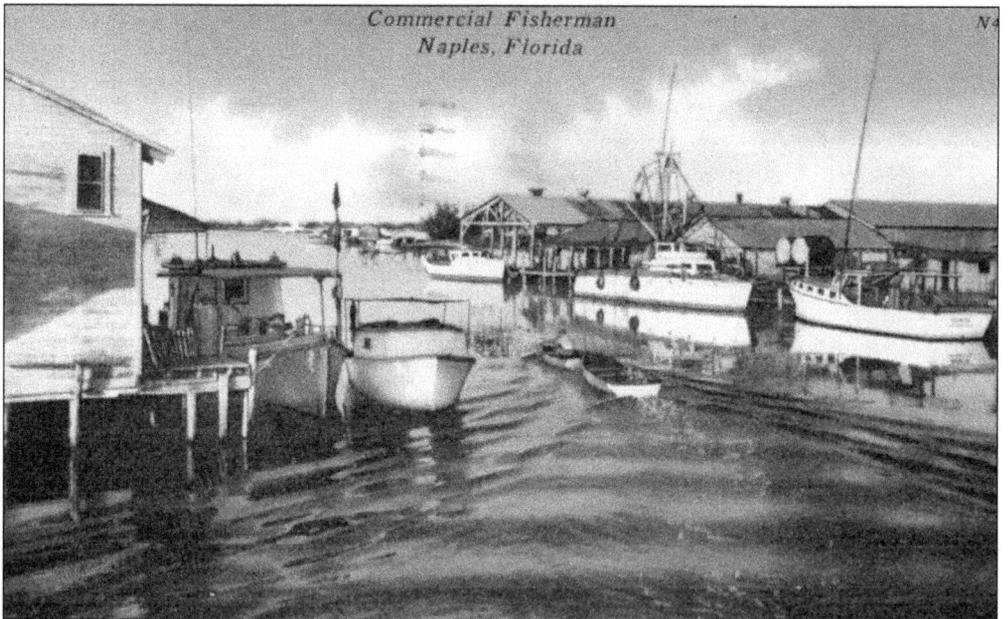

Commercial Fisherman
Naples, Florida

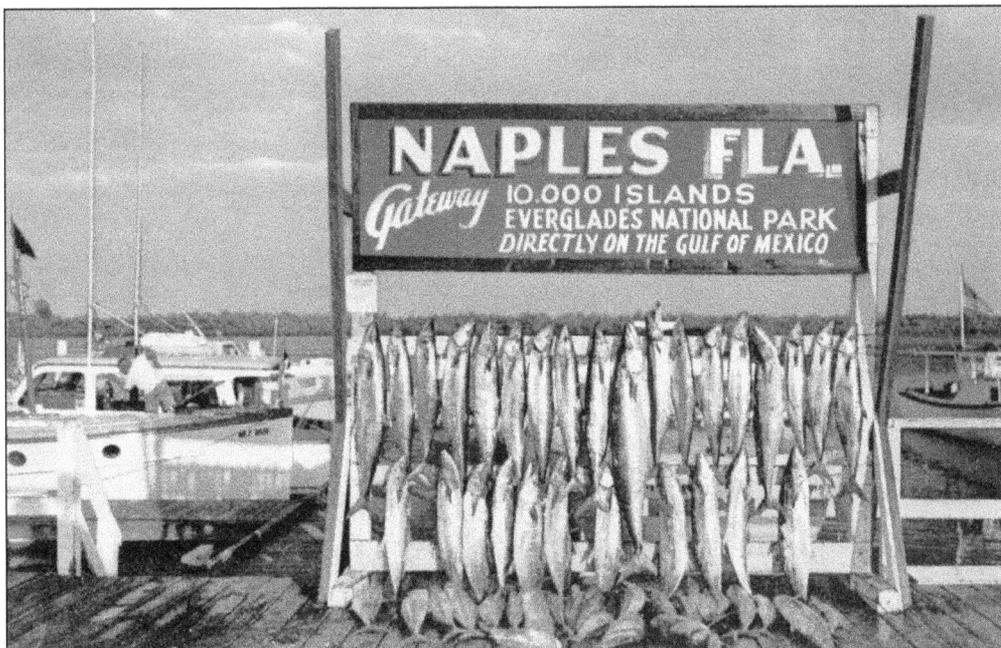

Recreational fishing remained an important part of the tourism industry in Naples. On the back of this c. 1953 postcard, the caption reads, "One day's kingfish catch on a Naples Charter boat." A visitor wrote that year to a friend, "Grand golfing and fishing weather. They brought in over 500 pounds of kingfish yesterday." (Courtesy of Nina H. Webber.)

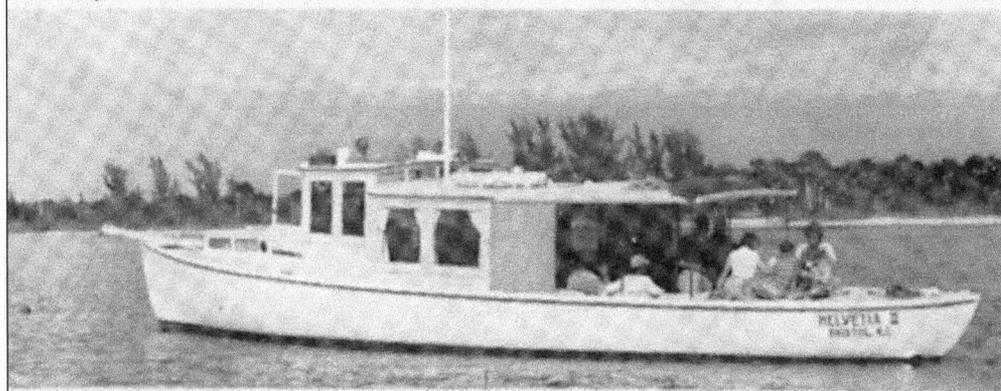

Explore the 'Glades Shelling-Wildlife-Beaches-Islands

"HELVETIA II" ORIGINAL GLADES EXPLORING AND SHELLING VESSEL
PHONE 2-9491 NAPLES, FLORIDA

Leaves Crayton Cove Docks daily 10 A. M. $5 per person. Comfortable Vessel. Licensed Master of 30 years experience. Bring your family, your beach picnic lunch and your adventurous spirit.

In 1949, the Back Bay dock area was renamed Crayton Cove in honor of Ed Crayton. As part of a redevelopment effort, 10 slips were installed for the exclusive use of the Naples guide boat fleet. On the back of a similar postcard mailed in 1955, a visitor wrote, "A fellow we know just told me he would take us for a boat ride down into the Ten Thousand islands. If we go in a shelling boat, it costs about $5 each." (Courtesy of Nina H. Webber.)

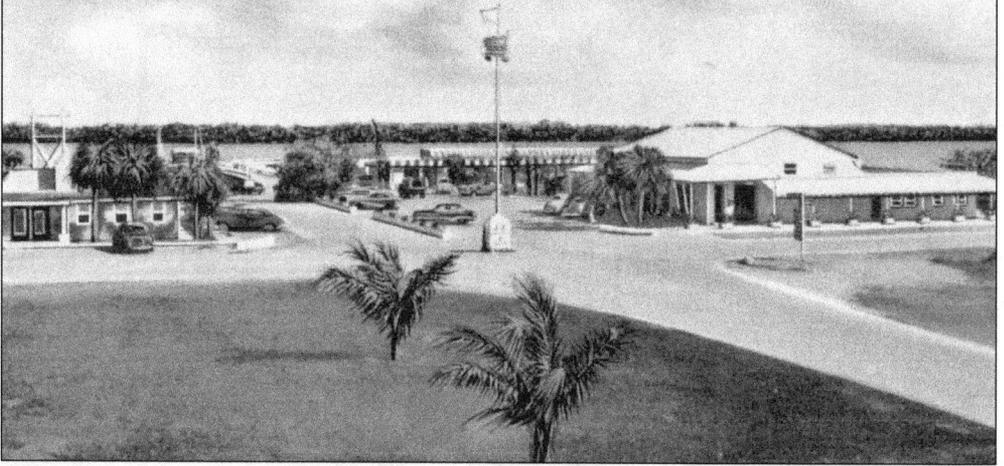

In 1948, B.W. Morris Jr. began developing the old Back Bay area, which he had renamed Crayton Cove. An editorial in the February 20, 1948 issue of the *Collier County News* praised the plans, noting, "In the Bay Dock area of Naples there is now unfolding an illustration of slum prevention. What might have been a town's typical 'fish house' waterfront area is to be a showplace." (Courtesy of Nina H. Webber.)

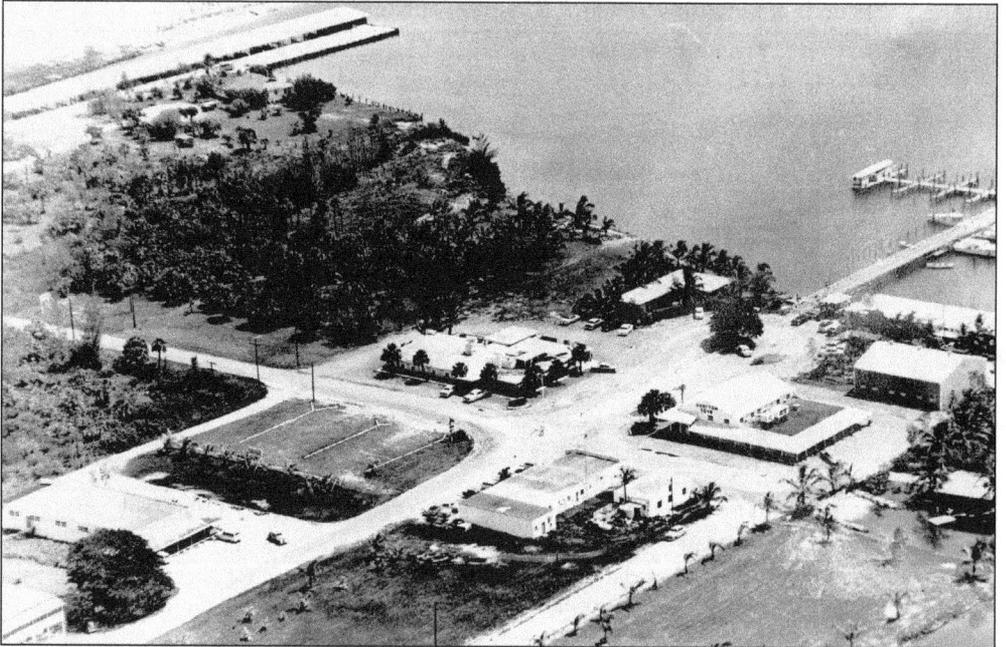

B.W. Morris Jr. planned to reconfigure the dock, add new businesses, and even a museum and war memorial to the new Crayton Cove. On December 16, 1949, the *Collier County News* announced the newspaper offices would be moving to Crayton Cove and "100 large cajuput [malalucca] trees will line the traffic circle." Note the *Collier County News* building visible on the lower left. (Courtesy of Nina H. Webber.)

116

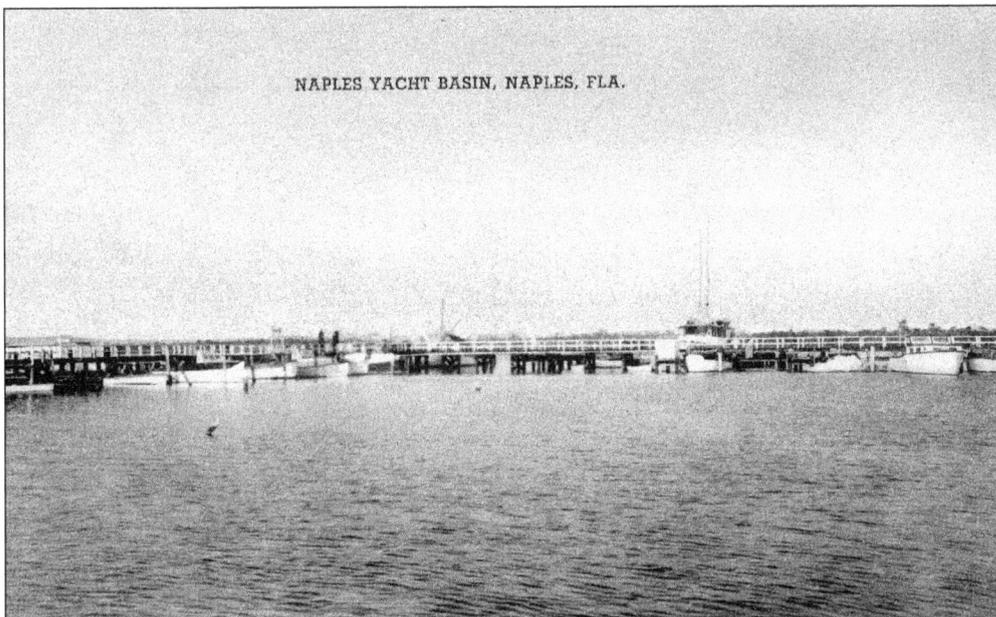

NAPLES YACHT BASIN, NAPLES, FLA.

In February 1948, the *Collier County News* reported, "Bulldozers and clearing crews have been busy for more than a week re-making the entire Bay Dock area. Hewitt McGill, dock master and operator of the town's yacht basin, will move his headquarters from the old building at the entrance to the dock to a new structure built by B.W. Morris Jr., part of his first step in the development of Crayton Cove. Mr. McGill operates a fish market there." By September 1949, Morris had added a marine hardware store to his Crayton Cove development. The growing business area attracted the attention of George Lake, a "flying service operator," who applied to the town council for permission to build a seaplane base at Crayton Cove, near the Bay dock. His application was approved, but the base was never built. (Courtesy of Nina H. Webber.)

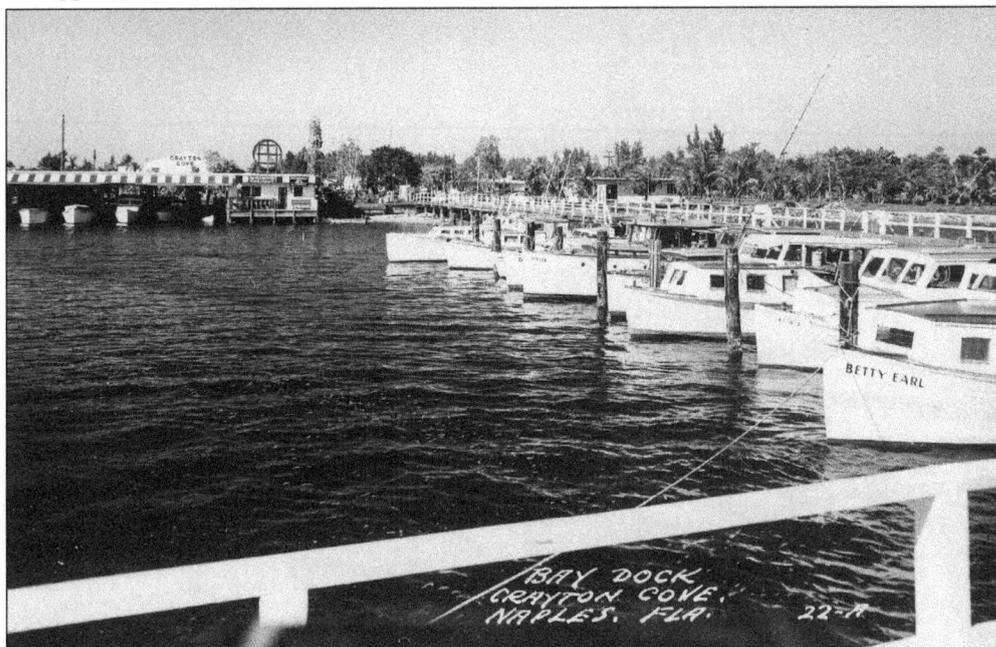

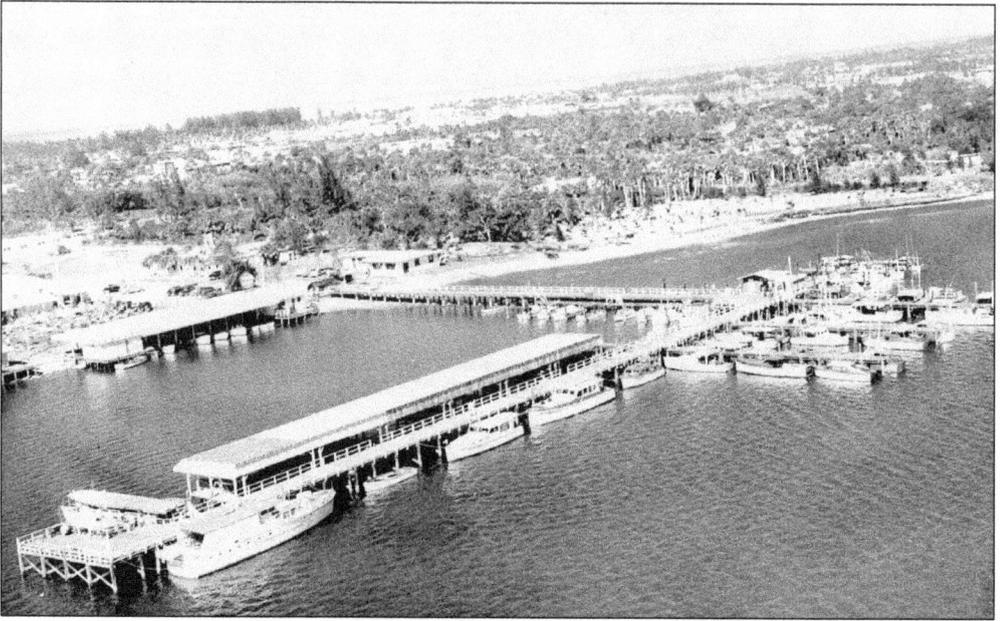

A c. 1942 Naples Improvement Corporation brochure revealed, "It is a matter of record that Naples has never defaulted on any obligations. Today, its outstanding bonded indebtedness is only $24,500, being the unpaid portion of an issue to provide a dock and anchorage for yachts and pleasure craft." The boating and fishing opportunities in Naples continued to attract a growing number of residents and tourists and, in 1956, the Naples Chamber of Commerce reported, "an estimated 4,500 people make Naples their year-round home; with an additional 5,500 visitors during the winter season." At the Crayton Cove traffic circle, B.W. Morris's Old Cove Restaurant and Pub was ranked by the December 1956 issue of *Holiday* as "perhaps the most interesting restaurant in town." (Bottom image courtesy of Nina H. Webber.)

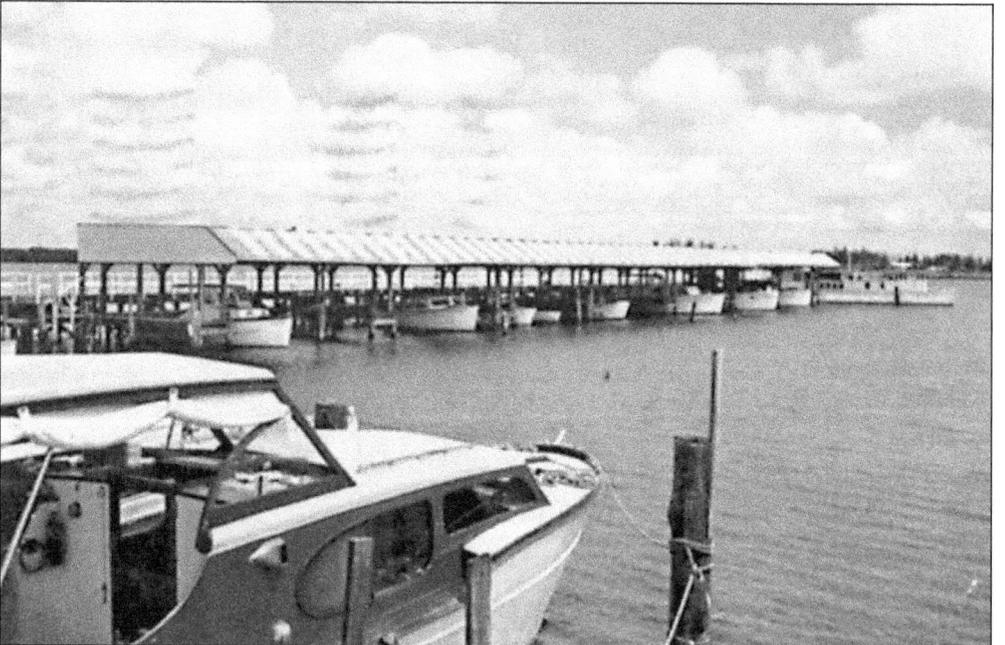

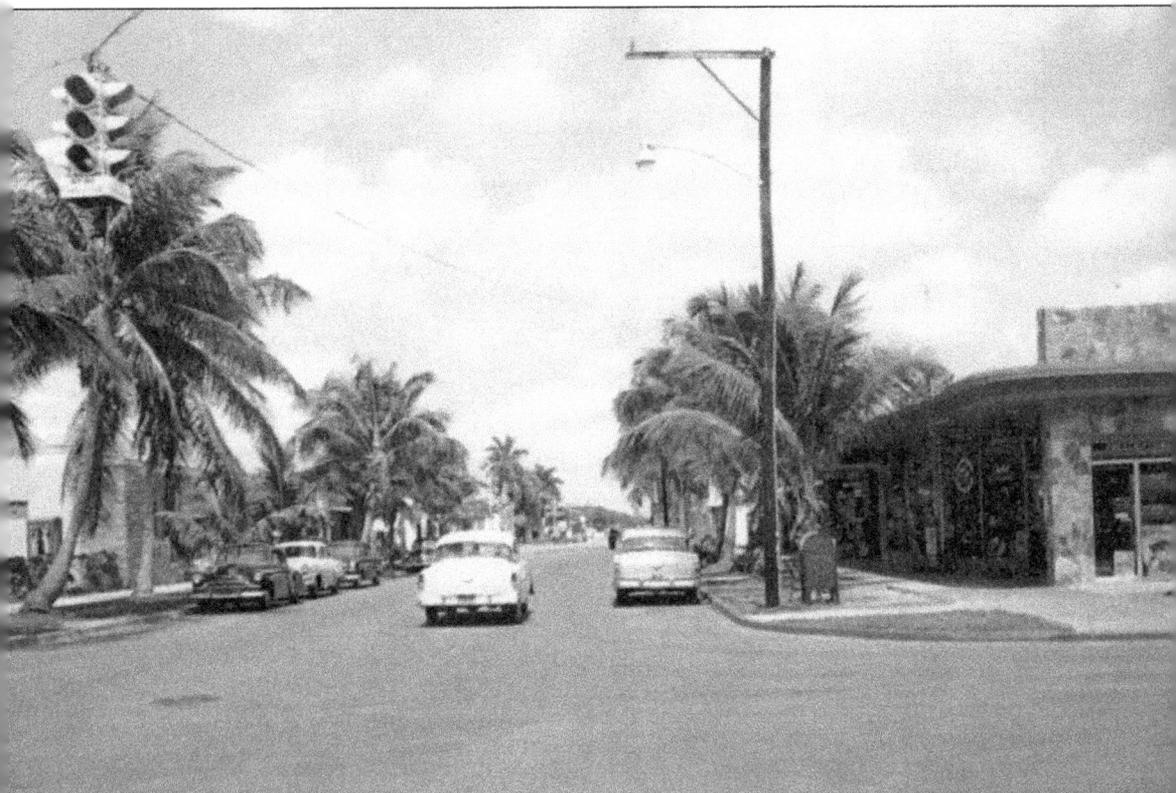

After the opening of the Tamiami Trail in 1928, a new business district slowly developed around the intersection of the Trail and Fifth Avenue South at Four Corners. This postcard shows an east view of Fifth Avenue South, with Four Corners in the distance. On the right is the Rexall Drug Store; by 1954, Naples boasted two drug stores, including the Rexall and the Beach Store Pharmacy on Third Street South. In 1954, the Rexall advertised, "drugs, cosmetics and luncheonette, featuring a businessman's lunch." According to Naples historian Maria Stone, "The Rexall Drugstore was the 'meeting place' on Fifth Avenue South. Local businessmen sat on the benches in front of the store and discussed the local business highs and lows each day. Breakfast and small lunches were turned out at the counter. Malts were ten cents. Kids frequently sat on the floor to read the new comic books." (Courtesy of Nina H. Webber.)

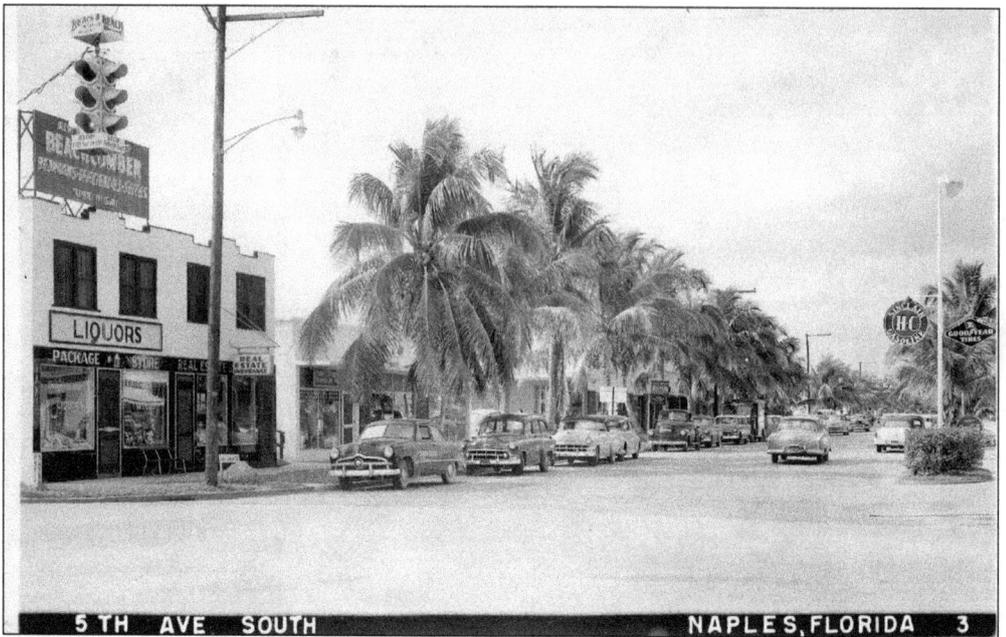

5TH AVE SOUTH NAPLES, FLORIDA 3

The Four Corners intersection *c.* 1952 is in the foreground of this west view of Fifth Avenue South. Four Corners was the site of the first stop light in Naples. On the left is Jack "Doc" Prince's Naples Liquors, with a sign for the Beachcomber apartment/hotel on the roof. The Beachcomber was located near the beach, on the corner of Third Street South and Fifth Avenue South. (Courtesy of Nina H. Webber.)

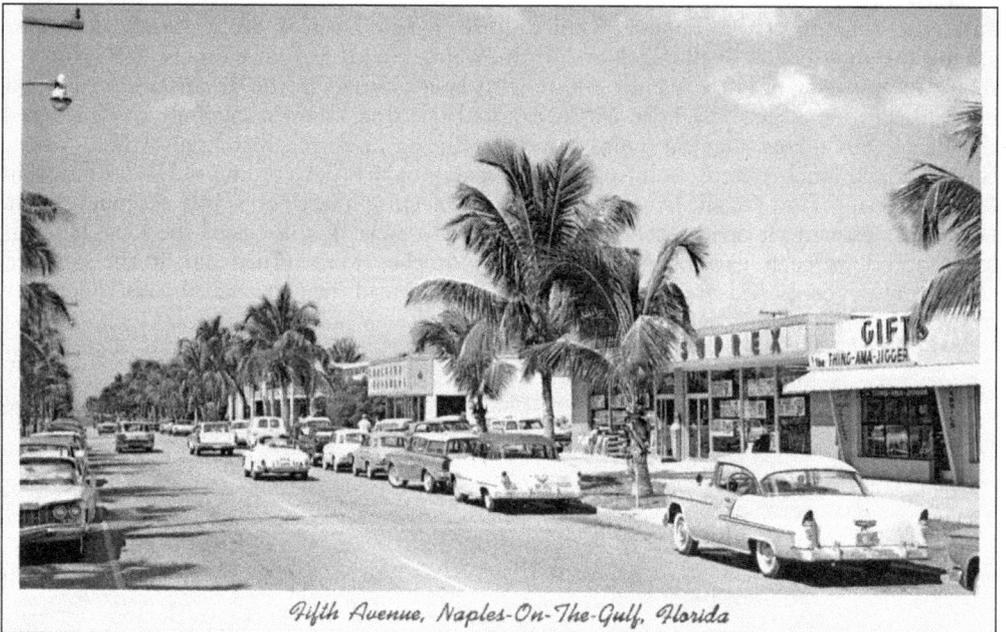

Fifth Avenue, Naples-On-The-Gulf, Florida

This 1950s postcard shows a west view of Fifth Avenue South, just one block from Four Corners. As early as 1905, Naples was also called Naples-on-the-Gulf, perhaps as a way of emphasizing its beachfront location. In 1954, Dewey Polly used this name as the call sign for his radio station WNOG, "Wonderful Naples-on-the-Gulf." (Courtesy of Nina H. Webber.)

120

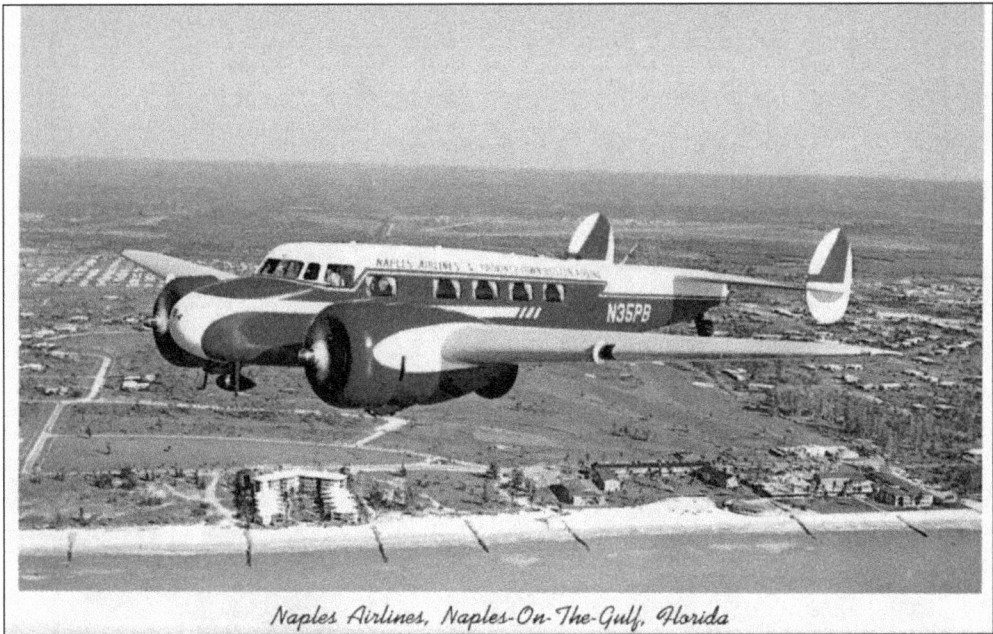

Naples Airlines, Naples-On-The-Gulf, Florida

The Naples Airport was built during World War II as a fighter training base. After the war, it was given to the City of Naples and Collier County. Naples bought out the county in 1949 and, by 1957, the first scheduled air service was offered by Naples Airlines/Provincetown Boston Airlines. This postcard shows one of the two Lockheed 10 airplanes operated by the airline in the late 1950s. The Naples Airport is visible in the background. (Courtesy of Nina H. Webber.)

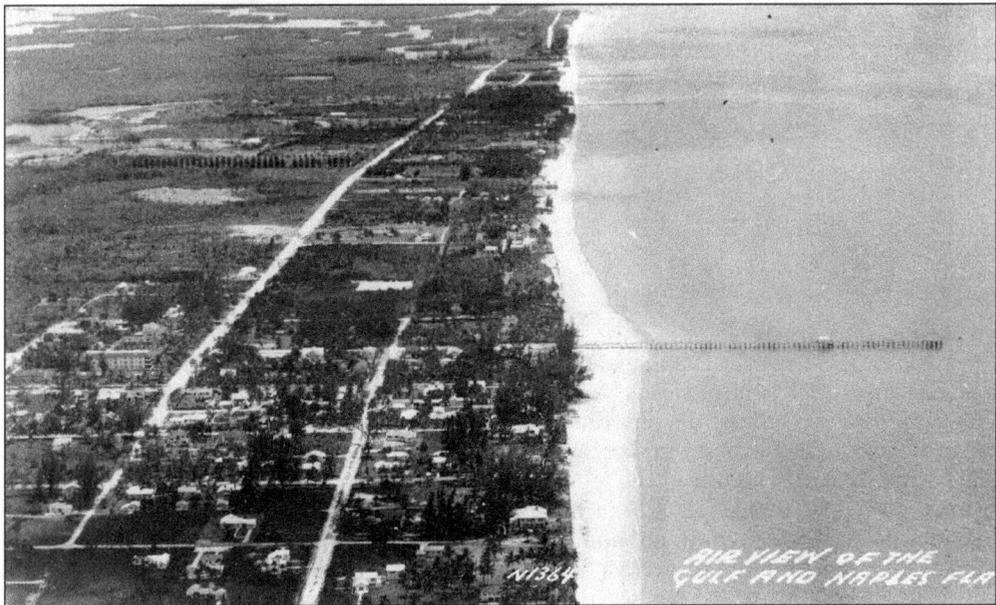

This south view of Naples c. 1950 shows the start of the dredge and fill operation for Aqualane Shores on the left. The Naples Hotel is also visible on the left, opposite of the pier. The top of the photograph shows the still-wild mangrove swamps that would eventually be transformed into John Glen Sample's premier dredge and fill operation—Port Royal. (Courtesy of Nina H. Webber.)

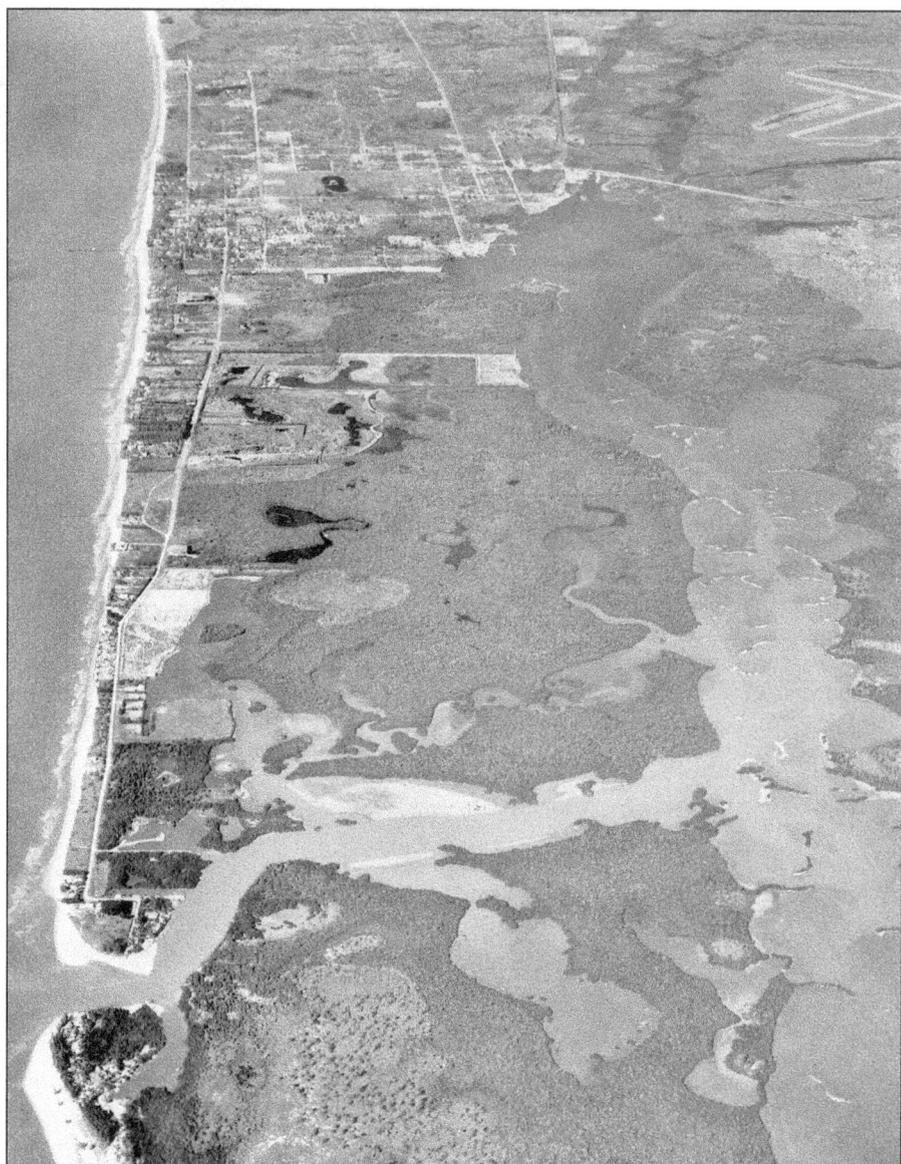

The December 1956 issue of *Holiday* featured a lengthy article about Naples, "Star of the New Florida Boom." According to writer Bill Ballantine, the area just south of the city was "just a tangle of mangroves, until seven years ago, when it was tamed by John Glen Sample, a retired Chicago advertising executive, who, as senior partner at Dancer, Fitzgerald & Sample, won a niche in the gray-flannel Hall of Fame by siring soap opera." Sample planned a community of luxurious homes on waterfront lots and required mandatory membership in the development's private club, signaling to prospective buyers that residents would be handpicked. He strictly controlled development and banned flat roofs in his carefully planned community. Sample often drove suitable prospects through the community in his Rolls-Royce Silver Cloud or toured buyers onboard his 70-foot yacht. This *c.* 1949 view shows Gordon's Pass on the lower left and the "tangle of mangroves" that would eventually become Port Royal. The Gordon's Pass Fish Camp, just to the south of Sample's property, was later referred to as the "pimple on Port Royal's nose."

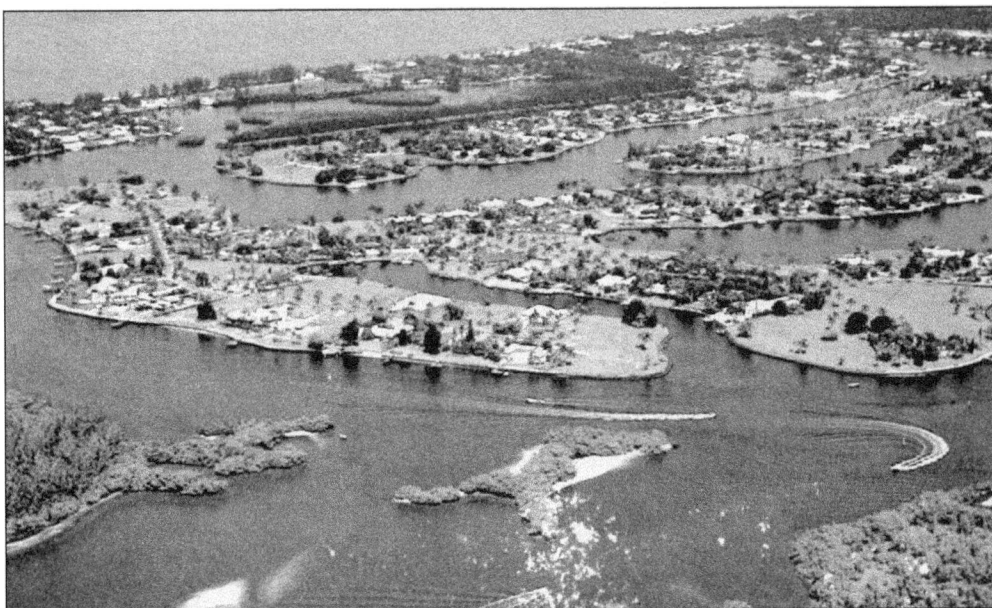

John Glen Sample began buying the future Port Royal property in 1938 and moved to Naples in 1946 to oversee his project. The dredge and fill development created serpentine peninsulas with 700 building sites—600 fronting deep water. By 1956, building sites were priced from $11,200 to $29,850 and in the first six months of that year sales in six newly opened sections totaled $675,000. (Courtesy of Nina H. Webber.)

In 1946, soon after Henry B. Watkins Sr. and his partners purchased the holdings of the Naples Improvement Company, the Naples Hotel underwent a complete renovation and redecoration. The caption on the back of this postcard notes, "The Naples Hotel, remodeled, charming and gracious. American Plan (winter)." This c. 1950 postcard shows the 1926 addition on the left, the solarium in the center, and the original building in the background. (Courtesy of Nina H. Webber.)

In 1958, the Naples Golf and Beach Club faced its first competition with the opening of the new Hole-in-the-Wall Golf Club, located in east Naples at the site of the original "hole-in-the-wall" entrance into the Everglades. By this time, the Naples Company group had enlarged the old Joslin clubhouse to accommodate Naples Hotel guests who wanted to play golf, calling it the Beach Club Hotel. (Courtesy of Nina H. Webber.)

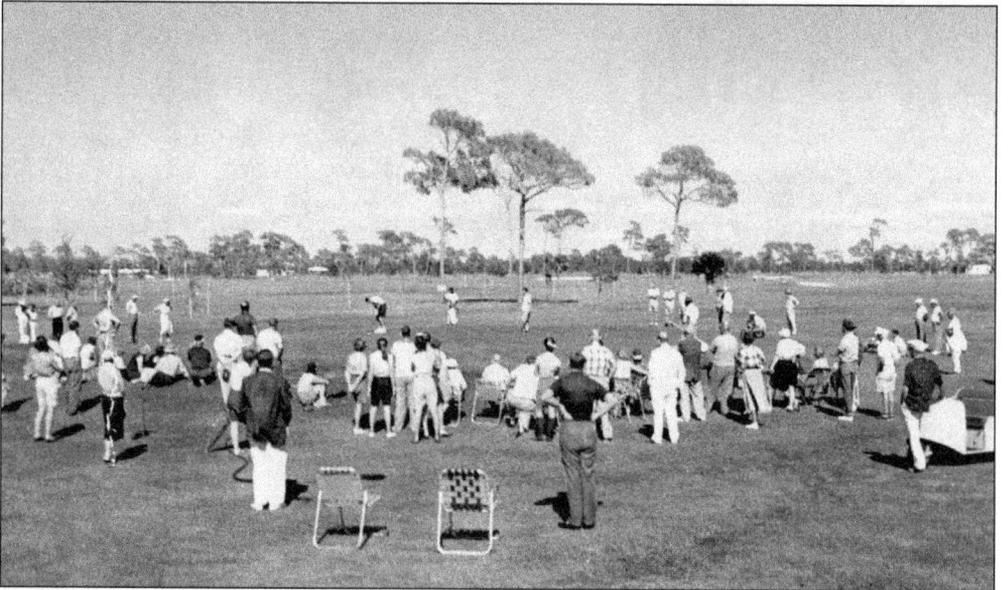

The back of this postcard mailed on June 5, 1960, is captioned, "A gallery of golf enthusiasts watch the final round of the Florida P.G.A. Open Championship tournament from the ninth green of the beautiful Beach Club Hotel course in Naples-on-the-Gulf, Florida." A visitor wrote underneath, "I'd tell you how wonderful this place is, but I'm too relaxed—it's divine. Hate to think of ever leaving here." (Courtesy of Nina H. Webber.)

According to a *Collier County News* report on April 8, 1949, "At present, the Pier Manager, Eddie Watson, buys fish from anglers who wish to sell them, and resells them to the Combs Fish Company at two-cents-per-pound mark-up." By 1956, the fishing pier still attracted anglers and the December issue of *Holiday* claimed the fishing was so easy that "Last summer, a visitor caught a twenty-pound bass with a coat hanger." The *Holiday* feature also noted, "Sunset watching is still as popular as it was in 1887, but hardly anyone bothers to watch the shrimp fleet come in any more, unless they just happen to be eating down on the docks at the small, popular Fish House (reservations two weeks in advance in season are not unusual)." Bob and Pat Combs owned the Fish House and Combs Fish Company, located next to the Gordon River Bridge. By 1950, Bob Combs owned a fleet of 12 shrimp boats. (Top image courtesy of Nina H. Webber.)

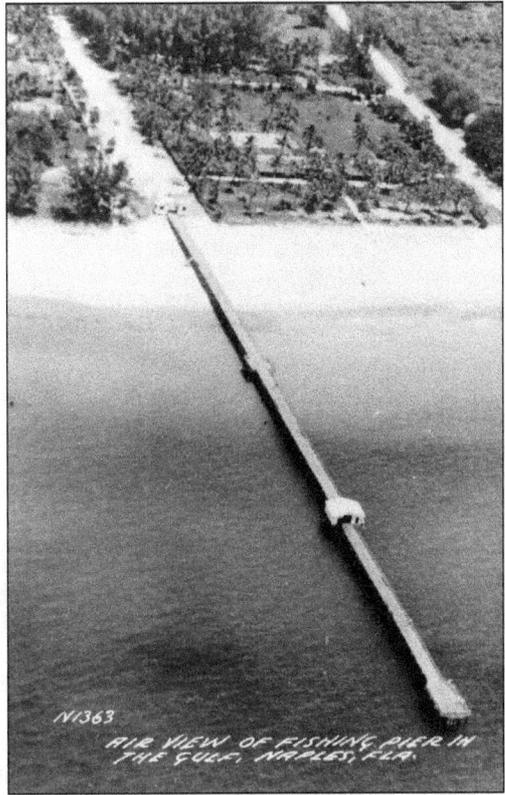

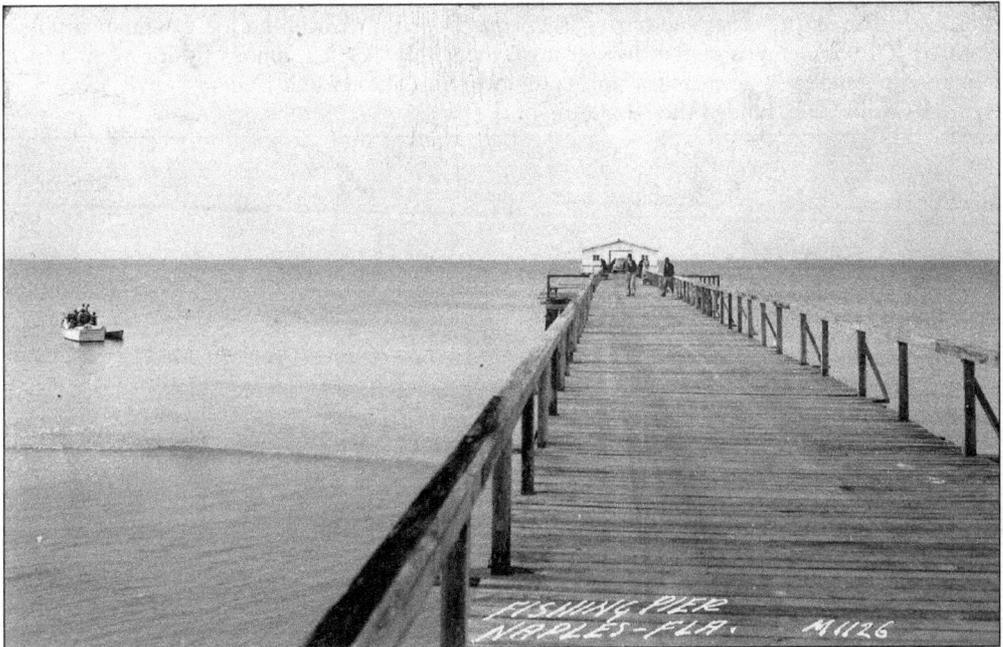

Souvenir of Hurricane Donna

Over 100 Exclusive Pictures

Hurricane Donna was the most dangerous hurricane that ever struck Florida, having winds exceeding 150 miles an hour.

Florida mainland was struck by Hurricane Donna on Saturday, September 10, 1960.

PRICE $1.00

On September 10, 1960, Hurricane Donna, with gusts up to 180 miles per hour, slammed into Naples, releasing an estimated energy equivalent to the explosion of a hydrogen bomb every eight minutes. Before noon, when the barometer reached 28.2, Naples Bay and the Gordon River were almost completely drained, with tons of wind-driven water pushed in the gulf. According to the *Diary of Donna* by William J. Ryan, when the eye passed directly over Naples at noon, the barometer was "28 even, and there was a sudden calm. The sky brightened, with nothing more than a thin overcast." *The Souvenir of Hurricane Donna*, produced by Joe Coleman Studios, featured 104 photographs of the disaster area, including "Naples' famous fishing pier," which was almost completely destroyed. Naples philanthropists Lester and Dellora Norris, owners of the Keewaydin Club, funded the rebuilding of the pier.

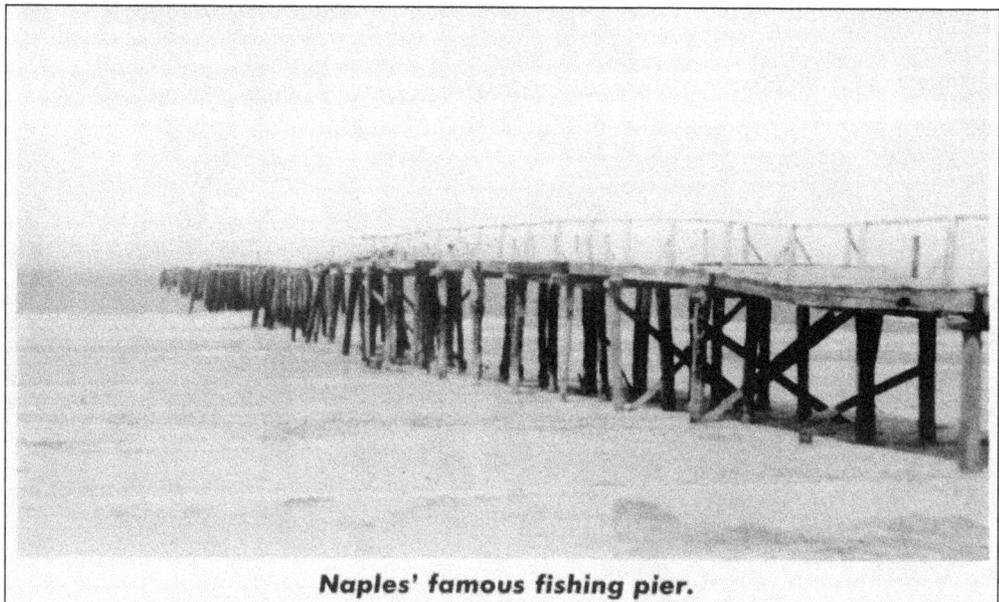

Naples' famous fishing pier.

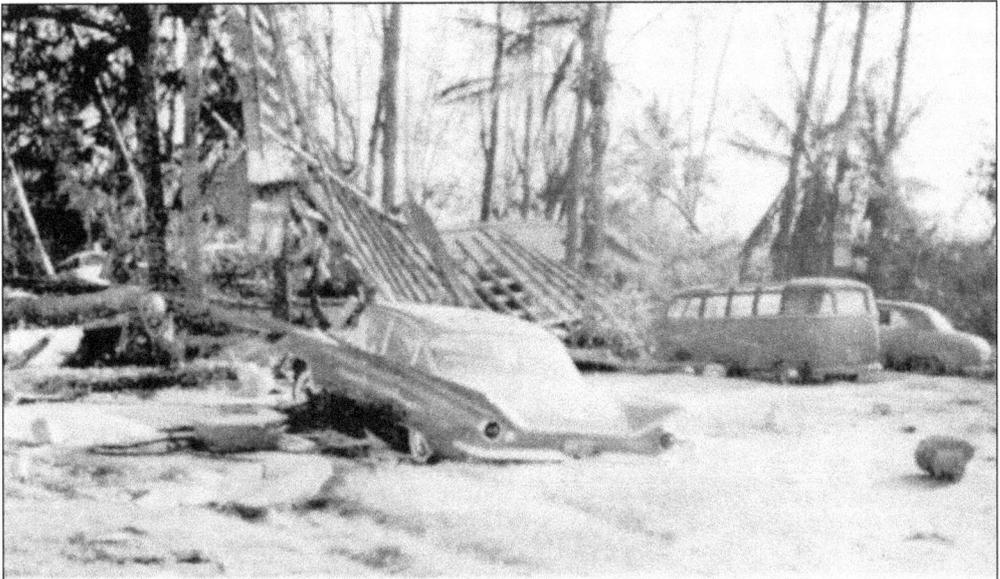

Gordon Pass Fish Camp, Naples.

One hour after the eye passed over Naples, the hurricane-force wind returned, along with a nine-and-a-half-foot storm surge, causing extreme flooding, with three-feet of rain and saltwater eventually covering most of the area between the gulf and the bay. The Gordon's Pass Fish Camp was nearly destroyed, effectively removing the so-called "pimple on Port Royal's face." Amazingly, not a single life was lost, but the county was declared a disaster area. Removal of debris began immediately, and, seeing the opportunity to rebuild a safer—and more beautiful—Naples, zoning and building regulations were tightened. With so many older buildings destroyed, a vast rebuilding program began, the start of a growth trend that continues today.

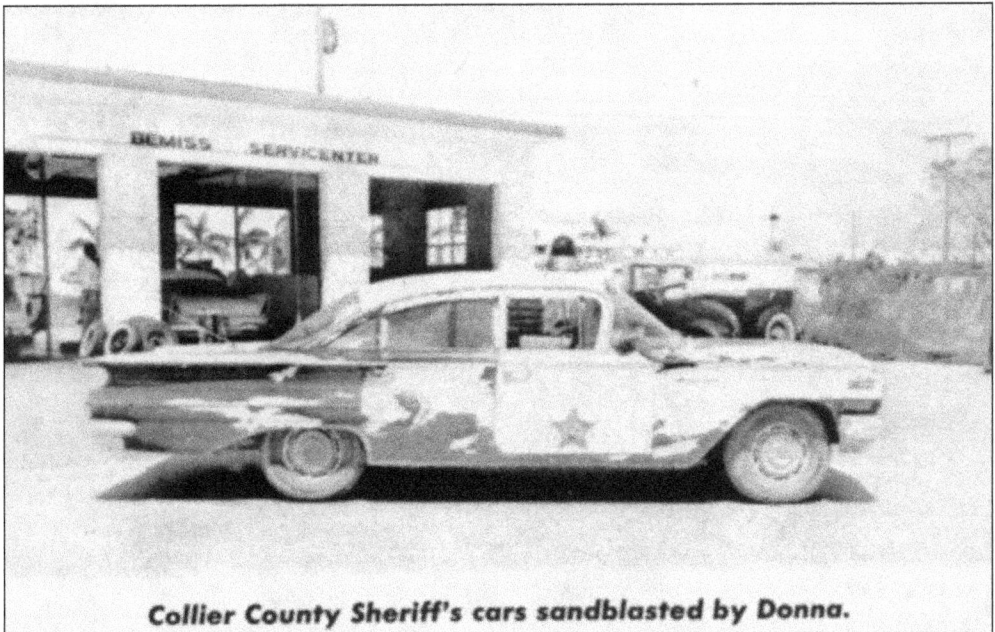

Collier County Sheriff's cars sandblasted by Donna.

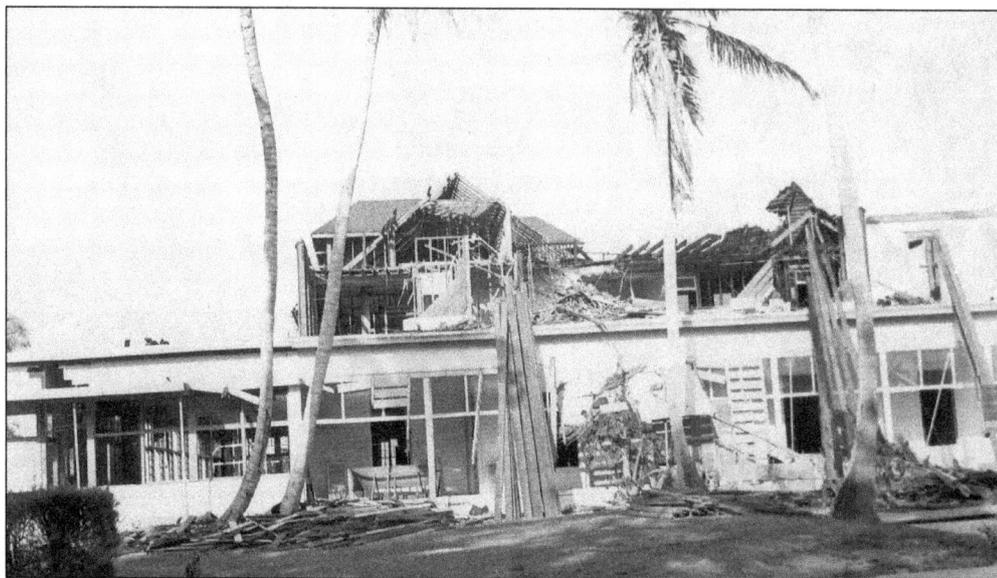

By 1964, operations had shifted from the old Naples Hotel to the increasingly popular Naples Golf and Beach Club. Owners Edwin A. Jones and H.B. Watkins announced a large part of the sprawling old building would be demolished, and a brief article in the February 20, 1964 edition of the *Collier County News* reported, "A Naples landmark since 1887, the old frame Naples Hotel is being dismantled. Work started with removal of doors and windows in the earlier part of the week. Nearly all the wood is still in good condition and will be salvaged." The 1926 north annex remained as a dormitory for Beach Club workers until it was demolished in November 1978. After demolition of the annex, shown below, most of the original Naples Hotel site became a parking lot. (Courtesy of the *Naples Daily News*.)

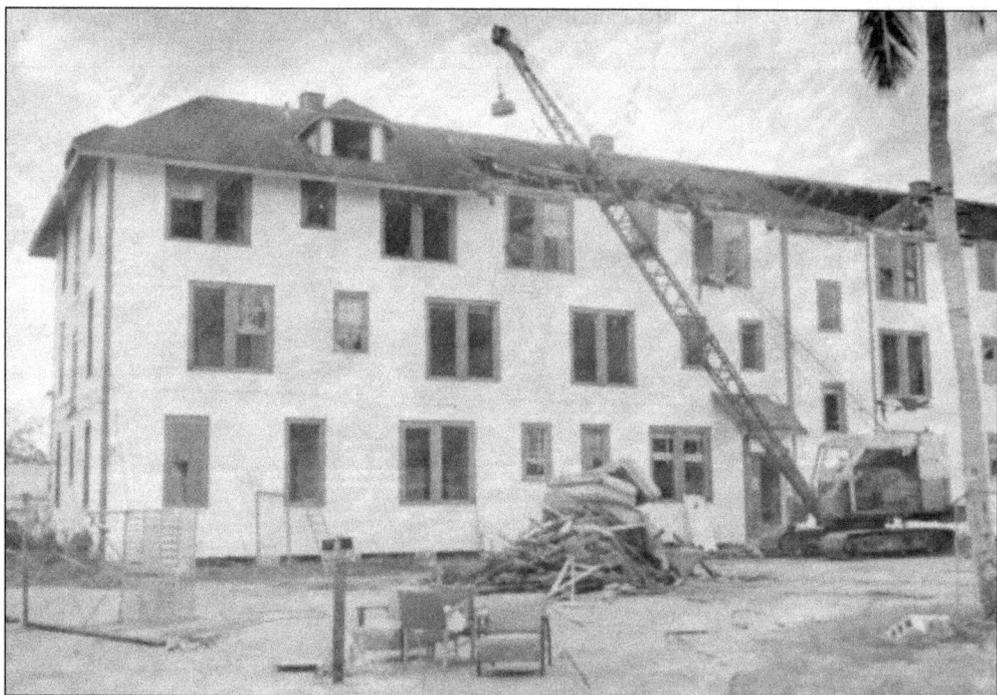